# Proust, Pickles, and Paychecks

# Proust, Pickles, and Paychecks

*Fourteen San Francisco Women*
*Tell Their Stories*

*Sally Mc Andrew*

❦

EDITED BY

ROSEMARY PATTON

SALLY MCANDREW

JOANN REINHARDT

SUSAN RENFREW

2003
Fithian Press
McKinleyville, California

Book design and typography:
Studio E Books, Santa Barbara, CA www.studio-e-books.com

Published by Fithian Press
A division of Daniel and Daniel, Publishers, Inc.
Post Office Box 2790
McKinleyville, CA 95519
www.danielpublishing.com

LIBRARY OF CONGRESS CATALOGING-IN-PUBLICATION DATA
Proust, pickles & paychecks : fourteen San Francisco women tell their stories /
edited by Rosemary Patton, et al.
    p. cm.
  ISBN 1-56474-424-8 (alk. paper)
  1.  San Francisco (Calif.)—Biography.  2. Women—California—San Francisco—
Biography.  I. Title: Proust, pickles, and paychecks. II. Patton, Rosemary.
  F869.S353A26 2003
  920.72'09794'61—dc21
              2003001082

*To our mentors*

*Mary Jane Moffat*
*and*
*J.J. Wilson*

# CONTENTS

# Preface

*Memory tells us not what we choose but what it pleases.*

*—Montaigne*

IN 1998, after writing together as a group for more than ten years, thirteen San Francisco women published a collection of memoirs, *The Subject of Our Lives*. We were delighted by the success of our efforts as word spread from families, to friends, to friends of friends, to strangers. We were pleased by the warmth of booksellers and the enthusiasm of our readers. We kept on writing, remembering, reshaping our memories, discovering details we thought we had forgotten as we unfolded our pasts and explored our presents. Perhaps it is in our writing that, as Emily Dickinson said, "intuition picks up the key that memory drops." We have found memory to be sometimes reliable, sometimes capricious as Montaigne suggests.

We discovered what most writers know. We write to find out what we have to say. We search for the telling experiences, the moments, as Virginia Woolf would have put it, of intense "being" that cast light on who we are or who we once were. Each of us has found a distinct voice with which to tell our stories.

English writer Enid Bagnold asked, in her autobiography, why people want to write and answered herself: "Because it is the answer to everything, to why I am here…to note, to pin down, to build up, to create, to be astonished at nothing, to cherish the oddities…to make a great flower out of life even if it's a cactus." Our indispens-

able mentor, Mary Jane Moffat, has pushed us toward these goals even if we sometimes fail to create the great flower.

We cheerfully acknowledge that when memory fails, a fictive self may slide in to fill the cracks. One story, "Too Soon," is actually a fiction growing from another person's experience rather than the author's. In two others, the authors tell someone else's story, not their own. But most fiction draws heavily on an author's reality as it looks for its own truth. Most memoir shapes itself around a form that creates as it records. Personal narratives slip in and out of factual history. All narratives can lie. That's part of their charm.

Because we started our married lives in an era when roles for husbands and wives were more clearly defined than they are today, most didn't expect to choose a profession. But when we started talking about our working lives outside our homes, we discovered that many of us had, in fact, developed careers, even if late or briefly. Seven of us have written about our experiences as working women. We found that our generation served as a bridge between our own mothers, most of whom did not pursue careers, and our daughters, most of whom did. As we matured, we found we'd been given new opportunities. Today, for the most part, our daughters, married or single, and our sons' wives take women's careers for granted.

In other stories, we've looked back to youth, explored distant or special places, thought about who we are today, and reflected on age. The process of looking for our stories, losing our stories, choosing our stories, editing our stories, arranging our stories has been, like most births, long, sometimes painful, ultimately worth the struggle. Luckily for us, it has brought laughter too.

Our aim has been to live up to Casanova's suggestion in the Preface to his memoirs: "If you have not done anything worthy of being recorded, at least write something worthy of being read." We hope we've accomplished a little of both.

R.P.

# Proust, Pickles, and Paychecks

# Another Time

MARGARET GAULT

# Sonata for Swing

BENNY GOODMAN'S "Sing, Sing, Sing," Tommy Dorsey's "Well, Git It," Artie Shaw and the Gramercy Five's "Summit Ridge Drive"—these recordings and thousands more could not be bought or heard on the radio when I first became interested in popular music as an eighth grader in Los Angeles in the 1940's. There was a long, long musician's strike going on which prevented the playing of instrumentals for recording or broadcasting. The only way I heard these marvelous numbers was if a big brother or sister of one of my friends had begun collecting them in the late 30's. The other way I might have heard them was to go to live performances of the "big bands" appearing often in Southern California after World War II. But that was later, in the tenth grade, when I was allowed to drive with boys old enough to have a driver's license.

I don't remember when that strike ended, perhaps near the end of World War II, but it was wonderful to hear new music recorded by the great orchestras at last. Recently I was at a party, dancing with a friend, and the band began to play Glenn Miller's "In the Mood." I thought I was following my partner but he said, "Oh, you're going to jitterbug." I couldn't stop my feet from doing what

they were doing! It was so much fun, just like the junior high dances at eighth grade lunch period. There were some fabulous dancers to watch then. My friends and I loved to dance, had gone to dancing school since fourth grade (and continued in some form or other through high school), but we were never the really good dancers. One boy in particular, Bob Irwin, was smooth as silk, manipulating his partner to do acrobatic flips, landing her on the right foot to fol-low his steps in perfect unison. How I loved to watch Bob Irwin and wished I were good enough for him to ask me to dance. So we danced to swing band records in the junior high gym and at the first boy-girl parties we had—starting in about the eighth grade.

By the time the boys were old enough to drive and our reluctant parents allowed the girls to be passengers, a favorite date was to go to the Palladium or the Casino Gardens to dance and listen to the big bands. The Palladium was in Hollywood and attracted many young service men. Our dates did not like the practice of those boys who asked any strange girl they favored to dance. We had always been taught that the cardinal sin was to refuse to dance when asked, so we moved out on the floor whether we wanted to or not. My dates preferred the Casino Gardens at the end of the Ocean Park pier, anchoring the weathered gray boards which stretched far out into the ocean. The Casino Gardens was most convenient for people who lived on the West Side as we did, and if we saw strangers, they were like us. My boy friend and I went to the Casino Gardens whenever a band we really liked was playing. Although you could drive all the way out on the pier and park near the entrance, we liked to park on the street and walk through the darkness down the pier, enjoying the sound of the waves breaking beneath us, the love-ly sight of phosphoresence at the edge of a breaking wave, the salty sea smell, and the view ahead of the softly lit mosque-like architec-ture of the Casino Gardens.

Once inside we would choose a little table, order a soft drink, and move up to the edge of the dance floor. Most numbers were fine for dancing but the really great performances were too good to waste on dancing. All the dancers would cluster under the bandstand

and wait for the stars to do their stuff. I can remember once when Roy Eldredge and Gene Krupa got into a competition—Eldredge on trumpet and Krupa on drums—and they took turns improvising, sometimes as much as ten minutes at a time. Then the other answered back. It was so creative and exhilarating to hear a trumpet imitate drums and then the other way around, talking to each other, trying to outdo each other. We young listeners would shout for joy at these precious moments. We knew we were lucky to be there, and the other band members yelled and cheered along with us.

World War II was over in August, 1945, and soon the young soldiers and sailors came home. One of my four best friends lived across the street from the family of a returning serviceman who congregated with his buddies at his parents' big house. We five friends were not yet 16 and the boys were about 20, but we formed a gang and had a wonderful time together. The boys were members of the 52-20 Club. That meant if you had served in the armed forces and returned alive, a grateful nation would pay you $20/week for one year while you took an extended vacation. Our new friends took full advantage of this offer so they had lots of leisure time.

These boys loved music and took it upon themselves to educate us about the really important music scene in LA at that time. The thread of Negro talent running through the history of jazz was evident in the mostly white big bands I was hearing at the Casino Gardens, but the all Negro bands who played for Negro audiences played in south central Los Angeles, a long way from our homes on the West Side. We went many times with our new friends, Bunny, Ray, Jack, Jay, and Tom, to Central Avenue ("Central Avenue Breakdown") to the Million Dollar Theatre to hear Lionel Hampton, sometimes featuring Billy Eckstine. We always sat in the balcony and looked down on Lionel Hampton playing the vibraphone, so confident and proud, his hands hitting the keys so fast the little mallets were a blur, his gorgeous big white teeth shining with enjoyment in his brown face as he looked up at us while he played. Sometimes Billy Eckstine sang with the Hampton band, sometimes with a combo which simply backed him up. He was a beautiful singer and

a favorite with the Central Avenue audience. I don't remember if there were other white people in the audience, but we never felt different, unwelcome, or threatened. I ask myself, what was my mother thinking of, letting me go down there? She never knew nor did any of my friends' mothers. First, they had never heard of the places where we were going and second, we had elaborate stories to explain our false plans for each evening. Usually we said we were going to one or the other of our houses to spend the night and we always got home on time so our mothers would have no reason to check up and they never did.

Closer to home the boys took us to the Boulevard Stop, a club in Beverly Hills. We all liked it a lot because it was not too careful about checking ID (we girls didn't drink but needed ID just to get in the door), and they had great vocalists. My favorite was Slim Gaillard ("Cee-ment Mixah, Puttee, Puttee"). Slim was an overstatement. He was so thin it seemed like the microphone stem was fatter than he was, and he swayed and bent like a straw in the wind as he sang. Frankie Laine also played there a lot ("To spend one night with you, in our old rendezvooo, That's my dee-ziah.") and he was as good a scat singer as a white man could be.

We went to the Million Dollar Theatre and the Boulevard Stop on weekend nights but there was another place we went on Sunday afternoons. This was on Santa Monica Pier and it was a big room with a bar that was rented for single performances. The real, genuine, Dixieland players would appear there. Only the cognoscenti knew about this place and who would be playing, the New Orleans jazz players who had hit their peak of popularity years before but were still alive and could still blow. They all seemed about 100 years old to me. The boys paid for us to go in but it was priceless to hear the music and think about how much these men had seen and what important artists they were. Kid Ory was there a lot with sidemen and they played the New Orleans music they had played on flat-bed trucks for Negro funerals. The pioneers of boogie woogie, Meade Lux Lewis and James P. Johnson, were there at different times. These performances were not put on just for enjoyment like Lionel

Hampton's or Slim Gaillard's, but also to hear the sound of these old men before they were gone. When I started college at Vassar, sometimes in New York I went with an old LA friend to a club like Eddy Condon's, but no one except my California friends did this for fun. The Eastern boys I knew liked to go to parties or to the theatre but seemed not to know anything about the music scene in New York. BeBop came in shortly after I started college, but I never got into that because I went where my dates took me.

When I went home for vacation, I branched out to date Ivy Leaguers, mostly from Pasadena. There was one great club in Los Angeles, the Haig, that combined the sleek sophistication Ivy Leaguers liked and on-the-edge, virtuoso playing or singing. Bobby Short sang here for a long time and I used to hear him often. He still sings at the Carlyle Hotel in New York, the same marvelous Cafe Society songs like "Miss Otis Regrets" and "Bobwhite," done in his original, creative style. What a survivor! That was fifty years ago and his voice is still sweet and malleable, his delivery knowing, wicked but romantic, too. I think Bobby Short is as much of an artist as Ella Fitzgerald and I hope he will be idolized as she is.

My four friends and I had tremendous fun growing up. Looking back at our musical experiences makes me glad they and I contrived in a rather underhanded way sometimes to get to these places, hear great music, and collect rich memories which still bind us together. Maybe it was all the fun we had that has kept us alive and healthy and full of love for each other more than sixty years after our friendships began.

SALLY McANDREW

# Going South

FROM THE TIME I was a baby in 1930 until I was about twelve, we went to Florida on the train every winter for three months to stay with Daddy's parents, Dollie and Lucius Robinson, whom we called Meme and Mepa. My earliest memories stem from when I was five.

Shortly after New Year's there is a stirring in the house, clothes spread out in the bedrooms, discussions about arrangements between Mommie and Daddy, and long-distance telephone calls. I can tell they are long-distance because my parents shout on the phone as if they're trying to reach someone in the next room. Then, one night about 10:00 P.M. Daddy stands at the foot of the stairs with his watch in his hand and calls to Mommie who is upstairs packing.

"Dearie," he says, "are you about ready? It's almost time to go."

"I'll be down in a minute," she responds. Mommie knows it isn't nearly time to leave, and Daddy knows that she knows, and my sister Ruth and I, who are supposed to be asleep and are about to be wakened for the trip, also know. But the ritual is comforting and we slip easily into our respective roles. Daddy wants all the bags to be ready, so he can take them to the station by taxi early, saving the big car for

Mommie, Ruth, Lucia and Jean, her nurse, Miss Haub, the governess, and me. Even though the overnight train to Washington doesn't leave until midnight, we always arrive very early so as to "get settled" before it leaves.

Organizing the Pittsburgh household for three months while the family is in Florida is a big job for Mommie, and even though she does it well, she becomes frantic at the last minute. She must lay out household tasks for the help over the months we are gone, pay the bills in advance, and supervise the packing. Instructions are detailed: the downstairs rooms must be stripped of curtains and slipcovers, the floors waxed, the furniture polished and the rugs and curtains cleaned, closets emptied and de-mothed, kitchen and pantry walls scrubbed and painted, and the basement scoured. All the other rooms must be cleaned thoroughly. Major repairs are scheduled and instructions for the gardener written—when to take the burlap covers off the boxwood and azaleas in the courtyard, when to plant spring flowers. Winter slipcovers and curtains are to be replaced with lightweight, pale-colored ones for summer, while the dark, heavy winter furnishings dictated by custom and Pittsburgh's filthy air are sent out to be cleaned. When we return in April, the house will welcome us for spring, even though it won't really arrive until early May if we are lucky.

Finally we are ready to go. Ruth and I must dress for the January winter in warm underwear, then wool challis dresses, buttoned up the back, thick knee socks and sturdy shoes. Then the outer garments. We wear matching cardinal red wool coats, hats and leggings from Best & Co. with dark red velvet trim. I hate the scratchy feel of the wool against my neck and under my chin where the strap of the hat rests. Finally, wool mittens and lined boots over our shoes. Never mind that we are going from the warm house to a warm car, and after one night en route to a warmer climate, we won't need all these warm clothes. We must be protected from the evil draughts of the night air and the cold railway station. An empty large suitcase is brought for the winter clothes, which will be packed up and shipped back from Florida.

"I'm exhausted," says Mommie as she sinks back into the car seat.

"I dibs the jump seat," I say, waiting until the others climb in. Baby Lucia, equally bundled, sits on Jean's lap, Miss Haub sits in the back with Ruth and Mommie, me in the jump seat, then we're off. Daddy takes a taxi with all the bags that don't fit into our car and meets us at the station.

The route follows The Boulevard of the Allies along the high slope above the Monongehela River. On the other side of the river, blast furnaces from the steel mills shoot fiery sparks high into the thick black air like a continuous display of fireworks, each spurt illuminating the scene in a bright flash. Descending gradually into the narrow crotch where the dark office buildings of downtown nestle in the triangle made by the confluence of the Allegheny, Monongahela and Ohio Rivers, we cross a steel bridge and pull up at the B&O station. The Baltimore and Ohio Railroad station is housed in a large Beaux Arts structure like those depicted in Monet's paintings. The sparks from the furnaces at my back illuminate the façade intermittently, not like a spotlight but rather a door to a lit room opening and closing. I am awed by the vast building and feel as if I'm stepping through a giant mouth into an alien world. I cling tightly to Miss Haub's hand and our footsteps echo on the cold marble floor. I stare at the few people who wait for the train on wooden benches, their faces blank with the mindless expressions of a Daumier etching. The air smells sour, of dank coal dust. Behind the iron gates that separate the seating area from the tracks, I see the monstrous black engines crouching, waiting for me impatiently, reminding me of their awesome power with little coughs and tics.

The inside of the Pullman car smells even worse than the station with the dirt and coal dust absorbed in the rough plush upholstery, which gives me a creepy sensation when I rub against it. I feel sick and know I will be sick for the whole time I'm on the train, but I don't care, it's so wonderful to be going to Florida. Miss Haub makes Ruth and me sit on the bench along the wall of the drawing room compartment while she washes down the window sills, arm

rests and bathroom with Lysol, adding yet another smell to the sickening mix. We are not allowed to touch the floor with our bare feet in case we catch some dread germ. Miss Haub insists on the lower bunk, I claim the upper, so Ruth gets the narrow bench, all of which have been made up as beds. From the top bunk I can't see out, and it seems unfair that Miss Haub should hog the lower bunk when she won't even look out the window once the whole night. But she is the grown-up, so I guess she gets to have her way.

We carefully fold our clothes in the little hammocks above our bunks, then turn out the lights with their miniature shades and wait for the train to start moving. I am so excited I can't possibly sleep. "When will we go? Oh, I can't wait to get there," I say to myself, my heart singing a little song "We're going to Florida, we're going to Florida. Hooray! Hooray!" There is a sharp lurch, then a chugging sound, and we're off.

The rhythm of the wheels on the track and rocking motion soon lull me to sleep, and the next thing I know it's morning, and we're in Washington. We take rooms for the day at the Mayflower Hotel, and I remember the happy feeling of familiarity as we draw up in the taxis. It is early morning and we will have breakfast in our rooms, settling in until time to leave for Union Station and the Orange Blossom Special that night. I hear the breakfast tables wobbling down the corridor, the sound of the wheels on the rug, the faint tinkling of glass and silver jostling against each other as the carts bump along, and I rush to open the door before the waiters knock. I love to watch them unfold their mysteries. First the places are set, then the orange juice poured, then the silver pitchers identified for coffee, tea, milk and cocoa. Then the silver ovens under the table opened—imagine having your own hot oven under your dining table! The delicious smell of bacon wafts through the room. There is hot cereal with brown sugar, and eggs, bacon, toast, jam and butter in a little silver dish nestled into another dish filled with ice. What a feast.

After breakfast Mommie takes Ruth for her annual visit to the eye doctor, a specialist in an exercise program to correct crossed

eyes. Lucia and Jean go out for a walk, Daddy reads the paper and makes arrangements, and Miss Haub and I go sightseeing to the Smithsonian, the zoo, the Mint, or Mount Vernon. Finally it's time to set off for the most exciting part of the trip.

Now I know that we are really on our way. To leave Pittsburgh, which, in January, is all dark—black snow and freezing gray cold— and travel to a land of warm, bright, clean technicolor is thrilling, and to do it gradually is the best of all, the changes unfolding like time-lapse photography. We will be on board two whole nights, one whole day and a half, arriving at our destination on the afternoon of the second day. Every stop south brings us closer to spring—a few green leaves in Richmond, azaleas and magnolias in Raleigh, more flowers in Charleston and Savannah, then hibiscus, orange blossoms and palm trees from Jacksonville south along the coast to our stop at Hobe Sound. At each stop, we pile off the train and run around while it refuels, the men re-filling the coal-car right behind the engine. Daddy peruses the newsstand and smokes his pipe, and I take deep breaths of the soft, fragrant air. My queasy stomach feels better at each successive stop.

During the trip, the railroad company changes three times, but we never do. We leave Washington on the Richmond, Fredericksburg and Potomac Line, then switch to the Seaboard Line further south; then in Jacksonville, we turn into the Florida East Coast Railway. I love to watch the switches at Richmond and Jacksonville, which involve re-routing to another track, a new engine and new crews. We watch the workmen closely to see how they couple the cars, and sometimes they talk to us or smile.

On the journey, Ruth and I first learn about Negroes. We don't have many in Pittsburgh, the workers being mostly Irish and Slavic like our household help. The porters are all handsome cheerful black men dressed in starched white jackets. I remember their graceful hands especially, dark on top and lighter brown between the fingers, which mostly are long and thin. With expert efficiency, they transform our daytime living room into a cosy bedroom, and in the dining car, the waiters carry heavy trays of food over their heads on

only an upturned palm all the way down the swaying cars without spilling a drop. We sit at tables against the big windows so we can watch the world go by as we eat. Starched, clean white cloths, little silver serving dishes and cutlery, a single red rose in a silver vase at each table, gleaming glasses and white china all clink merrily as the train jiggles along the tracks. And best of all, the delicious taste of guava jelly and cream cheese on saltine crackers for dessert. Even now, when I taste the translucent amber nectar, Florida and our long winters in the sun flood over me.

Inside the train, all is clean and under control. The porters are uniformly kind and helpful and tell us about their families and where they live when they aren't on the train. They seem happy and hopeful about their lives, which we accept without question, being young and naïve. As we progress south, though, we see ramshackle cabins outside in the dreary landscape along the tracks. Thrown together of weathered scrap wood, the shacks are set on tiny stilts, and look flimsy, as if a little breeze might knock them down. They have tarpaper roofs and sagging porches with broken rocking chairs. Most of them have openings for windows but no panes, and we can see newspaper crookedly stuck on the walls. Outside there are a few scraggly-looking plants, dilapidated washtubs leaning perilously near a wall, rusty farm implements lying around helter-skelter, and a few sickly-looking animals. Many people seem to live in each shack, all dressed shabbily. The older ones sit on the porch smoking, children play in the yard, and women stare at us sullenly out of the windows.

"Who are those people?" I ask Mommie. "Why do they look so sad? Why don't we have them in Pittsburgh?"

"Well, they're very poor," she says, "and that's just the way they have to live. They're probably descended from slaves and do the best they can with what they scrape together," she adds. "There are colored people in Pittsburgh too, but we just don't happen to have any working for us."

"But why do they have to live like that?" I persist. "It doesn't seem right for people to be so poor. They're worse off than the coal miners."

"I know, dear," Mommie answers with a resigned sigh. "It's all very complicated. Don't let's dwell on it anymore," she adds, cutting off further discussion.

Ruth and I ponder this for a long time, but we don't find any answers. It is the only dark aspect to going south and each year I anticipate seeing the shacks with a mixture of dread and hope. (But during the years I went to Florida, nothing changed.)

Ruth and I get really excited when we cross the border into Florida. Now it can't be too long. Jacksonville, Daytona Beach, Fort Pierce, past acres and acres of orange groves, and when the train starts to slow down for Hobe Sound, the stop for Jupiter Island, our destination, we crane our heads to see out the window. Since Hobe Sound is just a station with no town around it, the train doesn't stop there unless there are passengers aboard who want to get off. It is called a flag stop because the stationmaster stands next to the tracks and waves a tiny flag at the engineer. That makes it even more special. To think this great big train stops just for us!

Now we are here. The minute I smell the air, I forget the sick-making coal dust smell. I squint my eyes against the bright sun and silently greet the road, which is made of crushed white shells, glistening in the sun and crunchy under foot. I greet the oleander hedge, the vivid blue sky and the beautiful bright-colored flowers.

The Jupiter Island Club bus, re-fashioned out of a Ford car that had been cut in half and "stretched" by the Toledo Bus Works, meets us, along with Mayeda, the houseman, in the wooden-paneled station wagon, who will take the luggage. We watch the train leave for Palm Beach and I wave to the conductor who waves back.

"Goodbye," I shout. "See you in April."

We are in Florida! I am in heaven!

AVA JEAN BRUMBAUM

# Childhood

WHEN I THINK of my childhood, two images are strong: a comfortable, brown-shingled house on Russell Street in Berkeley, and the rustic cabin high up on a hill above Fallen Leaf Lake.

The Russell Street house brings warm memories of its inhabitants, two older sisters, a brother, Mother and Father; of a garden surrounding the house, rather casually tended; and of a neighborhood of friends always ready for games.

But the summers at the lake, anticipated all winter, bring the happiest memories: of mirror-smooth water with the reflection of the mountain across, of wild, windy days, of white caps, of hot climbs up that steep hill from the lake to the cabin, of my father and his friend who shouted at the drivers while directing the traffic jams that occurred on our narrow stretch of the one-lane road.

Our days were filled with swimming and boats. We lived in bathing suits and swam from the docks of friends and neighbors around the lake. One kindly old gentleman who enjoyed having children around paid us five cents for every box of rocks we collected from the bottom of his cove, eventually leaving a sandy bottom. We seemed to be always in or under that clear, cold water, pure enough to drink from our taps.

Dad bought a two-seated metal rowboat which he considered safe for us because it had flotation tanks under the seats. My brother Tom and I rowed it the first year or two, when we were six or seven. Then there appeared a three-horsepower motor, so simple that there were seldom mechanical problems, and we could fix them ourselves if there were. No one seemed to worry about us out on the lake and we didn't wear life jackets; nobody did. Our greatest sport was going out in the boat during the biggest wind storms when the waves were at least three feet high. If we headed into them, we banged up and down and were often drenched by the spray; sideways, we rocked back and forth, coming very close to taking on water. The bigger the waves, the more fun. Rain didn't deter us, lightning never seemed a worry.

My teen-aged sisters had other pursuits which didn't interest Tom or me, there being something of a generation gap between us. But we did like their wind-up "Victrola" and the collection of 10-inch, 78 rpm records. Most memorable were "Red River Valley," "Hallelujah! I'm a Bum," "Night and Day," and "Love for Sale," which Dad banned when the words "Follow me on up the stairs" happened to catch his attention.

I pestered my sisters to take me on their hikes with their boy friends, usually college students working at "The Lodge," who sometimes had to carry me down a too rough, too steep trail. As adolescence approached, I longed to have boy friends of my own to drive me in their Model Ts or out to the Big Lake (Tahoe) and the one little casino at Stateline where people went dancing—slot machines were not the principal attraction.

All those happy summers melt into memories of a little house with a large stone fireplace, a bathtub too short to let a grownup stretch out his legs, my sisters carrying ice up the steep trail before we got a refrigerator, an empty gallon jug sitting on a stump halfway up, waiting for the milkman, who came every few days, Mother in the tiny kitchen making her special spaghetti with tomato juice, cheddar cheese and black olives, Dad coming up weekends, sharing rides with whoever was coming too, and both of them leaving us,

dejected, with our sisters, as they went off without us on their wedding anniversary each July. Memories, too, of us girls asleep on the lower deck, beds exposed to the stars unless it rained, when they were pulled in under the upper deck, the wind often swishing through the tall trees against our faces until we hid them under the covers.

Later, Tom got summer jobs and I did find boy friends for long hikes to cold lakes where we swam, and to mountain tops with breathtaking views. Most of the cabins are still there today; the friends of my childhood are grandparents now and still we meet, swimming from the same docks, riding in faster boats, with grandchildren who don't miss the simpler, idyllic life we knew.

JEAN-LOUISE N. THACHER

# The Old Pool

TO GET TO THE Old Pool from our summer camp at The Cedars in the Sierra Nevada mountains, walk along the edge of the creek through the meadow bordered with quaking aspens and red-barked cedars. Check for orange tiger lilies and red ice plants in the meadow and jump across the tiny creek, bordered with sword-shaped iris leaves, which only has water in early spring. Go down a small hill marked with a huge fallen cedar. Following the family custom, stand on the giant trunk and give a Tarzan yell while beating on your chest on your first visit to the Old Pool each summer. You are expressing your joy in being once again in your beloved mountains. Then leap from rock to rock to cross a large creek and run through the cedar forest. Finally, on your left a familiar mountain rises and you know you are about to reach the North Fork of the American River with the Old Pool at the bottom of the canyon.

The Old Pool is a very special place. It is hidden deep in the mountains in a narrow part of the American River. The pool begins abruptly where the stream is a shining rapid and suddenly drops off into a fall composed of rough, dark boulders, which the rushing water must force its way through. In its search for a way out, the water

still remains pristine. Fresh from the melting snow in the mountains above, it is very cold.

Below the falls stretches a pool bordered with granite and layered with multi-colored rock. Deep enough for diving, the pool curves around the canyon to a wider area with black basalt rocks covered with lichen where the water moves slowly and even permits some moss to grow and where a few skippers skitter on top of the water and annoy the water snakes. Then the pool narrows down to the exit fall and tumbles over.

The pool has very few places where it is necessary to take more than eight strokes to reach the other side, not a fearsome place for learning how to swim. Mostly, the pool is for splashing and laughing and sliding on rocks and, of course, looking for gold. There are even places where you can hide under the overhanging cliffs and be invisible from the well-worn trail.

As children, we loved to break our parents' rules and, when they were not looking, climb the rocks and slide down the falls. They seemed ridiculously afraid we might hurt ourselves, but we secretly suspected they were sure we would frighten the fish, distract them from biting or ruin the bathing suits given to us by a great aunt we disliked.

A few trees managed to grow in the scarce earth around the pool, but they don't get anywhere near as tall as the cedars and pines in the forest by the river where there is more soil. There was a juniper tree, scraggly and fragrant, with slender strips of bark and pale gray-green nuts, and lots of buck brush and wild roses around. By far our favorite plant in the area is the Washington Lily. Tall and straight, its blossom is a spotless white. It looks pristine amidst the gray and black rocks and the small wild flowers with their bright blossoms. There was a tall sugar pine nearby with huge cones. They could be ripe brown and sticky and full of delicious nuts or deep green, unripe and hard, and you never knew when one might loosen and fall on your head. Underneath the pine on the higher shelf was a prickly wild rosebush whose round pink flowers had golden centers and a delicious fragrance. A gray granite rock nearby was just the right height

to lean on and gaze. With the roar of the river, the scene provided just the right amount of noise, beauty, color, foliage, everything needed to inspire something significant or memorable or simply satisfying. There were no signs of humanity—it was like a living dream.

My father wouldn't let us splash in the Old Pool until he had cast a few flies for trout. He had a beautiful, light, slender rod presented to him by a grateful patient, which we were not permitted to touch, much less use. It was a pleasure to watch him cast his favorite fly, a colorful Royal Coachman, and make it behave just like a real fly, bouncing and dancing on the water. When a trout bit, my father played with it in the water until the fish tired. After he landed it, he would lean his rod against a tree and swing the wriggling fish against his chest, then seize it and carefully remove the hook from its throat. He would put his thumb in the fish's mouth and pull down on the jaw until he broke its neck. The trout didn't wiggle after that. Then Father would open his jackknife, cut off a piece of buck brush and run it through the trout's neck and mouth. Often he would clean it right there on the bank by slitting its stomach open with his knife and sliding all the insides out onto the brush with his thumb. My sisters and I insisted on examining them to see which kind of insects the fish had been eating, and we fought for the privilege of carrying it home in the fork of the stick.

Having worked in a gold mine in Nevada City, my father was sure we would find gold in the deep potholes in the falls at the Old Pool, gold that had escaped from the miners' pans when they eagerly washed gravel from nearby streams. As small children, we were lowered carefully into the black potholes, father holding us tightly by the straps of our Jantzen bathing suits, and encouraged to reach around on the bottom and bring up what small pebbles and rocks we could find. My mother would stand on the cliff beside the stream, and I can remember her saying, "That's enough, Howard! That's enough. The gold has all washed down to Sacramento."

"Just wait, Louise. There may be a college education here!" my father would reply. Then mother was very quiet. She didn't argue. College had not been her good fortune.

After a while we would slide down the rocks and receive a short course in the dog-paddle and floating and finally climb out, shivering, on the shore to warm ourselves on the warm rocks. Then my mother and father would go swimming. Mother, in her purple one-piece suit and broad brimmed felt soldier's hat with fishing flies on the band, and father, in his red trunks with the white stripe, would head for the falls. We would sometimes hear my mother sing the "Indian Love Song" above the sound of the splashing falls. More often we would hear, "Stop it, Howard, you'll ruin my hat!"

No one has ever been able to tell me who gave the Old Pool its name. If it was called the Old Pool, it had to be older than something. On a river isn't everything the same age unless it's yesterday's sandwich paper or the floating tangerine peel or the fresh new aspen leaf?

Years later, this part of the river always manages to remain the way I remember it, clear and shining, the beautiful falls at one end, the deep dark pool underneath with the shy fish and the skittering bugs, and the rapids at the other end. The trees I remember are still there, the Sugar Pine with the sticky cones, the Juniper and prickly rose. The pool is a little shallower today than it was long ago. Much sand and gravel have washed down this way, and, in the intervening years, a cement dam was built some way up the river to form a lake. The children from The Cedars were given a rowboat, which they were urged to learn how to handle. They had to wear life jackets or swim with rubber tubes. These things kept the children and the water apart, even as they sat in the sand and stared at the peaks and valleys and the pines reflected under the water. Somehow the river was no longer so close and special a friend. Something had been taken away to be replaced by shovels and buckets and rubber tubes and rafts, things that use water as nature did not intend.

Whatever it is today, though, the Old Pool will always be a place for us who remember it as it was to love and cherish.

MARGARET GAULT

# Swimming

TO A CHILD growing up in Southern California, water is a
friend. The beaches are the playgrounds for all, from exclusive
beach clubs to Muscle Beach and the board-surfing coves around
Palos Verdes and San Clemente. Many houses have pools, and it is
essential to learn to swim or use the water safely and to enjoy it to
the fullest from an early age.

My grammar school included swimming lessons for its students,
and we swam one afternoon a week from about third grade on. Each
class had an appointed afternoon when we trudged up the hill from
our school buildings to the main UCLA campus. As the class strag-
gled along, we passed between Royce Hall and the library on the
wide main walkway. These two huge red brick buildings anchor the
plan of the UCLA campus at its highest plateau. Sweeping down
from the piazza between them are wide, shallow steps leading to the
women's gym on the right and the men's gym on the left. Standing
at the top of the stairs before starting down, I saw to the west Sunset
Boulevard sweeping around a curve toward the campus, grass play-
ing fields stretched out below and, several miles away, the sharp viv-
id blue line of the ocean on the horizon. It is a fine architectural

effect. I am grateful to have lived in a well-planned community like Westwood Village and the UCLA campus as they were when I was a child.

Our class always swam at the Women's Gym pool. On a cold, foggy day in San Francisco, I go there in my daydreams. It is outdoors, of course, and the sun is always high in the sky as it is after noon on a warm day. We change in the dressing rooms and emerge into brightness so dazzling we shade our eyes. Within a rectangle of three high brick walls and the building wall is a sparkling Olympic size pool with three heights of diving boards, turquoise tile and water shimmering in the sunshine. We all jump in, the boys doing cannonballs. After a time of playing around, we practice all the strokes and end up with races using the various strokes.

The bravest thing I ever did I did at that pool. I was then and still am so afraid of heights it is like a sickness, but all the good guys, the boys and some of the girls, challenged each other to jump off the very highest of the diving boards. I got so I could dive off the low board pretty well, but that was no feat. Everybody did that. One day someone in the class noticed that I was swimming around or treading water when I should have been in line waiting to jump off the high board.

"Margaret is a sissy. She never goes off the high board. I dare you, Margaret. Sissy, sissy, sissy!"

What else was there to do? I climbed out of the pool trying to act cool like "I do this all the time." Standing in line with the boys and a few brave girls, I prayed that the bell would ring and we'd have to clear the pool before my turn came. No such luck. I worked my way to the bottom of the ladder. It was a long climb up, rather like the distance firemen have to climb to reach the third or fourth floor of a burning building. At the top, the narrow black rubberized board stretched out. The end of the board was the point of no return. I had seen my classmates get to the top of the ladder and after taking a look down, turn around and retreat down the ladder. Others had walked all the way out to the end of the board and then ignominiously turned back. I knew that, horrible though the feat

would be, turning back to the catcalls, teasing, and contempt of my classmates would be worse. Not for me the stigma of "sissy." Standing at the tip of the board, I looked down at my friends and enemies arrayed below, yelling at me to do it. It was like being in a plane looking down at the tiny cars and trucks on a freeway. The earth and safety were so far away. Summoning up the same kind of courage it would take for me to commit suicide, I jumped. It was a long way through the air and just as long after I hit the water where I plunged to the bottom of the deep pool. When my feet gently touched the tile, what a relief to stroke back up to the surface, to the sunshine, to the blue sky, to my admiring classmates. The agony and nausea had been worth it, and are still worth it because whenever I have had to summon up courage in all the years since, I say to myself, "I jumped off that diving board and I can do this too!"

ROSEMARY PATTON

# A Light Went On

THE LIGHTS WENT OUT and the room grew silent except for the hum of the projector at the back, which cast a dim glow into the gloom. The voice of Miss Jenkins, Professor Marianna Jenkins, began to soar.

"Quattrocento, chiaroscuro, perspective. Giotto, Rafael, Leonardo, Caravaggio." She caressed the words as they tripped off her tongue like cascades of clear water, filling the darkened room for fifty glorious minutes of nonstop magic. Pens raced to keep up as eyes stayed fixed on the screen before us. The colors, shapes, lines were luminous, but it was the language with which Miss Jenkins informed the images that brought them to life and imprinted them forever on our minds. Rafael's *Disputa*, Leonardo's *Madonna and St. Anne*, Michelangelo's *Last Judgment*. The carefully enunciated syllables echo still in memory. This was a class where all the senses were engaged. Eyes and ears worked overtime as brilliant slides clicked into place one after another, and Professor Jenkins' powerful voice sang the art of the Italian Renaissance into vibrant life. The heat of the projector lamp lent a warm, singey odor to the crowded classroom. Dust motes must have been burning. My heart beat faster.

My vision was forever changed. From that murky classroom, the world took on a new luminosity.

Miss Jenkins was not a compelling presence until she spoke. Very short, with a failure of chin below a gaping wide mouth, she nonetheless grew in stature and charm when she used her powerful voice. She exuded intellectual confidence and infectious enthusiasm for her subject. Too small to stride, she rushed into class three mornings a week, high heels clicking on the old wooden floor of the art building, her well-chosen suits, dresses, and scarves signaling unusually expensive taste for an academic. In fact she was not, in the narrow sense, an academic. Her course load was small, her degrees limited. She did no research or publishing. She lived, as I learned later, in quiet elegance with her mother, with whom she traveled a great deal. In my senior year, I came to know her outside the classroom. She served as advisor to Student Forum, the campus committee that arranged for visiting lecturers, on which I served. When she complimented me on a suit I particularly liked, I felt as sartorially validated as I have ever been.

She knew her students would follow her into the brilliance of fourteenth, fifteenth, and sixteenth century Italy. The Florentine school was the locus of her passion. Fra' Angelico, Masaccio, Leonardo's Madonnas and saintly saints, Andrea Del Sarto bloomed in the focused radiance of the darkened room before she took us breathlessly to Rome as we followed Michelangelo to the Sistine Chapel. Her rich voice was still with me when at last I gazed on the Sistine ceiling twenty-eight years later. Staring up, I could hear her describing the modeling and shading of Adam's form, the sweep of the garments, the richness of pigments. As Renaissance painting flowered, she moved us to the Venetian school, exploring the lavish abundance of Giorgione, Titian, Tintoretto. But when I spent a recent week in Venice, I still had with me her view of Venetian painters: brilliant but lacking the subtlety and sophistication of Tuscan and Umbrian masters. Her taste was classical in its preference for the less adorned. In her eyes, the late Renaissance works of the Mannerist painters, as they experimented with elongated propor-

tions and other innovations, did not measure up. Even the lush beauty of Botticelli remained for my own appreciation later.

Perhaps more stunning than her exploration of the painters was her passion for Renaissance sculpture. We built up to Michelangelo's monumental David, two Pietas, Moses, and the struggle of the unfinished slaves, but along the way I was captivated by two earlier Davids, the delicate bronze by Donatello, said to be the first life-size nude sculpted in the round since the days of Greece and Rome, and also the one by Verrocchio. When finally, in 1980, my husband Gray and I went to Italy, I was first struck by the ethereal simplicity of Fra' Angelico's frescos in the Museo di San Marco in Florence and then by the bold glory of the sculptures in the great stone Bargello, where I encountered the two smaller Davids. The powerful plasticity of Renaissance sculpture, first revealed to me that spring of my sophomore year at Duke University, has remained vivid for all the years since. Nothing at the Louvre moves me more than the enormous sculpture terraces in the new Richelieu wing. When Marianna Jenkins described those sculpted forms of the Renaissance and repeated her mantra about the rebirth of humanism from the relics of classical antiquity, she was etching fine lines on my mind.

"The measure of mankind is man," she would say. It was news to me at eighteen. It sounded brilliantly profound. I was ripe for such a philosophy. Renaissance humanism was beginning to agree with me more than the Christian religion. My decision to move from the Bible to Renaissance art had been a wise one.

And I might have missed it all. I was a dedicated English major, in thrall to Donne, and Milton, and Pope, and Keats, Jane Austen and the Brontes. The fall semester of that sophomore year I had embarked on fulfilling Duke's two-semester religion requirement with a popular survey of the Bible. The semester before I'd suffered through the memorization-approach to Greek myth and was finding the treatment of the Old Testament not much different, albeit the professor a good deal more engaging. Two days into the spring semester, my roommate Janice, not always the most dedicated of students and more likely to advise me on clothes and boyfriends, confronted me.

"Rosemary, you must find a way to sign up for Miss Jenkins' course. She's brilliant. The class is stunning. You'd love it."

How could I, already frantic with five classes, add another? I'd just have to drop one. Janice was a talented artist, a natural for art history. My mother's enthusiasm for museums had led me to many galleries, and I had often enjoyed these family sojourns. But I hadn't really considered college classes on art, given my total lack of facility in any medium.

Janice prevailed. I fled from religion into the humanism of the Italian Renaissance, at first quite lost as I scribbled notes in the semi-darkness. But my heart was won in less than an hour. I emerged from the first lecture—Miss Jenkins never entertained discussion—dizzy with delight, frantic to catch up on what I'd missed in the first classes. Often I was unclear about the categories, about which new word referred to an artist, to a style, to a period, to a region. Miss Jenkins didn't stop for explanations. That was up to us.

I walked away from our first test unsure whether I'd even passed. All I knew was that I'd written furiously for an hour as each slide appeared on the screen, requiring identification, analysis, comparison to other works. True to her format, she included one or two previously unseen slides as the ultimate test, the equivalent of the dread spot passage—the identification of often unfamiliar quotations—on English tests. A week later, she began class by reading from one of our papers. A few sentences into it I recognized it as mine. Unlike my sisters, I was not a Phi Beta Kappa, and spent much of my college years socializing when I might have been studying. My freshman English teacher had read a short story I wrote to all her sections. But otherwise my academic career had not, to that date, been marked by distinction. My exact words or even the questions have long since fled, but those moments when Miss Jenkins read my responses to Italian paintings and sculptures sent chills through me and gave a new dimension to my college pursuits.

I took three other art history courses—Contemporary Art, American Art, and European Painting, and showed slides for various professors in the art history department for two years. I treasured

my copy of Bernard Berenson's *Italian Painters of the Renaissance*, given to me by my English Aunt Iva. When I later showed it to Miss Jenkins, she asked to borrow it and her note still lies within its pages: "Dear Rosemary, Thank you so very much. It was a delight to look at, and the slides we have made will add immeasurably to the collection, Marianna Jenkins." I was thrilled to have made a contribution to the art history department. And to be addressed by my first name rather than as Miss Dundas gave the note particular significance in those far-away times of formal professor-student exchanges. Today, reflecting on my innocent enthusiasm, I have to smile.

When I married after graduation, I was pleased to learn that Gray enjoyed museums as much as I. Soon we were introducing our daughters to the delights of painting and sculpture. Sarah has always been a talented painter, but none of them caught the art history bug the way I had. Visiting my mother in Washington, living in Boston and then settling in San Francisco, I was able to keep the art history flame alive.

In 1965, Sue Renfrew, a good friend in San Francisco, called.

"The de Young Museum is expanding its docent training to include Asian art," she said. "The Avery Brundage Wing is opening next year. How would you like to join me in taking a once-a-week class?"

I was delighted. Just what I'd been waiting for. A volunteer activity that didn't require fund-raising or hospital rounds or making cookies for elementary school children. Sue and I completed two years of challenging classes in the arts of Asia—India, Southeast Asia, and Japan the first year, China the second. When the lights went down, I found myself immersed in vocabularies far more difficult than "quattrocento" or "chiaroscuro," but the world was finally becoming round, looking more like the globe. Learning about the culture and history of Asia through the arts of its peoples was extraordinarily enriching. Ten years as a docent led me to think about a career in teaching, something I had dismissed when I graduated from college. I returned to English, but Miss Jenkins' long

reach had been felt, helping to build my life incrementally. A profound appreciation of art, of artists, of museums had been kindled in that dark classroom in 1952. The museums of the world glow because of her insights. The quick adrenaline rush occasioned by a painting, a sculpture, an elegant architectural design is a gift that has given me visceral delight for almost fifty years.

Even a book club series I led recently drew inspiration from my initiation in Miss Jenkins' class. Three novels about Vermeer and one about Bruegel allowed me to tie literature and the visual arts together and to darken the room as I showed slides of shimmering paintings. Was Miss Jenkins looking down from her heaven of rose-tinted Italianate clouds?

KATHRYN K. McNEIL

# Too Soon

BY ALL ACCOUNTS it was the prettiest June in memory. The Great Smokies, the southern mountains of the Appalachians, were ablaze with orange "honeysuckles" and "ivy." Outsiders born away from there called them by other names: flame azaleas and mountain laurel. The shrubs grew twelve feet high in the depths of the deep hardwood forests, the honeysuckles lighting up the dense shade with brilliant scarlet and yellow trumpets and the ivy with soft clusters of pale pink flower heads. It was the second week of June, and walking in the forest was like being invited to stroll in some great estate planted by a master gardener.

Colin Messer didn't think much about this summer splendor as he sat on a log in the midst of it all. School was out and he was with his pa today watching Joel plow out a mountainside for a new road. When his father looked at him a certain way of a morning, studying him, judging him, Colin knew he might be invited to ride with him on the tractor that day, and get away from home and the demands of his little brother and the chores around the farm his mother had saved up for him.

He was ten, still with a little boy's fat cheeks and round stomach. He did his best at school, but reading came slowly as he bent over his book, his lips working out the sounds. He was in a special class of slow learners, old for their age, who needed extra help to catch up.

"Watch my lips, Colin," Miss Edwards, his teacher had said. "When you see the letters w-h-a, work it out. Wha comes out this way," and she pushed out her lips with the sound. "You try it."

"Whaaa…" he tried, "Whaa…."

"Add an *aay* sound with a soft *le* at the end."

"Waal….whale," Colin tried hard to follow.

"That's it, Colin. You did it. You just learned a new word." Miss Edwards smiled encouragingly at him. "Have you ever seen a picture of a whale?"

He shook his head but a pleased smile flushed his cheeks and he went to work on the next word. His mother and father could read if they had to, but they were tired at night from hours of work, and the television gave them the news, the weather and the relaxation they sought. There wasn't a book in sight in his small house but the Bible, some Sears catalogues, and an old Farmer's Almanac on the mantel of their stone fireplace.

Every afternoon when the school bus dropped him at his door, his mother asked him the same question: "You got homework tonight, Colin?" He always nodded. He was a quiet boy like his father. He noticed a lot of things and thought about them as he sat whittling with his knife he'd got on his eighth birthday. But when he heard his mother call or if Danny grabbed him around his neck to play, he shook his head, rousing himself from his reverie and put his knife away.

"Get your studying done first," she said firmly. "The outside jobs can wait."

She said the same thing each day. She was eager for him to be "someone" when he grew up.

She was a thin woman in her thirties, but the lines in her face told of work and worries and outdoor labor that added years before

their proper time. Colin loved her and waited for the moment each night when she came in to sit on his bed and smooth his hair while he drifted off to sleep. She was soft and whispery then. The darkness changed her somehow.

This morning when his father asked for his company, Colin knew he'd won out. His mother couldn't stand the pleading look in her son's eyes.

"Go along then," she had said crossly. "I'll just have to work that much harder, watching Danny while I put up jars." She turned her back on both of them and went in the other room to change her little son.

"We'll both help you when we get home, hon," Joel said, leaning against the bedroom door, trying to soften their leaving.

She didn't answer and kept her back turned.

Colin sat on the bank above the job with his knife and a piece of poplar wood, whittling, the roar of the bulldozer drowning out the world. His father held a different spot in his heart. He was like a god in the stories the teacher read to the class, harnessing his 'dozer and tractors with quick hands and sharp eyes, making them work for him though they roared and groaned at the task, moving forward and backwards at his command, carving the earth the way he wanted, leveling the torn black ground into home sites or a road in the forest where there had been none before. He loved watching his father turn the levers of his huge machines and perform magical changes to the land before his eyes.

"Stand over there, son," Joel would say before beginning his day's work, and always the same words: "I can't hear you, you know, so keep your eyes on me."

Colin never knew when he whittled just what would come out of the wood. The knife seemed to lead him, this way and then that, until he saw it. One time the shape was a man's face like Mr. Greenly's. He'd heard Joel talking loud one night to his mother about Mr. Greenly at the equipment store, and how tight he was and how he didn't give a man time to pay his debts. Or maybe, out of the wood,

he'd find the bear cub he'd seen one day that ran right in front of him.

Right at twelve o'clock Joel turned off the engine, and suddenly it became quiet as a church. It was lunchtime, and from the back of his pickup Joel picked up the two pails his wife had fixed, and the tall, lean father and son walked over to a mossy log to eat.

They ate silently, while the leaves of a thousand trees murmured over their heads and the stream nearby made a pleasant watery sound running over its rocks. Sometimes they talked about the job and Joel told him the town was growing up and lots of new people were moving in, summer people, retired people, all of them liking the mountains and the cool fresh air and wanting a place of their own.

"Gives me more work, Colin. Maybe we'll have a new place to live in one day. I'm doing better than I ever thought."

"Danny'd like that, Pa," he said, "and Mom, too, I guess. She'd like a new kitchen. That's what she told me."

"Your mother's one patient woman, Colin. You help her all you can. I'm gone too much from her. Too busy, jobs keeping me 'til dark most days."

Colin felt like a man when his pa talked to him that way. In his mind he knew they were close to being poor, just a step away really. His mother was always watching their money carefully, making things last and fixing them when they broke down. But they always ate well. He took another leg of chicken from the pail.

"That's one thing we'll never scrimp on, son, is food, lots of it and good." His father lit a cigarette and inhaled a long thoughtful breath. "What are you working on today?" and Joel picked up the piece of cut poplar.

"Maybe a trout, I'm not sure yet, Pa."

Joel looked at his watch. "Time to rev up. Why not try out your fishing pole? Suppose to be some good fish in that creek we passed. Help you pass the time."

Colin watched his father swing his long legs over the seat of the tractor and turn it on.

"Mind yourself, son. I'll be up yonder making the road. Make sure I see you." Joel gave him a quick wave and moved away.

The first time when he was eight and his father asked for his company, his mother said "no" and gave Joel a worried look with her eyes. But summer days are long and boring for a boy ten years old now and stuck in the country with only a little brother for company most days. So she relented once in a while and he got to go.

Joel was good for Colin, she thought, toughening him up a bit with man's talk and man's work. Good to take the boy away from his dreaming. Reflecting was maybe a better word. She'd seen Colin sit for hours with his knife making strange little figures right out of his mind. Some with horns and tails and a man's face. What do they teach him in school to give him such ideas, she wondered?

"He tries very hard," Mrs. Edwards told her at the PTA meeting she went to a month ago. "Let him read to you at home in the evenings, that would help."

She meant to do just that but Danny needed her, too, and Joel, and the vegetable garden and "putting up" and, God knows, all the other things a woman had to do.

She went into Colin's room to find dirty clothes for a washer load and instead found herself looking at his whittling figures lined up on a shelf over the bed. Joel had tacked the board up there as a kind of present to the boy one Saturday, and Colin had spent hours arranging and re-arranging them. Animals in front and the gnome-like figures in the back. She picked one of them up. It was smooth as silk. How had he gotten started on this? No one in her family whittled. Maybe it came from Joel's side. An idea came to her. She'd go down to the building supply store one day soon and get him some walnut. She'd owned a walnut stool once. Walnut was pretty wood. Dark and rich.

Colin took his fishing pole from the back of the truck and a piece of chicken skin from the lunch box and hooked it on his line. He could hear the tractor far up the road and the sound kept him company. He wandered down through the forest of big poplar trees,

their trunks clean and straight and the dark green hemlocks in be-
tween, and scrambled over the rocks to the stream. A dark pool
caught his eye and he sneaked up on it, keeping his shadow from
spooking a fish if there was one there.

Joel told him way back, "Just drop it over a rock, son, and let it
fall soft as you can into the pool so the trout will think it has a nice
dinner falling out of the sky."

He did just that and like a flash saw the swift pencil shape of the
fish dart across the dark water. His heart quickened at the chance
and he pulled up his line. Too fast. He'd missed. No smart trout
would bite his hook twice.

He moved to another pool. The hours passed as he played up
and down the pretty stream, getting a few bites and no fish. He took
up his pole and wandered down the road.

Saturday he'd see his friends, neighborhood boys who rode the
school bus with him. They played war on Saturdays in the old ceme-
tery behind Eureka Baptist Church. He wasn't quiet then. They
screamed and yelled like banshees as they attacked each other until
old Mrs. Henshaw saw them and said it wasn't proper, yelling like
that and using the old grave markers to hide behind. They'd slink
off then, wait a few minutes and then go at it again, trying to be qui-
eter the next time.

He heard the 'dozer coming his way at last and saw its telltale
yellow color moving through the trees ahead of him. He'd ask Joel
on the way home how many strikes it took to catch a fish. He'd lost
his chicken skin and resorted to stick bait he'd found under the wet
rocks.

His father saw him now and they waved to each other, Joel turn-
ing down the motor as he leaned out.

"Any luck, son?" he shouted over the low roar.

Colin shook his head.

"Be careful if you're going up ahead on this side. They're some
rocks I worked around. Too big to move. Had to change my direc-
tion. You'll see them. Almost through, son." Joel moved past him
slowly, working his blade, his eyes on the new road.

Colin walked past him, his boots sinking into the soft, rich, up-turned soil. He'd have to see those rocks. Must be big for Joel to have to go around them. Then around a curve was one of the biggest he'd ever seen, a monster rock sitting on the downhill shoulder of the new road. Getting closer he whistled at the size of it. There were tracks where Joel had tried to push it out of the way down the steep slope.

He liked rocks like this, covered with moss and cracks in them where little trees and other plants caught their roots and started growing. It was twice his height and had an odd pointed head with warts of lighter stone flashing on its granite surface. Ferns, some broken where the 'dozer had touched them, clung to the sides. Rocks like that made you want to conquer them by climbing up on top of them and yelling "Look at me!" He often did that with his friends when they found them in the woods.

He walked around it to find a foothold. There, on the downside where a little maple grew in a crack, he found a place and started to climb. He was a good climber. Suddenly something went terribly wrong. He began to slip, or the rock began to move. Which was it? His heart took a fearful leap. He tried his best to get on top but it was rolling, slowly at first as he clung to it, his arms outstretched, his face pressed against the cold granite. Faster and faster it rolled down the slope, crushing him as if he were an ant, crushing the small trees in its way, cutting a swath of destruction twenty feet wide until it found its resting place against another rock of its own size.

When Joel found him he seemed asleep, lying on his back on a bed of crushed leaves, a branch of honeysuckle hiding his head, his arms outstretched as if they were reaching for something. Joel knelt beside him, gently lifting the scarlet blossoms from his face to see the life blood trickling from his ears, his nose, his mouth, silently, inevitably, draining into the earth beneath him. Then the stillness was broken by a cry of anguish that echoed and re-echoed through the great forest as the shadows lengthened and the day came to its close.

*Based on a true story reported in an Appalachian newspaper.*

# Another Place

NANCY GENN

# Inverness Storm

A heavy gray sky full of damp envelops the great oak trees.
Their dark arms covered with bright green velvet
Curve and twist pushing upwards into the opaque sky.
Through the wall of windows in my studio,
I see the trembling leaves and feel the sway of their strong limbs.
Few hikers will be on the trail to Shell Beach.
There will be no swimming today.

MARY THACHER

# A Stroll Before Supper

THE HIGHLIGHT OF the summer was our family reunion at the Skinner Campsite in the Wind River Range in Wyoming about two hours south of Jackson Hole. The week together turned out to be even better than we had anticipated. Our son, John, and his wife, Carry, and their two daughters, Lauren, twelve, and Carolyn, nine, arrived at camp a few days ahead of us. Our other son, David, and daughter-in-law, Nancy, and their two daughters, Katie, nine, and Emily, three, traveled with us to camp. The cookshack, consisting of a large tent where we ate breakfast and dinner, was the center of activity. The tents for each family were nicely spaced out not too far away.

Each evening around six-thirty we would all gather together by the cookshack for beverages and snacks. On Thursday we talked about how we all missed the John Thacher family who had left that morning. It was becoming a cool evening and I was feeling quite chilly as I sat there. I decided to take a little walk before dinner. I chose an area higher than our campsite where I could watch the sunset. It was a fairly large, flat area and provided a superb view of the mountains nearby, as well as the highest peaks surrounding us. I

knew dinner was about to be served, so after about ten minutes of walking I turned around to return to camp.

This area is notorious for being easy to get lost in. We had been warned not to walk alone, but at this point I did not consider that I had taken a "walk"; rather it seemed to be just a short stroll. However, I found it hard to pick out distinguishing landmarks. The terrain is similar, characterized by groups of medium-sized trees amidst outcroppings of boulders, with many small trails used by horses, people or other animals.

After ten minutes or so, I realized I must be a little off track. At this point I made the classic error. I should have stayed right there, hollered or just waited. Instead, I tried to correct myself. I was pleased to see a horse trail nearby, so I followed it, mistakenly believing that I was headed in the right direction. I felt extremely anxious, anticipating the worry I must be causing back at camp. I desperately wanted to succeed in getting myself back there.

The minutes were passing all too quickly. The shadows were lengthening. I could see that the sun was about to set. Yesterday evening we had watched a spectacular sunset. We saw the sun go down behind the black silhouettes of those tall conifers in the distance. I tried to recreate a sense of direction and orientation. I not only have no sense of direction but had always followed others when we returned to camp. A feeling of utter helplessness assaulted me. My heart was pounding as I realized I did not know which way to turn. I felt a terrible sense of guilt.

I suddenly realized there was no time for more self-recrimination. I was confronted by the awesome truth that I had no choice but to spend the night in the woods. The light was fading. I had to find the best possible place to position myself, and quickly. At this point I was on the side of a hill. I wanted to see if I could find a flat area. I walked further and did come to level ground but it must have been near water. I tried out several places under large trees but the ground was damp. I certainly did not want to spend the night there. It was also much darker than on the hill and it was easy to trip on roots and fallen branches.

I saw another fairly steep hill studded with boulders and headed in that direction. I checked out each boulder to see if I could find one with a little space in front where I might hollow out a flat area. I knew I would have a better chance of staying warm if I could press my back against a rock. I tried one but it actually was quite narrow. When I lay down I found that the rock itself had a sharp edge that pressed into my back. I tried another with a smoother face. I quickly dug around it, using a rock to help me. When I lay against it, it was obvious the ledge in front was not wide enough. It would have been hard to keep from slipping.

I tried not to feel frantic, but I knew my time was running out. I wanted desperately to be found, yet I knew I still had to get myself situated for the night. I rapidly made several more attempts. Then I saw two good-sized boulders with a small area of ground between them. I decided that I could clear a place there and still use one of the rocks to lean against. The ground was damp but I didn't care at this point. I was able to dig quite far into the hill. I felt incredibly lucky to have found this place. It was almost dark now.

There were ominous clouds overhead. I remember fervently saying, "Dear God, *please* don't let it rain!" My prayer was obviously rejected as a few minutes later I felt a light sprinkle of rain commencing. It was useless to feel despair. I was acutely aware that my fate was clearly not in my own hands. After a few minutes and before I was really wet, the shower stopped. I can't describe how thankful I was as I pictured myself shivering through a night of rain stuck between those two boulders. At this point I said another, even more fervent, prayer of thanks.

I was wearing my running shoes, blue jeans, a T-shirt and a partially wool, long-sleeved shirt and parka. Ironically, I had started out with a rain hat but when I tried out those various sleeping places, I had left it on a tree. It was the first time I had worn the parka. It was quite long and best of all, it had a hood. Already I was feeling the chill.

Suddenly, I heard several rifle shots. I realized that everyone at camp was trying to give me an indication of their direction. But with

my one deaf ear, I was not able to distinguish their direction accurately. My feeling of remorse was almost unbearable.

There still was a lingering twilight though I expected that it would soon be completely dark. Then a remarkable sight appeared, the full moon rising. The sky was filled with dark, drifting clouds. The sight of the full moon appearing and disappearing among them was quite extraordinary. It was a constantly changing panorama. It seemed to me that I watched it for hours, feeling grateful to have such a diversion. I could have glanced at the time on my watch but I decided that to keep track of time, to know, would only make the night seem longer.

I decided to lie down. I pressed my back against the boulder, making myself into as small a bundle as possible. There was no way to be really comfortable but a change of position was welcome. I closed my eyes, though I knew sleep was out of the question. The temperature was probably in the low forties so it was too cold to lie still for long. Every so often, I would resume a seated position. I spent most of the night holding my legs as close to me as possible, rubbing and hitting them to increase the circulation. I also did exercises with my arms. I forbade myself from dwelling on my sense of guilt. "Think of something constructive," I kept telling myself. Sometimes I said prayers.

I never had the slightest doubt about physically getting through the night, provided there were no encounters with wild animals such as a mountain lion. "Daylight will come," I told myself, but meanwhile the night seemed interminably long. Finally the darkness began to lift. I was longing to get out of my cramped position. But above all, I did not want to fall and injure myself. I forced myself to wait until I could see the ground more clearly.

But what direction should I take? With utter misery, I realized I did not have a clue. I started walking up the hill behind me looking for a more open, visible place. I happened upon a most idyllic scene. There was a small pond edged with lovely green foliage. There right before me was a large moose eating grass. He raised his head, looked at me and continued to munch. I felt as though I were a

character in a children's story and wanted to say, "Please, Mr. Moose, lead me to my home and you will be amply rewarded."

I continued walking and came to a narrow stream. I decided to follow it in hopes that it would take me to a lake where I would be more visible and water would be available. It was a difficult route but eventually it did lead to a lake. If only it were Horseshoe Lake near our campsite! But it was just another of the many lakes with the same lovely yellow water lilies floating on the surface. At this point, I began to hear airplanes. I knew they were search planes. I realized just how far off course I must be because none of them came near my area. I kept walking around the lake until I found an open space. There was a large, rather flat rock that extended into the water. That seemed like the ideal place for maximum visibility. There was nothing left to do but wait and hope.

At first I felt quite optimistic. I was so glad to sit down and rest. The morning was slowly becoming warmer. I stretched out on the rock. The planes kept circling but never got closer or even came into sight. As the hours passed my spirits flagged. "What if I am not discovered? How long would they continue to search for me?" For the first time I felt total despair. "How long could I survive without food?" I looked around for anything edible. I remember reading that for almost every edible plant there is a look-alike poisonous counterpart. I could drink the water, giardia or not. Then I realized how thirsty I was and I did take a few sips of water.

I thought of my husband, Carter, and the children. What an inglorious way it would be to die all because of my own stupidity. Next I thought of my ninety-seven-year-old mother. Every year before I set off on a pack trip, she would say, "You are just too old to be doing this sort of thing. What if something were to happen to you in the wilderness?" I instinctively felt that if I did die, she would have been crushed but also angry. I could hear her saying over and over, "I kept telling Mary she shouldn't go."

To my horror, the planes stopped. I began to review my life. My first thought was "I can't die. My desk is too messy!" Then I thought of the many aspects of my life about which I felt disappoint-

ed in myself. Above all, I kept reminding myself of how truly fortunate and privileged I had been. I wondered what lay ahead for those four darling granddaughters? "After all, I am seventy this year and that's not too young to die." Suddenly, with great clarity, I realized that I did not want to die. Even with all its deficiencies, life was very precious. Carter was dear to me.

The planes had resumed and now they were getting closer! My spirits soared. One small plane flew right over the lake. I frantically waved my plum-colored jacket and foolishly I shouted too. The pilot appeared not to notice. He did not return. Once again, I was crushed.

All of a sudden I heard a gunshot, high on the cliff above the lake. I saw Bob Skinner, the leader of our group. I felt weak with joy. "Just stay there. I will come get you!" he said. I was too excited to sit. Thirty minutes later when he emerged from the woods, I threw my arms around him and could not hold back my tears of relief. He had a canteen of water with him and he told me to drink all of it. "Do you feel well enough to walk back to camp?" he asked. "Of course," I replied.

He had a portable telephone but it was not working. He let off a gunshot to alert the others that I had been found. Ironically, it only took about an hour or so to reach camp. It was almost straight uphill. Walking back, I realized how truly exhausted I was.

The first family members I saw were Nancy and David. I was truly touched when Nancy gave me a huge hug and had tears in her eyes. David gave me a long, tight hug and said, "Oh, Mamba!" Then Katie and Emily rushed up and hugged my legs and said, "Oh Gran, they found you!" Emily added, "Gran, why is your face so dirty?" They all assured me it was absolutely black. Then Carter appeared. In true Carter style he looked at me, said nothing, and finally encircled me in a hug.

KATHRYN K. McNEIL

# An Appalachian Tale

UNTIL LAST SUMMER my only connection with pigs was a pork loin roast served with homemade applesauce, or "Bar-B-Que" in North Carolina cafes where each recipe is uniquely different from the other, depending on which town you're in. Nothing prepared me for the scene that greeted me one morning on my Appalachian farm in the Great Smoky Mountains. My beautiful, carefully mowed lawn of wild mountain grass that surrounds the house had been plowed and furrowed into ugly clods of earth scooped and turned upside down by a snout like a spatula, roots exposed to the rising sun. In a flash, though I had never seen their handiwork before, I knew I had wild pigs as visitors.

I had seen wild pigs at a distance a few times on hikes and feared them. They were squat and solid, some weighing over three hundred pounds with sharp tusks eight inches long. My mountain neighbors prized them as a delicacy. They were introduced in the early years of the century by hunters, and have since proliferated in all parts of the country.

I put on my sneakers and still in my nightgown walked out into the middle of this carnage. Filled with fury and the despair that

attacks me once in awhile when my well-ordered existence is upset, I hitched my nightgown high between my legs and began to place the clods back in their holes. It was like a giant puzzle, seeing the shapes and fitting them back in the sod where they had been.

The job was too big for me, and soon my hands and knees and white nightgown, which kept slipping down my legs into the mess, became a disgusting sight. I had to strip and stand naked under the garden hose before I could go inside and take a shower. I was too upset to eat breakfast.

Who could help me? My faithful Tom who takes care of the place would replace the dozens of clods that were too heavy to handle at my age of seventy-five. But the pigs would be back, of that I was sure. Guns are what I wished for and a band of local mountain men, dead-eye shots, who would sit in their trucks and wait for the moon to rise and the pigs to come out of their hiding places to grub on my lawn.

The Great Smoky Mountains National Park is my neighbor along the west side of my property and the Superintendent is a friend. I called Karen Wade for advice.

"Kathy," she said, in her calm unruffled voice at the other end of the phone in Tennessee (she was used to dealing with emergencies), "The pigs multiply, have four litters a year. We're overwhelmed with them over here in the Park but I'll see what I can do."

What the pigs wanted, I learned from Tom, who hurried up the mountain on my call, were worms, acorns, grubs, roots, all kinds of good things that sat beneath my grass. He did the best he could by replacing the clods, and then pressing them down with the mower, but it still looked terrible to me with a plowed muddy look about it that spoiled the setting I loved so much.

"When they have so much land to dig in," I asked Tom, as he used his pitchfork to lightly replace the roots, "three hundred acres of grass in the fields. Why pick on what grows by my front door?"

He shook his head. "Maybe they like the smell of gasoline from the cars parked out here, like yours," and he nodded at my jeep.

I looked at him curiously. I get the strangest answers sometimes

to my questions from Tom. They contain a mixture of fact and superstition he's learned growing up in these quiet mountain valleys. "Do you honestly believe that?" I asked him.

"Just wait till it rains. They'll be back."

He said this, I thought, almost joyfully. He liked to make predictions and see them come true.

It rains a lot in the Smokies, a bit every day at times. So it rained the next day and they were back and Tom was right. The hogs picked the same area, upturning the clods we'd just replaced. It was easier for them this time and they must have enjoyed themselves. Then they moved to the lawn over the septic tank and worked above it. Being nocturnal diggers they did their digging while I was asleep inside and were gone by dawn. I needed a dog who would chase them away but I didn't own one.

One evening just before dark while I was out on the porch, sipping a martini and watching the last bit of sunset touch the mountains, a young man, dressed from head to toe in camouflage, drove up and introduced himself. He stepped out of his new white pickup truck with the National Park logo on the door and walked over to me.

"Howdy," he said, handing me his card. I read his name: Dale Quist—Biological Technician.

"I'm a pig hunter on the Park staff and I hear you have a problem. I'll wait up there in the woods tonight if it's okay with you and try to shoot some of those buggers."

"Well," I said, vastly relieved. "That's wonderful. Can I give you a pillow or coffee or something?"

He shook his head. "I have all the coffee I need. I'll leave around dawn. Should have gotten a few by then."

I'd spent so many nights alone in this remote house of mine, miles from any neighbors, the thought of someone around with a gun looking after my property was incredibly reassuring. I should sleep like a log!

"What will you do with the dead ones?" I ventured timidly. The thought of bloody pigs on the lawn was formidable.

"Oh, cart them off, feed them to the bears, don't worry. You'll not see them."

He was sturdy and confident. I liked him immediately.

"Good hunting," I said.

The night went its way and I nestled into my pillows, pleased I had a new guardian angel in a white pickup truck above the house. I went to sleep and never heard a sound or a shot.

I saw no sign of pigs the next morning, and I walked gingerly around the area where the truck had parked and looked for blood or ammunition caps.

Dale was back the next night, neat and clean in his camouflages, arriving just before dark. He told me he had shot several pigs and carried them off. We were on a first name basis from the start, he calling me Kathy, and we developed an easy friendship.

The pigs disappeared for awhile and the grass began to grow again.

A week later they were back.

I drove down to see George Wood. His wife Bonnie is my caretaker but I rely on George for help with big problems.

"Had you ever thought of motion lights?"he asked.

"What do they do?"

"When it's dark and something moves in front of them, they come on, stay on two or three minutes and go off. Only trouble is that bats and moths activate them as well as pigs. Still they might work."

I called Rufus Cagle, an electrician who lives on the mountain.

"Sure, I know about them," he said. "Can't promise they'll take care of your problem though."

"It's worth trying," I said.

He installed two floodlights high on the front of the house. I walked out the first night and just as he said, the lights came on and illuminated a good part of the front lawn. When I returned now at night from dinner with friends, they came on as soon as I drove up, lighting my way to the front door. It was a comforting addition to the place where I spent much time alone, and I wish I had thought of them years ago.

But there were also problems with them. Luna moths and bats could activate them, too. Several days after they were installed, the phone rang at 6 A.M. It was still dark outside. Lynn Yawn who lives about two miles away at Cove Creek can see my lights at night. "You got a problem up there?" he asked.

"No problem, Lynn," I answered groggily, "except you woke me up."

"Sorry about that but your lights keep flashing off and on," he said, "I thought there was an emergency and maybe you were sending signals."

"Signals?" I was too sleepy to figure that out. I explained briefly about the new lights and hung up.

My guests that weekend had another complaint.

"I couldn't sleep," my son-in-law, Ray, said sourly at breakfast. "Those damn lights lit up the room every ten minutes. You don't see them because your room is up front."

He was right. I sleep in the master bedroom, a prize room whose windows face the mountains. Ray figured I could turn off the circuit at the front of the house at night when I had guests. I just had to remember to turn it on again when they left if I wanted to scare off the pigs.

But the pigs didn't turn up and Ray was disappointed.

"Hell," he said to me, "I love wildlife. Those pigs make the place a lot more appealing to me."

Ray has his priorities and I have mine. I told him I liked an undisturbed mountain setting for my house, grass manicured, everything neat and pretty.

"You're the one upsetting the natural order of things up here, you know, Kathy," he said, "with your lawn mower and garden flowers. The pigs are bringing it back to what it's supposed to look like."

Ray has a way of hitting a nerve and I felt my blood reaching a boil. "Those pigs aren't natural here," I retorted. "They were brought in fifty years ago for hunters and now they're taking over."

Dale, my biological technician, was going on vacation, he

informed me a night or two later in his friendly breezy way. "Good luck, Kathy, but I gotta get some sleep. I'll be back in a couple of weeks."

I watched his white pickup truck disappear around the last curve and felt strangely lonely. Of course, the pigs came back that night.

News of bad luck travels faster around these mountains than good, and gossip is a favorite pastime. Everybody on the mountain seemed to know I had pig trouble. One day shortly after Dale left a truck drove up. It was Bonnie's cousin Wally, and his pal Ed.

"My, my," they said as I led them over the grass, "what a mess," and they shook their heads. "You need a dog. He'd scare them away fast."

I love dogs but I live in a big city apartment nine months out of the year and a dog would be impractical. I've never heard of a rent-a-dog arrangement for the summer.

Wally and Ed walked around studying the place, the clods, the motion lights on the front wall, discussing the situation between themselves. Then they walked over to me with a plan.

"Now we're not guaranteeing anything," and Wally spit a wad of tobacco out the side of his mouth on the grass, "but it seems to us if we camped up here a night or two right in your yard and put out corn on the ground, we'd attract plenty of hogs. The lights would make them easy targets."

I was pleased as punch that two mountain men without being asked had turned up to help me. I was receptive to any suggestions.

"No problem with your camping here," I said, "especially mid-week when I don't have company."

A week went by and I figured they must have found other things to do. l was busy with my own affairs and making plans for a family re-union coming up.

Then Saturday afternoon with my yard full of grandchildren playing soccer, the pool filled with their parents, a hundred-pound mongrel pet by the name of Vesuvius who might bite anyone he didn't know wandering about, Wally and Ed turned up, easing a

care-worn pickup with a housekeeping appendage on the back into my yard.

"Just tell us where to park and we'll go about our business," Wally yelled out the window. He appeared to be full of high spirits and his face was flushed

My mistake was I didn't tell them right off it wasn't a good night for their hunting project. But I was torn over their willingness to help me and my better judgment that things might go awry with so many people around.

"Over there by the spruce tree, I guess," I said, feeling somewhat overwhelmed with all the activity. The spruce tree was huge and could hide half of their odd looking truck.

Wally and Ed had known me and my children for years, so it wasn't long before they brought their own drinks from the truck and were sitting with the rest of us on the porch having drinks and enjoying the splendid evening sunset. My son-in-law, Ray, was there again, too, and everyone was intrigued at the plans for the middle of the night.

"Now Kathy," Wally said, stretching out his heavy boots comfortably down the length of my lounge chair, as he accepted another shot of bourbon that Ray offered him, "This is the way Ed and I figure it. We've thought it all over and this is the plan. We're going to attach an alarm to one of your motion lights that will ring in the truck and wake us up. That way we'll know the pigs are out there. We might get half a dozen without any trouble at all, just shooting out the front window from our big bed."

My grandson, Lincoln, whistled. "What a blast! I don't want to go to bed at all tonight."

"What we need," Wally continued, "is a very long electric cord. We have one but need a longer one that'll stretch from the light to the truck."

I sent Lincoln to look for that. "Come in and have a bit of dinner with us," I said. It was well past eight o'clock and getting dark, and everyone was hungry.

"No thanks, we've got everything in the truck. How about sharing our dinner?"

I deferred with thanks. They didn't seem in any hurry to part from us.

I was busy slicing the chicken and not listening to the chatter around me until one comment made me pause.

"What about Vesuvius when he has to go out at night?" my granddaughter, Claire, asked. "Won't they shoot him by mistake?"

"Or me," Ray said "if I go out after Vesuvius? I'm not so sure about the aim of those guys."

Lord, I could see a tragedy unfolding before me, a dead dog, even a wounded son-in-law. The front lawn could become a killing field! I sat down unable to enjoy my roasted chicken.

There were many suggestions on how the night should be made safe. By general consensus: no one should go outside to look at the moon; the dog should be put in the enclosed swimming pool area when he needed to go out; and all children should be kept inside until morning.

I couldn't believe I had willingly permitted such a situation to develop!

In time, the presence of my happy, energetic family around the crackling fire dispelled earlier premonitions of danger, and, near midnight after an hour of charades, we said our goodnights to one another and went to bed. Again, I slept deeply, insulated, as Ray liked to remind me, in my master bedroom, from whatever went on elsewhere in the house.

The next morning, he informed me, it had been a terrible night. He stood grumpily over the stove cooking a pound of bacon for our breakfast. "Hell, I didn't sleep a wink! Bells rang every time the damn lights went on. I swear those hunters of yours made a racket, singing and laughing until dawn."

"How about the dog?" I asked.

"Vesuvius was too scared to go out. He's out now finally."

"You didn't hear any shots?"

"Hell, no. Those guys would scare off any respectable pigs with their ruckus. If you ask me, they came up here to party not to shoot." He put the bacon on some paper towels to drain.

I peeped out the kitchen window and saw the truck sitting peacefully by the spruce tree, its occupants inside, apparently asleep.

By 9 A.M. everyone was up and we were in the midst of a lively breakfast together when another grandson, Chris, came running in to the table. "Grandmother, I looked out the window and one of those men is lying in the grass, like he's dead. He looks dead, he's not moving. The other guy's just standing over him."

I felt my heart go weak. I knew someone would get hurt this weekend. Guns and whiskey: never mix them.

"Ray," I moaned. Argue though we do, I needed him badly now. Together we rushed to the door. "The rest of you stay inside," and I looked fiercely at all the young people at the table.

It was as Chris described. Ed lay on his stomach, spread-eagled on the grass, with Wally standing over him shaking his head as we approached. "Bad," he said, "Ed's bad."

"What are you saying, Wally." I knelt down by Ed and saw how white his face was but there were no signs of blood. His eyes were closed and he seemed to be in a sound sleep.

"He's had a kind of fit just now when he woke up, like he's lost his mind, doesn't know where he is. He collapsed on me. Can't rouse him." Wally kept shaking his head.

"You mean he's ill," I could handle illness.

"Plumb out of his mind what it is," Wally asserted. "He tried to stand up inside the truck. 'Gimme one of those Goddamn pigs,' he kept saying. 'I'll throttle one with my bare hands.' I tried to quiet him then he fell down, plumb out the door, and been lying there ever since. I don't know what to do with him."

"Let him sleep," Ray said "He's dead drunk, if you ask me, and is sleeping it off. He just needs time."

Ray took my arm and together we walked back into the house. Once inside he looked at me and I at him and we burst into peals of laughter.

"Take your pick, Kathy," he said when we calmed down. "You can have pigs rooting about your lawn or drunken neighbors with

guns who can't tell the difference between two legs and four. Which do you prefer?"

It's September and the pigs are still with me. I'll go a few weeks and think they're gone for good and then they'll return. My lawn looks like it's constantly under renovation, but I've learned to let it go. It's taken awhile, but now when I go outside, I keep my eyes on the mountains instead of my lawn. Pigs are pesky for sure, but, if you come right down to it, and as Ray would put it, I'm an intruder on the landscape, too. There's still lots of room for all of us.

AVA JEAN BRUMBAUM

# Shell Island

ONE MORNING last week, I went outside earlier than usual to get something from the cooler. The air was crisp and fresh, and as I looked up, the sun was just hitting some of the tops of the mammoth firs that surround our cabin. I was filled with a feeling of joy and told myself, "Surely, this is enough." Twenty sea miles or so northeast of Victoria, British Columbia, an outpost of Eden.

That evening as we finished dinner and remained sitting outside, enjoying the pink in the clouds over the expanse of water with small, rocky islands in the foreground and San Juan Island blue in the distance, my husband said, "If I could make only one more trip before I die, I would come here. No view in the world could content me more." Again I thought, "This is enough."

Why, then, have I so often been filled with sadness this summer? It's grief-work, I suppose. I seem to be haunted by the memory of what Shell Island used to be. I so well remember the island as it was when we first came here more than thirty-five years ago. In those days every walk-around was an adventure, and we walked around almost every day to see what new wonders the tide had brought up.

Let me describe the island. We have been told that it consists of

about seven acres. There can be eleven-foot tides in the area so lots of it disappears when these tides are up. At low tide there are many rocky promontories between four pebbly beaches. One beach is almost white with crushed shells, thus the name of the island, I suppose. The island is shaped rather like a crescent, and we have cut a trail along its length, slashing through a dense shrubbery of spirea, salal, Oregon grape, wild rose and much more. Everywhere there are tall Douglas firs interspersed with some very tall arbutus whose rusty trunks and shiny green leaves light up the forest. Except for that trail and an area around our small cabin, all is pristine, untouched by human hands; if we did not go out with a sickle and loppers every year, the trail would itself soon return to the brush.

On our walks in the old days, we often spent long minutes looking into just one tidepool. At first there seemed to be no activity, but as we watched quietly the pool came to life: the hermit crabs started to move, and if we were very quiet the barnacles put out their tongues to feed, weaving them back and forth so we could barely see the tiny things, tiny mussels clung to the rocks, periwinkles like tiny snails moved on the bottom, sometimes a chiton or a limpet shell was there, algae, sponges, and more.

At low tide the rocky promontories were covered with sea urchins in places, purple star fish, abalone; sea anemones clung to the pilings around our dock, and clams spouted on the beaches—one beach had succulent butter clams, the others had larger clams good only for chowder.

For almost ten years a pair of gulls lived and nested on a small rocky island about a hundred yards from the beach in front of the cabin. They watched us closely. If we walked out on a little point above the beach to scrape a dinner plate they were there in a flash. During the day they spent most of the time on a large rock on the edge of our beach. They served us well as garbage disposers and became an important part of the Shell Island scene. Pete and Paula, as we called them, knew when it was time for lunch and waited on the terrace near the house for whatever we did not eat. Pete could catch scraps in his mouth when we tossed them to him. They would both

swallow the bones of a chicken thigh whole and we could follow its progress down their necks by the bumps on each side. A book entitled "The Herring Gull's World" taught us to know their vocalizing as they clucked to each other and the alarm call which signaled that a stray gull was flying by, warning any intruders that they must not land on that rock. Pete was banded, probably by a research station on a nearby island, so we could always identify him. For those ten years, Paula always came with him. But one summer Pete did not come. Paula came and tried to sit on the rock but sadly she had lost her place in the pecking order and other gulls chased her away. She tried the cabin roof, but after a few weeks she gave up, and we didn't see her anymore.

Many people are not fond of crows, but I have read that they are the most intelligent of birds. Although their raucous calls woke us early when we slept outside, we found their antics entertaining. There were five or six nests near the house and we watched with amusement as the noisy, begging babies, almost as big as their parents, followed close behind their moms with open mouths and bright red throats. They became quite tame and also waited for our leftovers when we ate outside. As dusk fell, crows would arrive from other islands—150 or more—to roost around us for the night. Before settling down they had a tumultuous meeting in the tree tops—all talking at once.

A favorite pastime of mine was to take a bird book and binoculars down to the beach. Knowing little about birds at first, I spent hours trying to identify the shore birds and ducks who visited our beach and bay or the two rocky islands nearby. In those days they were numerous and we often took our boat to neighboring islands to see what varieties were around. In my journal from 1973 I listed the following ducks, gulls and shorebirds: oyster catchers, yellow-legs, black turnstones, guillemots; three kinds of cormorants; American widgeon, Bonaparte, Heerman, mew, and glaucus-winged gulls; two kinds of grebes, American golden plovers, many sandpipers, mergansers, harlequin and scoter ducks, plus eagles and osprey. On the island itself were song sparrows, chickadees, finches, crows, kingfishers, flickers,

sometimes a screech owl, and Herman the heron whom we saw and heard every day, our next-door neighbor for years. The birds, the clam digging, the oysters which we ate as we pried them off the rocks, carrying a bottle of cocktail sauce with us, were all an important part of the summer experience.

Each year the wild life has diminished. This summer, as I write, there are seldom gulls on the big rock, crows don't often come to eat the scraps we put out for them. There are no clams, no oysters, the tidepools have no life in them. To be sure, the surroundings still display some vital signs. The eagles are still nesting here this season and have fledged one young. We still see our heron nearly every day and hear his outraged croak when we disturb him from a tree where he is roosting, and there are a few song birds around, sometimes chickadees and flickers, and the kingfishers who nest in the bank near the boat dock often visit our bay and regale us with their chattering. The otters are still bent upon taking up residence under the cabin; the seagulls and seals who live on the adjacent small islands bring their babies out about dusk and float lazily in the bay, teaching them to swim and fish; and of course, those handsome, infernal Canada geese just won't go away. On my walk this afternoon I saw the thirteen Harlequin ducks that live nearby. They are my favorites because of the way they travel together like a little flotilla and bob out of the water like corks after their dives. There used to be a lot more of them, though.

As I write this, I realize that we are not wholly bereft of wildlife. But where are all the migrating birds? There is no food for them: no crustaceans, no blennies, no little crabs and none of the plankton needed in the food chain. There are simply too many boats—too many people. We keep our small boat in a marina in Tsehum Harbour. Four marinas are tucked into this little harbor, and there must be a thousand or more boats moored there in all. There are several more marinas outside Tsehum as well. In Canada there is no anti-dumping law, so the sewage from all those boats—and from the shoreline communities—goes into the water. The huge tides come in from the straits of Juan de Fuca and great surges of wash twice a

day keep the water clear and appealing to the eye, but the sea life
knows better. It cannot live in this water, so there is little prey for
the birds in turn.

Yes, of course this island experience is enough! The quiet, un-
complicated days here without distraction or appointments or the
telephone, the joyful feeling of returning to the cool woods after a
hot day of shopping for groceries in town, the meals outside watch-
ing the boats with the many islands as background, and tonight a
full moon spilling its light on the water in a luminescent trail: of
course it is enough! It's downright wonderful. But the sadness of the
depleted wildlife—the aspect of those vacated tidepools, those ghost
towns—will always be here with me too.

ROSEMARY PATTON

# Our Way West

I TRY TO SEE San Francisco just the way it looked on June 25, 1961. I long to feel the air of the Bay again precisely as I felt it that innocent afternoon. I was in my mid-twenties when I recorded these first impressions:

> Across San Francisco Bay by the Bay Bridge [two-way traffic on the upper deck in those days], and so San Francisco, lightly veiled by fog—the Golden Gate Bridge barely visible through vapor in the distance. San Francisco, an awe-inspiring pile of sparkling buildings clinging to precipitous hills, splashed with gay colors of paint and flowers.

Later, I might have added: A skyline wedding-cake-white, brilliant, intimate, distinctly foreign to one who knew only the cities of the eastern seaboard, the deep south as far west as Texas, and those of England and Scotland. The horizons, so distinct from each hill, free of familiar treelines. The sharp, dry air purged of the heavy sea smells I associated with beach towns along the east coast. Even the plants smell lighter, except for the surprising eucalyptus dripping in the fog.

"Look to your right and you'll see Coit Tower," said my husband Gray, waving his hand in its direction. He'd been here twice before and was longing to show me the backdrop of the life he was inventing for us. I recognized the round tower from Herb Caen's *San Francisco*, and remembered it was on Telegraph Hill. I'd been studying the names: Telegraph, Russian, Nob. Gray had brought that book and others back to Syracuse, New York, the previous January when he'd sealed our destiny on a one-week trip to discuss pediatric practice with Dr. John Piel. Coit Tower and the Ferry Building below us were still landmarks then, before they were dwarfed in the '60s and '70s by the Bank of America, the Trans America Pyramid, the skyscrapers forever sprouting in between, and, tallest of them all, the TV tower atop Twin Peaks, not yet even a controversy.

We carefully followed our street map and the directions sent in advance by my Aunt Priscilla, my mother's much younger sister, and her husband Wolfgang Langewiesche. It was they who had first tempted us with the idea of California on a cold Thanksgiving in Connecticut two years before and it was they who would be welcoming us.

"California, that's where the future lies," Wolfgang had said to Gray. Wives in those days were hardly included in discussions of "futures." The Langewiesches had subsequently followed his advice, come out to San Francisco with their two children, and settled for what was to stretch into three years before his career took them east again.

Now, entering the city, I was dazzled by the hills, the buildings large and small, tall and short, snuggled close together as they marched up and down. Stunning views to the north across San Francisco Bay flashed by at every crest. I was to gain new respect for these hills a few weeks later when John Piel's wife Carolyn lent me her aging Morris Minor missing its second gear. I quickly learned that all destinations could be reached without a hill, albeit by a more circuitous route.

The thin, dry air rendered façades sharper than landscapes I was used to. The desert and mountain terrain across the west, through

which we'd just driven, had shared some of this clarity, but the light here in San Francisco cast a different glow as it bounced off pale surfaces and danced on the water. The cool temperature, carried on a fresh breeze, provided welcome invigoration after days of inland heat. Late June, and I found myself reaching for a sweater. Not what I was used to on summer days in North Carolina, Boston, or even upstate New York of the past year. We had been sweltering in a heat wave for days as we crossed the Western states. Our two-door Falcon had never heard of air conditioning. Not many cars had in 1961. Now, it appeared, we weren't going to need it.

As summer followed summer in the years to come, I found myself longing for a hot humid day as chilly June fogs stretched to gray Septembers, but that summer I fell in love with bracing air that seemed to glisten. My energy lasted all day without a long afternoon swoon. For the first time in my life I felt hungry for every meal. Sourdough bread and salmon and lettuces of strange colors and artichokes and long-stem strawberries and good Napa Valley wines were soon to enter our days. I was seduced by California cuisine, as it was in the beginning and as it was to become. But I'm ahead of my story.

Gray must have breathed a sigh of relief when he saw the delight on my face. He was thrilled to be showing off his discovery to such good effect as we dipped up and down, heading for the Langewiesches on Lake Street. Glancing at our map, we noted Julius Kahn Playground at the edge of the Presidio. I was eager to see it so close to the Clay Street address I'd just spotted on the map, where John Piel had already rented a flat for us—conveniently near the California Street office into which Gray was soon to disappear. Our cargo of two small daughters, Mary four, Sarah two, was the cause of my playground interest and thus of our driving up then down Pacific Avenue. As we approached the Presidio, the street narrowed and plunged downhill, the houses changing to a charming brown shingle.

"Here's where we should live one day," I said cheerfully and, as it would turn out, naively. It was too soon for me to recognize prime

San Francisco real estate. Those blocks have retained a unique magic, a thrill of first love.

The Langewiesche house was a brown shingle too. We were grateful for the shelter my Aunt Priscilla offered those first ten days until our flat at 3825 Clay was vacant. My grandfather Arch Coleman, in his mid-eighties, widowed for two years, was living with the Langewiesches that year and the guest room had disappeared. We camped in the semi-basement, Gray using his new office floor or the living room sofa the first nights he was on call, fearful that the constant ringing would awaken the household. No portable phones in those days to carry downstairs with us. He was gallant about groping his way to the car, studying the same map that had ushered us into the city, and setting off to make house calls in every far-flung corner. Gradually, he came to know the Western Addition, Hunter's Point, the Sunset, the Excelsior, Westlake, Telegraph Hill, North Beach, even Visitation Valley as well as the more accessible Richmond, Seacliff, Pacific heights, and Marina, weaving his way from Pacific Heights mansion to fourth-floor walk-up in Chinatown. "Warping and woofing" across the city, his partner John Piel called it. Even today, he will recognize the most remote street names. Sometimes, lost in the maze of hills and deadends not marked on maps, he would return to the office to check by phone and start out all over again. No cell phones in the car, of course. One night he found he'd been sent to an address that turned out to be in Pacifica, fifteen miles away, far beyond the boundaries of their practice, he discovered too late.

I marvel to remember the time when doctors made house calls day and night and when a white man could walk alone through the Hunter's Point housing projects at midnight without fear. And I shudder with shame when I consider how little my young self empathized with this brutal initiation. I was absorbed in my own adjustments.

Gray's new partners heralded his arrival on a small printed paper thus:

We are pleased to announce that on the first of July Dr. R.G.

Patton will join us in practice. We hope thereby to give prompt and personalized service. Thank you for bearing with us the past year while we have been short-handed.

I assumed this terse missive, recently discovered at the bottom of my desk drawer, was inserted in the bills.

Gray, we learned, was to work six days a week, Monday through Saturday, as well as Tuesday, Friday, and Saturday nights, for a year. After two years of post-residency training and research with no nights or weekends, the pace was a shock. Gray's new associates, John Piel and Dick Leonard, had shared the practice through a severe epidemic the preceding winter and spring and were salivating at the prospect of new young blood to rescue them. Each in turn disappeared for a month's vacation as soon as Gray arrived. Senior partner, Dr. Jo Thelander, still came to the office on weekdays, but she had given up the call schedule and built a house in Tiburon. How Gray survived the punishing routine, his first days of practice outside a hospital setting, and the intricate geography of a strange city I have no idea. Office nurse and manager, Maybelle Steinman, soon to become a friend to all the family, may have made the difference. True to his character, Gray didn't complain. He knew he could learn the ropes, that things would improve. He was right, eventually. And joining a practice that threaded back through Dr. Edward Shaw, then chair of pediatrics at U.C. Medical School, and before him, Dr. Fleischhner, dating to the first decades of the century, at least added panache to the long days.

I suddenly found myself alone with two small girls, isolated without a car (house calls meant our only car for Gray round the clock), perched in a second-floor flat half a world away from a large, close family and all the friends I'd made since arriving in North Carolina when I was twelve. With hindsight, I can find myself feeling sorry for that young me. But the reality was different. I was still excited about the adventure we'd dared to embark on, too self-involved to think about our parents left behind in North Carolina and Washington D.C. They'd cheered us on our way even as Gray's

parents in particular quietly mourned a son's decision to take himself and his family so far from his southern roots.

I was expectant, confident that a new life would start unfolding. And that it did, first in the company of my indefatigable Aunt Priscilla and her children, and then born of extraordinary good luck. I found new friends at the earlier-inspected Julius Kahn playground with the girls. I suppose such encounters occur today, but modern mothers are busier and many more rely on sitters or preschools while they're at work. I think we of that era were lucky in our timing. Madison School, only a block away, opened more doors when Mary entered kindergarten in the fall. One friendship led eventually to our rustic cabin at Steep Ravine on the coast just north of San Francisco. There we were to spend many weekends listening to the waves crashing on the rocks below, surrounded by poppies and lush green grass every spring.

San Francisco was a cosmopolitan city far from the familiar small communities we'd both known in the South and remote from my country childhood in England and Scotland. But we found ourselves in a friendly neighborhood. Perhaps I felt at home in a city where people didn't wonder at my vestiges of English accent. In 1964, the birth of a third daughter, Susannah, was to give us real roots in our chosen city.

Gradually the days, months, years were to lead me to volunteering—hospitals, Edgewood Children's Home, schools, the Asian Art Museum—and finally, most significant of all, a career teaching English at San Francisco State University.

But that first week of July, as I looked out the tall bay windows onto Clay Street, the impossible-to-imagine future was still to come. One question must have hung quietly in the air. Why and how had we "emigrated?" Behind our migration there was a real narrative of sorts.

Two years before, while continuing his pediatric training at Boston Children's Hospital, Gray met Dr. Jane Byars, who, at the suggestion of her friend John Piel, was regaining her medical credentials after several years of "retirement." Gray and a couple of

medical colleagues took this delightful woman under their wings. She in turn tried to convince Gray, and later me, that the San Francisco Bay Area, where she lived, was just the place for us. She painted vivid pictures of Marin County, bathed in sun, dotted with orange trees. She introduced Gray to John Piel when he came East for a meeting. Reading the weather page in the paper, I noted summertime highs of 60 degrees and thought San Francisco should be off limits. Gray went to Syracuse to work on a research project. Not much winter sun, no oranges.

Wolfgang's words of the fall before stayed alive in Gray's memory, jump-started by a letter from Aunt Priscilla describing the wonders of their new home in California and the fine pediatrician they had found, Dr. John Piel. Gray continued to hear that Dr. Piel was looking for a partner. In January, 1961, he left Syracuse in a snow storm, caught a train for Chicago and plane to California, landed in the sun of a San Francisco winter day, took the pulse of the city, was offered a position, and returned home.

"In June we'll pack our bags and head West," was his greeting as he walked up the icy path to our apartment. Before he left, we had agreed. If he liked the practice, we would go. I still insist that he never called while he was away, that I had no idea what was going on as he went the rounds with John Piel, and possibly even looked at another practice—in Redlands, yes, Redlands, beyond San Bernardino! I knew nothing about distances in the golden state. I'd decided that if he found a place he liked in California, I was willing to give it a try, just for the sheer fun of it. Could the Syracuse winter have played a part? Today, I don't know that young wife. Our daughters can't believe such a story.

"You just moved across the country to a state you'd never seen?" they say. And they are right with their incredulity. What an odd way to run a life.

But so we did. We arranged for shipment of our furniture—a very modest collection—loaded our tiny car, inside and out, and drove off. "We're doing to Calidornia," two-year-old Sarah, perched high on our pillows and blankets, called out the window to her

neighborhood friends as we drove off to campground number one. We kept the girls reasonably happy with daily surprises released from the trunk, many part of a generous care package sent by Gray's sister Susy. Lucky they weren't boys, I say today, after knowing our active grandsons.

In an old file I recently stumbled on a report, "Our Way West," typed for the family, held together by a rusty paper clip. I had kept meticulous notes, recording miles door-to-door—3,478, expense—$150. Yes, one hundred and fifty dollars for gas, food, lodging. Gray had equipped us well—a large tent carried on top of the car. Ice chest, lantern, sleeping bags, Coleman stove, all fit into the trunk with our clothes. Pillows and blankets lay on the back seat underneath Mary and Sarah. Some items came from Sears, others were earned with Green Stamps. We lived on a shoestring in those days. No goose down at this stage. We stayed with family in Ohio, with friends in Illinois, and dined with Gray's medical school roommate in Denver. We splurged on motels in Denver and Winnemucca. Otherwise we pitched the tent in state or local parks across the country, depending on a campground directory from Camp Grounds Unlimited, Blue Rapids, Kansas, a bible according to more experienced camping friends.

The first night took us to Letchmere State Park on the Genesee River in upstate New York, where we were the only campers. The temperature dropped to near freezing, a record for the date, but we loved our cozy accommodations, the girls especially. To our surprise they slept deeply every night. We quickly learned about protecting our food supply when a raccoon drank the milk I'd left out that first night, a lesson useful for later excursions into the Sierra. Campgrounds in Missouri and Kansas were prettier, more pastoral than I would have imagined. The landscape was awash with the fresh green of June, the fabled wheat fields, gently swaying in the breeze, still young.

But it was the West, rising up beyond Denver, that grabbed us. At Loveland Pass, the crest of the Rockies, now bypassed by the interstate highway, we stood in the biting wind and drank the air. The

adventure had really begun. We exclaimed over the canyon colors of the Colorado National Monument even as we braved the dust of our campsite, enjoyed a cool night camping in the Wasatch mountains above Salt Lake City after a sizzling all-day drive. Sarah eased the tension of one broiling moment when she piped up, "Close the window, I'm cold." Trust a two-year-old to offer the contrarian view.

On day ten we drove out of the blistering Nevada desert up the steep eastern escarpment of the Sierra Nevada into California, turning down the western side of Lake Tahoe to Emerald Bay and our final campground, still surprisingly hot for the elevation. Every Californian knows the thrill of those aquamarine waters. Gray and I couldn't stop exclaiming, stopping to take pictures every few miles. Mary, Sarah, and I didn't wait for the tent to go up or food to be unpacked when we found our campsite. We simply pulled on bathing suits and rushed toward the water, thinking only of cooling off after so many days of heat. Every Californian also knows what we didn't. Lake Tahoe is very deep, still filling with snow melt in June. That clear blue wonder knocked the breath out of us in one simultaneous second. We were initiated, forever prepared for the many chilly swims to come, in Lake Tahoe, Fallen Leaf Lake, and the Pacific.

The landscape continued to strike us, right up to the door on Lake Street in San Francisco. With a little effort I can still evoke the descent from the mountains to the broad flat reach of the Sacramento valley, through the golden hills so picturesquely rounded and dotted with dark oaks, to the dramatic views of San Francisco Bay. My childhood love of geography was working overtime all across the country. Memories of Roy Rogers; of an adventure story about the Rockies read when I was nine in Scotland; of my grandparents' descriptions after they circled the country by car in 1950; of my friend Jill's cowboy records when we were twelve in Southern Pines, North Carolina; of Clark Gable and Marilyn Monroe herding mustangs in *The Misfits*, all converged and then faded as my own vivid impressions pushed them aside.

We had arrived. I hardly knew where or why, only that I was excited, delighted by so much beauty, ready to start our lives anew.

Friends, family, colleagues, not to mention Gray and I, had assumed
we would return to North Carolina after Boston and Syracuse. Did
we think California was an experiment, perhaps temporary? I don't
know. I do know that, like so many other travelers from afar, we be-
gan to sink roots in the sand dunes, to feel possessive about the light
and the hills, even on occasion the wind and the fog, which I strug-
gle to embrace. Day by day, San Francisco became home.

JEAN-LOUISE N. THACHER

# Diplomatic Language

IN THE SPRING of 1962, I sat on the edge of the fountain in the American Ambassador's garden in Saudi Arabia. The fountain was octagonal, decorated with blue tile and built to my design. I was thrilled it had finally been completed and trailed my fingers through the warm water remembering all I had learned about tile and pumps and the first thing I had ever read about Saudi Arabia, "The sweetest sound in all of Arabia is the sound of falling water."

Ahmed, the embassy gardener, came over to speak to me. He told me that His Majesty King Faisal had just ordered all the slaves in Saudi Arabia to be freed. The news was startling even though we knew it had been imminent. The ladies had been talking about it for days. The question had been when. There was a lot of speculation. My Saudi friends told me that many of the slaves had been born in Arabia. They knew no place to go. Arabia was the only country they knew; Arabic was the only language they understood. They were in most cases very much a part of their owners' families. Many had come to Saudi Arabia to make the pilgrimage to Mecca, run out of money and been sold into slavery. Many had been with the same family for generations. They had been educated and given jobs and

even had marriages arranged. A lot of them didn't want to be freed. Life was all right the way it was.

What was going to happen next? Radio Mecca announced that the Saudi government had just purchased the freedom of 10,000 slaves in the Kingdom at more than three times the going rate. Most of the slaves elected to stay with their masters and be paid for what they were doing. They were perfectly happy. It was the only life they knew. They preferred to stay where they were, Ahmed told me.

I felt that somehow the abolition of slavery would make for rather difficult dinner conversation. In the hour after sunset, I was expected at Princess Jauhara's palace for a ladies' dinner. I wished my husband were home, so I could ask him about the official Saudi view of slavery. I wondered too how the former slaves would behave. Would they fix any dinner? Would they serve the delicious tea spiced with cinnamon and sugar and fresh lemon in the small glass cups rimmed with gold in the traditional way? Should I eat something before going in case the slaves were striking? Should I phone my friend Suad and nervously ask what might happen? Should I even go? No, not to show up would be rude. But how would freed slaves behave?

I walked home slowly through the garden, looking with delight at my blooming gardenia bush. The bush had come all the way with me on the plane from San Francisco. When it began looking desperate in the hot Saudi summer, I put it in the air conditioned living room. That didn't work at all. In desperation, I grafted it to a Sudanese rose bush. Miraculously, the international marriage was flourishing. Perhaps I should give a blossom to Princess Jauhara. It might cause a sensation. There were no florists in Jidda.

The sun was setting. I had to shower and dress for the dinner and remember to wear a wide skirted evening dress for I would be sitting on the floor. I bathed slowly and dressed carefully. I knew I should try to look elegant when going to a royal party and avoid costume jewelry and American cologne. Many of the Saudi ladies shopped in Paris or hired a French dressmaker to come to Jidda for a few months a year. The Saudis liked to point to the Americans as

people of elegance. It was a challenge to be worthy of the compliment in the very hot weather with no reliable dry cleaners. I would wear my best jewelry and my silk patchwork skirt from Gump's and carry my brocade purse.

I stopped by the pantry to see Tewfik, the Yemeni cook. I was fond of Tewfik. I had made him the Embassy chef but he began his career as an illiterate assistant gardener. He had done well with my favorite plants, raising the first cherry tomatoes in Jidda and supporting the foreign gardenias and the hanging baskets of ice plants from California. He was very imaginative and was rapidly promoted, but now I couldn't find him.

Homait, the chauffeur, was standing by the ambassadorial limousine in the driveway. I greeted him and asked him to drive me to Princess Jauhara's palace. He took the road along the shore of the Red Sea. Many Saudi families were sitting on the beach drinking tea and the children were dancing in the sand or playing soccer. The men were talking together in groups. I felt envious of these happy gatherings. I missed my children. Besides I didn't quite know what to expect of the party I was about to attend.

When I arrived at the white palace of Princess Jauhara, a turbaned guard opened the car door and led me inside. Immediately one of Jauhara's maids came forward and took me into the parlor. With palms together and head bowed, I gave the traditional greeting to Princess Jauhara. She walked with me to a seat at the side of the room. Instead of some remark about the slaves, I inquired about her health. Princess Jauhara responded in the traditional manner, "El humduillah," which meant "Praise be to God." I greeted everyone near me. When the greetings were over, I sat down and silently admired the gowns the Saudi ladies were wearing. A servant all in white passed lemon squash, orangeade, coca-cola and soda water in gold rimmed glasses.

The British Ambassador's wife came over and sat next to me.

"Ghislaine, how are you? What are you and Willie doing about this slave business? Is it really making any difference? Are you going to give the servants something extra? Does it bother you?"

Ghislaine laughed. "It's just the uncertainty of not knowing what to expect."

Taiba, a Saudi banker's wife, was sitting beside her. "What do you think, Taiba?"

"Well, it's about time! So many of our slaves are from Indonesia, where my husband learned banking. He brought many of them here when he started the bank in Jidda. I don't know what we'll do if they all leave. My husband hopes all the old ones will go so we won't have to worry about pensions and all that. We'll be happy for the ones that leave so we won't have to pay them. We do hope some will stay too!" Taiba sighed. She seemed concerned.

Princess Jauhara, tall and athletic and not particularly pretty, joined the conversation. "Yes," she sighed. "Most don't want to leave. They just want to be paid. This is the only home they and their parents and grandparents have ever known. We've educated them, taught them crafts, cared for them when they were ill. They have no place to go, this is their home. Besides we don't want them to go away. They know our ways." The guests began sympathizing as Princess Jauhara sighed and the phone rang.

The secretary answered and announced that the call was for the Princess. It was King Faisal calling from the plane taking him from San Francisco to Washington. Princess Jauhara ran out of the room, which quickly erupted in noisy chatter. The call seemed very touching to me. Although Jauhara and the King were officially divorced they remained good friends. It had been necessary for him to take another wife in order to have an heir. His principal wife was now the Queen If'fat, who lived in the palace in Riyad and had given him six children. The youngest was married to Prince Bandar, the current Saudi Ambassador to the United States and Dean of the Diplomatic Corps. Queen If'fat is a beautiful, charming well-educated woman who has done a great deal to educate the women of Saudi Arabia and encourage them in various careers.

When Princess Jauhara came back in the room, she was smiling happily. She announced that his Majesty had really enjoyed his return to San Francisco. This was the first time he had been back

since he was there as Foreign Minister of Saudi Arabia in 1945 and signed the U.N. Charter for his country. This final remark created incredible difficulties for me to be silent and maintain my poise.

In brief the story is this. When, as Foreign Minister, the present King Faisal came to the meetings founding the U.N. held in San Francisco, he spoke no English. A Saudi student at the University of California, Ali Ali-Reza, was selected as his translator. Ali was married to a young American named Marianne, who chose to write about the meeting in her autobiography *At the Drop of a Veil*, which was immediately banned in Saudi Arabia. Everyone was eager to read it. Naturally, I had invested in a copy before coming to Arabia. Reading the book was a good way for me to learn about the country.

When I arrived in Saudi Arabia, I studied Arabic. My male teacher would arrive at the residence at four in the afternoon. I would recite grammar and answer my teacher's questions about the lesson, and then we would have a conversation in Arabic. Tewfik would serve tea and cookies and stay to listen to the conversation.

At one of these sessions my teacher asked if I had read *At the Drop of a Veil*. Since the book was not allowed in the country, he was very curious about it. When I told him I owned it, he asked me to tell one of the stories. As I began, Tewfik was remarkably slow in serving the tea.

I described Prince Faisal and Ali Ali-Reza staying in the St. Francis Hotel in San Francisco and always leaving at the same hour for the U.N. sessions. They wore Saudi agal and kaffiya and thobe. Some San Francisco ladies loved to sit in the hotel lobby and watch the various foreign delegates march by in native dress on the way to their meetings.

One day Prince Faisal and Ali were crossing the lobby. Assuming they spoke no English, a woman sitting on a sofa remarked loudly to her companion "Oh, they are so handsome, so fierce, so romantic!" Ali turned to her and responded in perfect English, "Tch, tch, Madame, you should see us on horseback!" Unfortunately my Arabic was not as accurate as Ali's English. I remarked in Arabic that Ali had responded "Oh, but Madam you should see us on a bed!" (The

words are *farash* and *farush*.) The silver tea tray shook in Tewfik's
hands and almost crashed to the floor; two government teacups were
broken. Tewfik's face turned red. The teacher was laughing so hard
he couldn't speak or correct me and was busy wiping tears from his
eyes. I was devastated. I didn't know what I had said but I could tell
it was something awful.

It wasn't long before the story was making the rounds of the
government and the diplomatic corps. For weeks I could tell the
subject of a conversation by the color of my husband's cheeks. The
story embarrassed him so! Everyone who spoke to him about it
wanted to read the book!

Soon the guests at Jauhara's were urged to go into supper. We
were ushered into a large room where an embroidered cloth covered
the center of a magnificent carpet. There were enormous brass and
copper trays covered with pineapples, and all sorts of apples, banan-
as, oranges and palm branches. At the edges of the cloth were trays
covered with rice, dolma in bowls, kebabs, lamb chop stews, spinach,
dates, Arab bread, tabbuleh, humus, lebanich and rose water in crys-
tal bottles.

Princess Jauhara had all the foreign ladies clustered together eat-
ing with their right hands. At previous dinners they had learned
never to eat with their left hands, which were only used in the lava-
tory. Princess Jauhara personally filled the plates of her guests.
Shortly thereafter, a group of Saudi dancers appeared and danced to
the music of drums and cymbals ending with a solo by a plump belly
dancer.

After the main course sweets were passed. Then servants re-
turned carrying huge bowls of warm water and fragrant soap and el-
egant towels. After proper washing, the guests returned to the main
room for coffee, which was served from a huge brass pot with an
enormous curved spout. It was fascinating to see the coffee poured
into a tiny Arab coffee cup from the huge brass pot held at a great
height by the highly skilled coffee bearer. When the coffee ritual
was finished, large jars were brought into the room filled with sticks
of burning incense and put in the middle of the floor. The Saudi

ladies began laughing. Taiba explained through her chuckles that when the ladies left they must stand for a short time with the jars underneath their skirts. "To make you much more attractive to your husband," Taiba explained.

Naturally, I did as I was told and thanked Princess Jauhara for a very special evening knowing I would never forget the smallest detail, including the date. The date the Saudi slaves were freed.

BABS WAUGH

# Wildlife

OUR HOUSE IN LOS ALTOS is on a well-populated road that follows the crest of a ridge. When we have parked our car in the carport, however, walked up the ramp to the house and settled ourselves in our chairs, we could easily think we were in deep country.

Dick, my husband of only three years, is a birder, but because he doesn't keep a lifelist, he doesn't consider himself a serious one. At any one time, in the trees that surround our house we have a dozen or so brown birds which birders call "LBJ's" for "little brown jobs." I discover that these boring, brown birds are towhees.

"But I know towhees," I say. "We had them at the ranch and they were beautiful little birds with rust-colored breasts and black and white wings." My late husband, John, and I had the ranch for thirty years and sold it only six months before he died. I was remembering how he and I would watch the towhees scratch around among the leaves like chickens while we had our breakfast.

"That's the rufous-sided towhee," Dick said, absently. "We have them here from time to time," but I was dubious, for I have yet to see one. I can recognize the chickadees now, fluttering and twittering and hanging upside down in the pine trees outside our living

room windows. This year, there are more chickadees than before, but the usually plentiful, raucous bluejays are almost nonexistent.

Chaco, the cat, who has been part of Dick's household for at least sixteen years, has died. Nobody in Dick's family is quite sure how old she was. She was black with white paws, and looked much like "Socks," President and Mrs. Clinton's cat. Her coat was sleek and beautiful in the winter, for she supplemented her diet of gophers and birds with huge amounts of cat kibble. Her technique for catching birds, often a towhee or a thrasher, was to sit unmoving below a section of a three-foot retaining wall in the patio and listen for the sound of scratching on the level ground above. At the right moment she would leap onto the wall and pounce. Only a few days before she died, she caught a towhee, leaving evidence of her kill in the pile of feathers on the front doormat. Two weeks before that, I watched her descend slowly through the rock-garden from the field above with a huge limp gopher in her jaws, passing within a few feet of me without a glance, then disappearing behind the jungle-like planting near the front door to devour her catch.

She usually thinned down a little in the spring, but this year, as spring turned into summer, we were worried about her thinness, which was much more marked than usual; the day she disappeared we planned to take her to the vet. She was gone for the entire day and night, surely having gone away to die, we feared, but the next morning she appeared at the kitchen door as usual, waiting to be let in. When I opened the door, it was as if she didn't know where she was; she came into the kitchen, walked slowly into the dining room, stopped, and stared into the distance, one paw raised. The veterinarian listened gravely as we described her symptoms, asked us to come back in an hour, then told us her kidneys had failed. We left her there to be put down; it was the only thing to do. For several days afterward, as I worked around the kitchen getting breakfast, I would think I saw her waiting at the glass door to be let in.

Every year we have a quail family who live in the underbrush near the mailbox. For a moment in the spring, when we turn into our road, we startle the parents and their tiny, carbon-copy off-

spring, and it is a pleasing sight indeed to see the whole family
sweep across the road in front of the car. This year, we've also star-
tled a pair of skinny rabbits who dash around frantically, their ridic-
ulously tall ears at attention. So far the rabbits have kept their
distance from the house, but last week, I saw one not far from the
vegetable garden which Dick has swathed in netting in preparation.

Yesterday, I heard a mourning dove, the first one I've heard at
Dick's house since I've lived here. I don't like its call, perhaps be-
cause it makes me remember sad and lonely times at the ranch,
times when I was hating the place, thinking of it only as a black hole
where the money drained away and John, for whom the ranch was
Shangri-La, was angry and silent. I would be out with a hoe on a
hot, still summer afternoon, hacking at weeds that seemed to grow
overnight, and as a mourning dove gave its plaintive call, I saw my-
self unloved, drifting purposelessly through my life.

I liked the other birds that were around the ranch: the tiny juncos in
the spring with their neat black hoods, the acorn woodpeckers at
work high up in the linden tree, an occasional pileated woodpecker
looking prehistoric with its large body and small head, attacking the
trunk of one of a pair of giant tulip trees the first owners had plant-
ed a hundred years before. A landscape architect helping us with the
design of our entrance garden, said "beautiful trees, wrong place."
We loved them where they were, though, and looked forward each
spring to their pale chartreuse and orange blossoms. You had to look
for them carefully for they are hard to see against the bright green
of the leaves.

We had gray squirrels all over the property. Until John wrapped
the trunks with aluminum sheathing, they often won the race for the
walnuts we hoped to harvest each fall from the stunted trees an Ital-
ian owner planted some fifty years before. The half-dozen squirrels
around the house, their tails luxuriously bushy, could stay airborne
for a hundred feet, accomplishing this feat with great athletic leaps
from tree to tree, walnut to mulberry to tulip to magnolia. Only
occasionally would one miss and fall with a thud onto the leaf-

cushioned gravel below. We couldn't help laughing; squirrels aren't supposed to fall out of trees.

One year when the mulberries along the road began to drop their fruit, we had foxes every night for a week. Around ten o'clock we would settle into our chairs in front of the picture window in the living room to watch the show, the outdoor lights not bothering the foxes at all. First one, then another shadowy figure appeared until we gradually realized that the whole family—two adults and their five kits—had arrived. One of the adults stood guard at the top of the stone steps leading down from the terrace across the road as the others began to feed, the kits giving baby growls as they had mock battles with each other among the rose bushes. About ten-thirty or eleven, they moved silently away, vanishing into the shadows and soon afterwards, a large skunk would appear at the top of the steps and make its waddling way down towards the mulberries (I always wished for an oboe accompaniment), the elegant white stripe on its black fur coat gleaming in the light.

We also had rattlesnakes. Our daughter, home from college one summer, discovered two rattlesnakes in a dry, weedy area near the back gate, rearing and twining around each other like a caduceus. They stayed this way for some time, mating or fighting, then one went off through the gate and the other across the barnyard toward the woodpile near the backdoor where it disappeared. We had the pictures she took of the event on the sunporch wall for years. Though we never killed rattlesnakes outside our compound, we felt we must kill them near the house and each summer we killed six or seven, even as many as thirteen in the early years. One summer, when the children were small, I shot a snake near the gate at close range. It was not a difficult shot, for the snake followed the sun-warmed muzzle of my gun, striking at it, its fangs bared in its wide-open mouth lined with what looked like white satin.

If there was a small boy around, I would cut off the head and skin the snake for him for a belt or a hatband. I stretched one skin on a board and hung it up in a back room where it stayed for years until it faded and cracked. We always cut off the rattles and added

them to the dusty collection in a glass jar on a low shelf in the book-case. We would show them to visitors as a silent warning.

One winter, a stray cat took up residence in the barn. She was a beautiful, delicate looking Siamese, hardly what you would expect of a barn cat, and she had evidently been mistreated for she was afraid of humans and terrified of our dog. She lived in the barn, where she decimated the rodent population and by so doing, the rattlesnakes that came in after them, though, with all the stone dry-walls around the place Chinese laborers built a hundred years before, we were never free of the snakes completely and I was always wary when I weeded the garden or walked at dusk.

On one side of the house was a large deck where we spent most of our time during the warm months. One hot day in early summer, as I walked towards the table where we had our meals, I heard the unmistakable sound of a rattler below. It is a dry, insistent rattle that instantly drowns out background noises of wind and insects and makes the hair rise on the back of your neck. The idea of a snake under the deck was all the more horrifying because the day before, John had crawled from one end to the other to string wire for an outdoor light. He decided to shoot it from the open end of our deck where the ground slopes off and as we crouched down, we could see it about twenty feet away, coiled and rattling. He fired once, then once again to be sure. His first shot hit the rattler square in the head, the second bisected the wire he had strung the day before.

"I've never seen a rattler here," Dick said in answer to my question soon after we were married, but after three years, I'm still wary when I walk around without a flashlight after dark.

Late at night as he and I arrive home after an evening out, we sometimes see a white blur streak in front of the car. This is the pos-sum that lives under the ramp leading up to the house from the parking area. Dick built the ramp over the stairs for his first wife, Marian, when, during the last year of her life, it became impossible for her to walk up the stairs.

"I got it done just in time," he told me, and I could hear in his

voice the satisfaction he felt. I've broached the subject of having the ramp removed, but Dick is reluctant.

"We may need it ourselves, someday," he says cheerfully, and I let it drop. The ramp is not bad looking, but the stone steps would look better, for I can tell they would make a more graceful entry. I have resolved not to make an issue of the ramp's removal, but I think from time to time about the possibility of numbering each piece like the stones of the palaces rich nineteenth century Americans imported from Europe, each piece labeled so that it could be put into its designated place. We could store the dismantled ramp in the dead space under our deck until we needed it.

The frogs in the pond are less strident now, but in late afternoons and evenings during their spring mating frenzy, the noise is deafening. In the daytime, they are quiet and not visible at all. We are not sure where they go but we think they leave the pond and stay in the junipers on the slope above. In the spring when they were at their most raucous, the entire population numbered fourteen. We find it hard to believe that these small frogs, about two inches from head to toe and so few in number, can make such a racket. Some are army drab, some, a brighter green with a chevron-like pattern on their backs, and when we approach, they become suddenly quiet and look at us with tiny black eyes that shine in the light, their heads just above the water line. They are not quiet for long, though, and in a few seconds, they inflate their throats, open their mouths, and begin again their rhythmic calling.

I talk on the telephone to my daughter in Korea, and she pauses for a moment and says, "What's that?" I tell her that the frogs have been at it for weeks. I discover from my other daughter in San Francisco that the sound is the background on our message machine. A San Francisco friend comes for dinner, and as she walks up the ramp, she says, "Good heavens, Babs, what are you going to do about those frogs?" I tell her we are at our wits' end. Perhaps we could poison them, I think later, but then realize that Dick is fond of them and I, too, am fascinated, for I admire their diligence, their fervor, their compulsion to call for a mate, hour after hour, night after night.

Last year we had tadpoles but this year we have none, though we have watched for them carefully. I had hoped to see again what I saw one year at the ranch. On our way home from a walk in early spring, John and I made our way across the top of the earth-filled dam above the house to check on the spillway at the other end. I loved those walks I would take with him, looking for wildflowers, inspecting the vineyard we had worked so hard to create, enjoying the view of Mt. St. Helena across the valley and the turkey vultures that circled high and higher as they rode the thermals. When we reached the spillway, we saw in its sun-warmed shallows long, perfect ribbons of tiny tadpole embryos extruded only moments before, each curled-up tadpole encased in a transparent envelope connected like the ribbons of spaced seeds you can buy at a nursery. I continued to visit the spillway regularly, and, as delighted as a seven-year-old, watched the sperm-like tadpoles metamorphose to wriggling fish with leg-buds on their tails and, finally, to fully-formed, perfect little frogs. Here, in our Los Altos pond, we must conclude sadly that the prodigious efforts of our fourteen frogs have come to nothing.

In our bedroom, my desk juts out from a floor-to-ceiling window whose sill is part of a squirrel run. As I pay the bills or write a letter, I am occasionally startled by a sudden frantic scrabble at my feet as a squirrel races along the window sill to the safer, wider platform of the deck beyond. From my desk, I look out towards the western hills that remind me of hills in Tuscany, and in the winter, when the purple-leaf prune trees are bare, I can see Dick's orange trees on the slope below the house. The other day, a hawk sailed past at eye-level, not ten feet away, the raptor curve of its wings unmistakable.

Yesterday, as we sat reading in our usual places in the living room, Dick said "Babs," and I looked up, startled at his tone. His eyes were fixed, not on me as I expected, but at something outside the window at my back. "There's a nuthatch in the pine tree," he said, and, as I swung my head around, I caught the barest glimpse of a small brown bird on its trunk, just beyond the deck.

"Now, how on earth could you tell what that was?" I said.

"Well, they're usually upside down on the trunk, and this one was," he said. Then he went on, "I was out with a friend once and she pronounced it 'new thatch.' She and her husband were new at birding but were getting serious about it." He paused for a moment. "When I was younger, I would have corrected her," he went on. "I don't do that anymore."

In the spring, after the rains have ended, the ants begin to forage and I know that soon they will invade the kitchen and the bathroom. I see them outside in the shade house, through the glass door in the bathroom. They hurry in long lines across its wooden floor and at certain times in June, the sunlight slants at such an angle that its rays are almost level with the floor, illuminating the line of ants so that they seem magnified in size, their bodies turned from a smooth black to a furry gold. They look to me like a line of tiny lions.

I learned soon after I came to live here, that ants invading the house are nothing new. Over the years, Dick has developed a battle plan. Before you do anything you find their point of entry by tracking them carefully, which he did not long ago from the kitchen, through the hallway, across the living room and into the laundry room at the other end of the house. He sprinkled insecticide on the door sill where they were coming in, then spread it along the sill with an old paintbrush. If they come through a crack in the house walls, he tackles them with more finesse, first making a trough out of a small piece of paper to hold the powder, then, using a bulbous rubber ear syringe, blowing the powder into the crack. Only after spreading the surplus powder that has fallen below with a stiff white feather does he wipe up the line of ants with a sponge and soapy water.

"The soapy water was Marian's idea," he says happily, speaking of his first wife and their battle with the ants, as he mops up the remains of this last invasion with his sticky sponge. I see that he actually enjoys his apparently endless battle. Lately, we are trying arsenic-filled metal strips placed around the outside of the house, but both of us are leary; only time will tell how good they are. I secretly hope the arsenic doesn't get them all for I want my lions of early summer back.

A huge king snake lived in the iris bed at the ranch. John and I saw it only rarely and when one of us did, we would call the other and together would admire its hugeness, its handsome black and white ring markings. Much to my surprise, Dick and I have one here in Los Altos. Last summer, I discovered it in the rock garden, as huge and handsome as the one at the ranch, stretched out on the damp ground beneath an overhanging rock. After a while, it retreated smoothly into the deep recess beneath the rock and the next day it was gone completely.

The other day, as Dick was leaving to do some errands, I was surprised and alarmed to hear him call me in a tone that had me running to the door afraid he'd fallen. When I saw him standing just outside the door making exaggerated motions for me to stop and be quiet, I was greatly relieved, for I'd half expected to see him on the ground dying.

"Look over there," he said. "The king snake is back." This time it was traveling across dry, open ground on the level spot above the retaining wall that had been Chaco's hunting ground, and as we approached with careful steps, it continued on its path, gliding slowly toward the dark shadows beneath the junipers where it disappeared.

"I'll bet he's after the frogs," I said, waving Dick off once more, and as I turned back toward the house, I felt entirely—and unaccountably—safe, at least for now.

BETTY WHITRIDGE

# The Pig War and the Rabbits

CHAPTER I: "PICKETT'S LANDING"

THIS IS ABOUT the Pig War. Surely everyone knows about the Pig War in Puget Sound, a one-shot war, a war that never really happened. In the eighteen fifties, British soldiers were on San Juan Island. One of their pigs continually got into an American's garden. Repeatedly angered, the American shot the British pig. Hard feelings! An international incident!

The American residents of the island appealed to General Harney in Washington, D.C., for protection against the British. To quell the ensuing uprising, Captain George E. Pickett and sixty men were ordered to the island from Fort Bellingham. This young captain later became famous in the Civil War as General Pickett who led Pickett's charge (really Pickett's retreat). The good captain landed on the south end of the island at "Pickett's Landing," set up camp at a spot hereinafter known as American Camp at "Oldtown." The Brits had the north end of the island—English Camp—with a parade ground, several buildings and a blockhouse, which is still standing today. The incident became a hot border dispute between the United States and Great Britain. The one-shot war was settled by no less a personage than Kaiser Wilhelm of Germany to whom both countries appealed

for arbitration. The wise old Emperor simply took his royal pencil and drew a wiggly line down through all the islands in Puget Sound, thus putting some Canadian cities, Sydney, British Columbia for instance, further south than American ones. So ended the Pig War.

Oldtown thrived for some years as a wild west, windswept port with docks, piers, cabins, a salt-water pond, a monolithic rock, a water-well famous for never going dry in the water-short islands. After the soldiers departed, the docks crumbled and the cabins sank into the sand.

Later a legendary, quasi-mythical character called Whisperin' Smith farmed there, ran his sheep there, built a house there, perhaps smuggled rum from there. The place remained dreary and deserted for years except for sheep and the occasional water-short islander rowing in to draw a barrel of water from the blessed well. Years later someone named Katz purchased the land, fixed up Whisperin' Smith's house a bit, adding elementary plumbing, electricity and a marble slab in the kitchen for making pastry. Then once again, for years, no one came to the windswept, desolate spot at the end of a rutted track until a mysterious Mr. Sykes, said to be a remittance man (the islanders meant paid by his family to stay away), bought the place, but neither he nor anyone else ever actually lived in the house.

Our family, the Whitridges, had been transferred by Zellerbach Paper Company in a southward migration from Bellingham to Seattle, to Tacoma, to Deseret near Salt Lake City, Utah, where we lived happily. Happily, except that in this inland state, we missed the water, the seashore. Every summer we restored our thirsty homesick souls by coming to the Pacific Northwest where Fred and I had been married and our four sons had been born.

For several summers David, our oldest son, went to Henderson's Camp on Lopez Island in the San Juans. We would pick him up at camp, then stay on, vacationing for a time, usually on Orcas Island at the old Madrona Inn. We'd look longingly at cottages, beaches, fields, green mountains, the sea. One year when it was time for us to

return to the arid kingdom of Deseret, Fred said: "Why don't you
and David stay on, look around, find an old waterfront farm for us
to buy?"

Well! That was in the 1950s when such things really existed.
Ten-year-old David took his responsibility seriously and kept a me-
ticulous record of all we saw "to show Dad." I hope that document
is still in existence somewhere deep in our family archives. It was a
jewel, listing acreage, prices, advantages, disadvantages of the many
available, affordable, places which we saw, all from a discerning ten-
year-old's viewpoint. Some of his comments: "Gee Dad, this would
make a swell softball field." "We sure could have fun camping on the
beach here." "Great place to see Mount Baker." "Bet there are lots
of fish in this bay."

Although there were a multitude of attractive waterfront proper-
ties for sale, it was very hard to find anyone who knew anything
about them. The island's big town, Friday Harbor, had exactly one
real estate agent, Bill Suttles, a nice old man who hardly ever came
in to his office upstairs above the one bank. We left a note for him,
and, eventually, when he wasn't "out fishin'," he found us and
showed us several available places.

Out of all these, the one we advance scouts, mom and the ten-
year-old, liked best was Oldtown, desolate, isolated, windswept,
weedy, over-run with rabbits—a real plague of rabbits. Sheep had
been inside the ramshackle old house. But, *oh*, the view—Mount
Baker shimmering over the sea in the front yard. *Oh*, the flat fields.
*Oh*, the salt water pond. *Oh*, the gently sloping beach piled with jun-
gles of fascinating, twisted, gnarled, bleached driftwood from the
ages. *Oh*, the sense of history; the pioneer child's grave, the hint of
ancient docks. *Oh*, the looming rock just begging to be climbed.

Fred laughed at our description, but studied David's document
seriously and had to fly up, see the unique, antique old place, be
equally smitten and buy it, all forty acres.

The kindly locals thought we were crazy and more to be pitied
than censured; no one in his right mind would buy that awful old
run-down Sykes place at Oldtown, they said. Nevertheless, they all

fell to with a right good will, with shovels, brooms and dump trucks to clean up the sheep-infested house.

My mother, who lived in Bellingham with her invalid husband, took up a welcome new hobby. In their red Oldsmobile, she drove all over Skagit, Whatcom, Snohomish and Island Counties, from junk shop to second-hand store to country sales. With her finds, she managed to furnish our house for the princely sum of $200. She found two round oak dining tables with fat legs and claw feet, some sturdy benches, ice cream parlor wire chairs, braided rugs that she got from the inmates' workshop in Sedro Wooley; "the insane asylum" it was called then. Her proud trophies included old bureaus, mirrors, curly iron bedsteads, leather trunks, all still our treasures today.

After we added a stone fireplace, a wrap-around porch, a new roof and moved in all of Mother's finds, our beloved home was livable and cozy. Funky, but cozy. Everyone had to troop through our small bedroom to get to the one very small bathroom. *Everyone*— Mother, David, Arnold, Tom, Freddie, and guests. The very small bathroom's walls were covered with towel racks painted with each of our names plus "Guest #1," "Guest #2." Fred always announced when everyone could "use the facilities"—not always when they needed or wanted to. Our Salt Lake, Seattle and San Francisco friends, accustomed to places like Carmel, Tahoe or Jackson Hole, found our place surprising.

Our four boys slept upstairs—up steep narrow stairs in a peculiar space that they named "Zeke's Attic." Each son had a small bureau and a cot. Mother, when she came, was upstairs, too, in her own small bedroom furnished with one of her prize trophies: a beautiful Gaudiesque blue and brass iron bedstead.

We spent delicious, exciting hours combing the beach and exploring the fields. With our accumulated finds, we founded the Oldtown Museum. It was scruffily housed on the stair landing between Mother's room and Zeke's Attic. The historical artifacts were many: thick milky glass, yo-ho-ho-and-a-bottle-of-rum bottles, a wooden doll, a few marbles, lots of pieces of clay tobacco pipes, shards of

pottery. We distinguished founders had but one burning ambition: to discover a whole, unbroken object. This day finally came. At low tide our salt-water pond was a treasure hunter's paradise. In it, young Tom found a complete, unbroken cut glass plate. "Mamma! Mamma!" he called, running to me with his treasure held aloft, his face radiant with joy. "I've found a whole plate." Whereupon, in his eagerness, he tripped, fell and the plate broke into tiny pieces.

Rabbit over-population was a serious problem. No seed or plant that nosed above the ground at night was still there in the morning. The ground was burrowed and tunneled everywhere. Fred had to surround the house with wire dug in several inches below the surface. People later tried to introduce foxes or a disease, mixomytosis, to control the numbers, but the plague went on. This burgeoning rabbit plague was like the problem Australia once had.

Oldtown had been deserted, uninhabited for so long that the whole state of Washington thought it was the place to go to hunt. Unsavory hunters came by land and by sea, gun in one hand, can of beer in the other. I became a full time sign painter: "CHILDREN PLAYING DON'T SHOOT," "NO HUNTING—DON'T ASK," "NO SHOOTING." We plastered the falling down fence and every standing log with these signs that later became famous all over the island. "Hi," said a local one day, "I know you are the people who have all the signs. Can we buy some for our place?"

San Juan Islanders had their own peculiar way of helping to control the plague: Rabbit Netting—the most fun sport of Oldtown. It was an after-dark activity, and since "dark" in the northerly Puget Sound Summer doesn't arrive until ten P.M., it was a sport carried out very late at night using car headlights and long-handled fish nets. Our adored Crofton Bug, a sort of miniature antique jeep with a lawn mower engine, was the vehicle of choice. Bug bounced over the bumpy, rocky, rabbit-burrowed fields, headlights blazing. Shouting and laughing boys hung from every side attempting to catch the blinded rabbits in their nets, the boys' reward, hot chocolate later around the round oak table in the manse.

Oldtown bunnies went to many city homes. A nine-year-old boy,

a visiting friend of our sons, flew one home to San Francisco via United Airlines. His family swore that this brilliant rabbit creature learned to watch television regularly. The child of another friend craved one to take back to the family's own private little Canadian island. Our sons promised her one, but her father, absolutely, firmly, sternly forbade it, vowing to throw it off their small open boat on their way home. The children got it packaged tidily and hidden in a wee box. The baby bunny went back, not only to their island, but also, at the end of summer, on to San Francisco. The whole family, even Dad, became very fond of it. Other friends freed theirs in the San Francisco Presidio. Do we have descendants of Oldtown rabbits in this military preserve now? Goodness knows what happened to the bunnies smuggled into Utah. Perhaps they attended the Olympics in Park City.

Harry King, born and bred on the island and a long-time, deer-hunting friend, looked after our place all winter for $10 per month. He told us to leave clothes hanging on the clothesline as evidence of habitation. The clothes were always ragged, wind-ravaged strips when we returned the next summer. This pioneer ruse must have worked, for over the years, the only things that were ever stolen were a canoe, three little boy's handmade, fringed, deerskin jackets and one large cooking pot.

Archie Chevalier, our one and only neighbor, was said to be perhaps not a hermit, but a solitaire. For years, we never saw him, but finally had to seek his help when son Freddie's adventurous driving got Bug stuck in the salt water pond.

Archie protested, "Well, I was just headin' fer bed," but at our urgent pleading, he brought his tractor and hauled Bug out. After that Archie and his dog Rocky, came over frequently for CCC (coffee, cookies and conversation). This caused our boys to tease Granny about him.

"Oh ho," they said. "Archie's sweet on Granny." Maybe it was really so.

All the years we were there, we could never get a phone. "Not possible" was ever the answer to our applications. Sometimes the

Sheriff drove all the way out bringing us a telegram. Remember telegrams? To respond to the telegram, we usually drove the twelve miles in to Friday Harbor and waited in line to use the one pay phone. The nearest phone to us was several miles down the road in the ramshackle house of an illiterate tarheel family—(I do not use this term pejoratively; they said: "We'eze tarheels.") Their mentally retarded, grown-up son always had a brace of pistols strapped to his belt. We breathed easier when the Sheriff told us that they were toy pistols. Those folks could get a phone but we couldn't. If the telegram seemed urgent, we bravely went to the tarheels' dirty, smelly home and begged the use of their phone. "Come on in. Hope y'all don't mind the chickens in the livin' room. They's company fer Grandma," they said. We suspected that the pistol totin' son might know the whereabouts of our missing canoe, jackets and pan.

Most of our dinners were family picnics around a bonfire on the beach with David's guitar featured. One memorable dinner was Granny's birthday. We sang songs accompanied by Webb camp counselor David's guitar. One line we all recall and still sing is: "She'll give us meals never starchy, we'll make her marry Archie." There was a throne, a.k.a. a canvas camp chair, brought by Bug from the house for the guest of honor. There were ribbons, signs, decorations and, purely serendipitously though we pretended to have arranged it, a stunning air show—rolls, dives, flips by Ernie Gann in his World War I airplane. "Really it's nothing at all," we said. "Nothing is too much trouble."

At the end of our road was a locked gate leading to the old Cattle Point Lighthouse and a totally uninhabited point of land. It was scary because a Mr. Daugherty, said to be mean and unreasonable and to be avoided at all costs, owned it, adding to our sense of adventure whenever we trespassed.

After some years we were able to buy some adjoining acres expanding our no-bank waterfront to eighty acres—large by island standards. Then disaster struck, in the person of Senator Henry "Scoop" Jackson. The United States of America decided to make a National Pig War Park. Jackson flew over the territory and decided

that, of course, historic Pickett's Landing and all of Oldtown must be part of the American Camp Park.

"Can we fight it?" we asked our lawyer friends.

"Sure, go ahead. You might get life tenancy or a ninety-nine year lease but the government has the right of eminent domain and you'll eventually have to leave." The assessors came. The appraisers came. Fred thought they were fair. I thought how many millions of dollars he could have made if we had sub-divided, put in roads, developed those acres of no-bank waterfront. But sadly, inevitably we took the pittance and left. I like to say, "We were run off the island by the Feds." It's true.

Disconsolately, dejectedly, we searched and searched and searched for a similar place. Since there *is* no similar place in the universe, we were unable to find one. We looked in vain in Washington, California, Connecticut, Oregon, Utah. We rented houses in Seadrift, Dutch Flat, Inverness—liking them all but it just wasn't the same.

### Chapter II: How the Whitridges Came to Arcady

For seven years we pined, homesick for the San Juan Islands. We were living in San Francisco then, but one week when I was up in Portland, Oregon with Fred, who was traveling there on business, we began to smell the firs, the pines, the sea again. Fred said, on a whim, "Let's phone Jay," one of the now proliferating island real estate agents, "and see if there is anything at all for sale in the San Juan Islands.

"Not really," Jay said. "But come on up anyway. It's beautiful weather and, well, there's one run-down old farm that no one has cared about or spent ten cents on in years. Hippies are camped there. It's a mess and very over-priced. No one has had the courage even to look at it but it is in a gorgeous location. You and Betty might like to see it."

We flew up. Jay took us to Deer Harbor to see Arcady—pathetic, neglected, overgrown Arcady. The main house had burned down;

only a huge hole indicated where it had stood. Fred saw the barn. Fred saw the water tower. Fred saw the orchard. Fred saw the picturesque little cabins and the arbor leading to the dock. I saw the gaping holes in the barn roof and the water tower out-doing the tower of Pisa in its lean. I saw the arbor on the ground with blackberries, wild roses, snowberries, weeds wound through its ruin. Arcady was on the sea, but the sea was not visible through the raging undergrowth. Two tottering, little shabby cabins were painted purple and red and had stove pipes protruding crazily through their rotting shingle roofs. They had no sewers, no electricity, no insulation and the well had become saline, unusable. The ancient, gnarled fruit trees badly needed pruning, indeed, looked unsalvageable.

"Come on, Fred. We'll miss our plane to San Francisco. Let's go."

"Just a minute. Look at this workshop! Did you see the chicken coop? Has there ever been such a boathouse? It looks like a New England covered bridge. Look at the equipment-parking shed." Fred had fallen hard. Even though I was overwhelmed by its problems, I, too, knew that Arcady was a hidden jewel, a sleeping treasure. Once again we had stumbled onto a bit of Island history.

"O.K., I'll listen to your ideas if you promise to try to get that marvelous old truck in the barn going," I said. We had discovered that it was a 1948 model with barely legible lettering on its door.

The present absentee owners of Arcady were a University of Washington professorial couple. They had bought it from Mrs. R.B. Brown and it was still known as the R.B. Brown place. After her husband died, Mrs. R.B. Brown had sold bits and pieces of Arcady. A couple from Seattle had bought a fifty-foot waterfront lot and put up a small pre-fab Lincoln Log cabin. If we could buy that, it would be possible to live in whilst we mucked out the derelict place.

We encountered endless complications from neighbors on each side, ancient feuds, smoldering hard feelings of long standing: "Don't let anyone know that you know so and so or they will never sell to you," they said. Eventually we were able to buy both pieces of property, the "main" part and the Lincoln Log cabin lot. Déjà vu!

Again the island locals felt deeply sorry for us—"Oh! You're the poor (hear "ignorant" or "stupid") California couple who bought that run down old R.B. Brown place. You really got taken!" ($125,000 for fifty waterfront acres, a barn, two cabins, a fallen-down dock.)

"Fix the dock!" everyone commanded us. Fix the dock? We didn't even have a boat and thousands of things needed urgent attention. But it was explained to us that while something (just a few decaying pilings) still stood, we could "restore" the dock without permission, denials, prohibitions, court sessions, lawyers, rules of the powerful, unsympathetic Shoreline Commission. So, fix the dock we did, neglecting all the more practical matters.

After the first few years of hard work at Arcady, we felt we'd made sensational progress. Our friend Barbara Brown asked if she could bring her elderly mother, Nell, *the* Mrs. R.B. Brown, to see the place. We were thrilled. We raked, mowed, cleaned, burned, lined up the shiny restored, newly painted 1948 Ford truck with "R.B. Brown Under 1000 lbs" painted on its side. We'd saved it from a moldering rusted death. We stood beaming proudly, practically tugging our forelocks, bowing, curtsying, awaiting her praise. Nell Brown descended from her daughter's car and moaned "*Oh*, it just makes me sick to see this place!" Our smiles faded. Nell, of course, was seeing it as it had been when she lived there; we were seeing our vast, heroic improvements.

Arcady has a long, rich, fascinating history, one we are fortunate to be part of today. Thanks to the Orcas Island Historical Society who, together with the Deer Harbor Community Club, has undertaken a history of the area, we have become more and more interested in the people who have preceded us on the farm. For them, I have written "A Partial History of Arcady, an old Orcas Island Farm," too long to include here but interesting for our family. From her mother's effects, Barbara Brown gave us two copies of the ancient "Abstract of Title." We gave one to the Orcas Historical Society; we own the other. From the dry, legalese of its yellowed pages, one can glimpse Arcady's History. In 1883 President Chester A. Arthur

deeded a Homestead Certificate to Joseph and Betsy Bridges for 136 acres. The homesteading but illiterate Bridges signed the certificate with their "X's." The document goes on and on from there. Ownership changed often; one sees the farm being bought, sold, enlarged, diminished, loved, named Arcady. It was mortgaged, divided by divorce and the site of burials. Over the years, owners built a tennis court, swimming pool, barn, water tower, boathouse and dock, and, at one terrible moment the house burnt down.

Since Fred's retirement from Zellerbach, we have been spending longer and longer time at Arcady and less and less at 3249 Pacific Avenue in San Francisco, which we also love but which I now call shabby chic since we never spend enough time there to polish it. Our sons were prone to turn up their noses at Orcas Island and Arcady as being too civilized after the delicious wild isolation of Pickett's Landing at Oldtown, but now that they are grown and have families of their own, they have come to love it, as have each of our nine grandchildren.

All told, we've spent more than twenty-five years of constant loving labor reviving the lovely old place, restoring it to some of its former glory. It has been our sole obsession, our greatest delight and joy.

LUCIA EAMES

# Light as a Feather

THE HOUSE IS DARK and still; it holds its breath with me. Darkness has entombed the world. Formless fog blots out trees, hills, stars, all but a faint uncertain vestige of a vanished moon. The fog bends darkness down and presses hard against my throat the sound that woke me, a hollow, muffled sound of...was it...owl?... wind?...spirits?...vandals?...it must be an owl!...

The haunting, eerie sounds weave bewitching fugues. A two-part conversation of overlapping harmonies emerges. The feathery resonant timbre of exchanges floats lightly upon the air it gently stirs. The steady cadence begins to catch and calm the night and gradually restores to house and heart serenity and peace.

The next morning dawns behind still heavy fog. The memory of the owls brushes the ruffles of their strong, whispery recitatives against my eardrums and draws me out of the house to see if one has left behind a feather. That would be a calling card to cherish. So finely formed for flight, feathers serve as talismans, icons, shamans' wands, symbols and harbingers of happiness, mementos and inspiration. The ethereal, ephemeral magic of all feathers makes finding one in the garden, woods, or fields a restorative surprise. In such a

moment, with delight, I stoop to pick the treasure up, smooth its interlocking barbs, murmur quiet thanks to the bird from whom it fell and offer gentle wishes that the bird still may sing and lightly fly across the sky.

But no feathers are to be found this morning, or so it seems at first. None by the tower, nor any under the nearby stand of pine trees, the sentinel vantage points from which the owls sometimes scan their world. No matter, their whispery song still sings in my heart.

Then a very small feather, a soft gray smudge of airy fog, catches my eye, and then another, and another. They nestle half hidden in the grasses, weeds and stubble, occasionally a few together, flung out a bit apart yet linked, almost as close together as in a cozy nest. Farther along there are more: scattered and alone, just spots of slightly different textures, barely perceptible amongst the tapered leaves, mottled bark and dry pine needles.

The fact that each feather is perfect and pristine and that no signs of violence mark the ground twist in my mind against the fact of so many different shadings and shapes and sizes of feathers having fallen to the ground in just one area beneath the pines. All from just one bird? Inexorably, the bleak realization of reasons for this tightens the constriction in my throat. Nothing within the quiet setting changes, and I do not pause, but scenes swiftly slip and slide within the confines of my mind, then spiral back to question: "Did the owls...?" and then spin off again.

Breezes carry the feathers short distances in different directions, until something, often a spike of hay or thistle, holds them fast. I comb the area in widening circles and seek them out. I find more and more the more I look. Respect for the spirit of the bird compels me to pick up every single one I see. Each one, remarkable in itself, is to be honored and treasured, if only for a moment in time.

As minutes drift into an hour, and then into another, it comes to matter little if an occasional feather is, perhaps, from another bird: for all creation seems to begin and end as one. The progression from bending over, up and down, again and again, to crouching,

then crawling and finally being on my knees seems quite natural and appropriate. The feathers themselves suggest a tangible, if tangled, metaphor in which a single feather can symbolize a single soul. No matter how many feathers there are, how large, or how small, each one counts.

This perception soon is strengthened, and its compulsion softened. Just as I tuck a last feathery dot of down into the pocket folded into my sweater, a subtle breath of air catches up that tiny feather, wafting it away. I follow quickly, but each time I reach out for the bit of down, it floats just ahead of me with a graceful arabesque and gently drifts higher, rising by stages until out of reach. Then, a moment later, it disappears from sight into a sudden brightness of sunlight breaking through the clouds, and I can only whisper:

*O spirit sweet and strong that fuses earth and sky,*
*lift unsung passing birds to soar to highest heights*
*to sing again and grace the music of the spheres*
*with joyful obbligatos of harmony and peace.*

AVA JEAN BRUMBAUM

# The View from the Window

OUR HOUSE SITS on a hill with a drop on one side to a pasture about a hundred feet below, a vantage point which affords ever-changing scenes beyond the breakfast room window. My desk is there, looking out on hills just turning brown as last week's hot weather hurries the end of the winter green. (I love the golden hills, too, but there is nothing like the lush green of early spring after the winter rains.) Live oak trees follow the ridgeline, the bottom of the canyons, and the slope to the south. As I look down, just the steeple-like top of the old red-and-white, one-room schoolhouse can be seen where the trees leave a small V-shaped gap. A little to the north, through another opening I see a small section of the recently bulldozed parking lot where a new school is taking shape, and from beyond those trees children's voices waft up the hill at recess times.

To the south are more hills with gentle, soft curves, the highest (at 1400 feet) even has a name on the map, Shroyer Mountain. Dark oaks mass in the undulations, and at the very top and on the ridge behind is a thick stand of Douglas firs forming an uneven skyline. It is there that the full moon comes up, enormous as it appears over the horizon. When it does, my husband and I watch it at dinner

time, for we like our breakfast room so much that we eat our other meals there as well, read, do crossword puzzles (at least the one of us who is addicted to the *New York Times* Saturday Special), and watch television. There, too, is my desk, where I try to make sense of the piles of papers that always await me.

From the pasture below me grows an ancient oak, whose top is just below the level of my window. (I think it is a valley oak, but am not sure.) In the wintertime, without any leaves and with grey lichen hanging from its branches, it seems to have no life in it, and walking beneath it I see broken, rotting pieces of branch on the ground that have fallen off. I always worry that the spring will not renew it as it has each year before, but today it is completely covered with fresh growth, far lighter in color than the green of its relatives, the live oaks. This tree is important to the birds, and to me as well, because I can look down on any visitors perching there at close range, my binoculars at the ready beside me. The blue jays and noisy robins are always there in the fall and winter, attracted to our various berries and water. Flocks of migrating birds stop there as they pass through to wherever they are going. Sometimes a redtail hawk or a kestrel will perch near the top of the tree—a great vantage point for hunting in the pasture below.

About six feet beyond the window is a Rainbird for watering the small garden on days so warm that the drip irrigation system won't suffice. The Rainbird is mounted on a pipe about three feet above the ground and there always seems to be one drop of water clinging to its mouth. Various small birds like warblers and tits and goldfinches perch on top with their heads reaching down for that drop, and the sight is always diverting. Today I saw two crows harassing a redtail high over the pasture—it must have come too close to their nest. As one crow dove at it, in a calm and graceful way the hawk would dip a wing to avoid contact, and as the other crow approached it repeated the maneuver. Then, after a few minutes tiring of this game, it slowly flew away. I have seen the crows chase away a raven and even a large vulture. They seem fearless, and I have read that they will attack in groups to help each other out.

Our pasture is bordered by shrubs and trees on the banks of a creek that is hidden unless the winter rains turn it into a torrent. The shore birds that winter in the nearby reservoir often follow the creek up past our place. A pair of noisy Canada geese fly by often and land in our pasture, sometimes bringing six or eight more with them. A great blue heron flies by, scrawny neck and bandy legs tucked in, massive wings outspread, and sometimes a flight of ducks can be seen. On the ground the occasional bobcat roams around in search of prey, and often deer. All this is mine to behold without leaving my desk—and, as well, the many horses (our caretaker boards them) which ornament the pasture all the time, especially when a brisk wind excites them and they race back and forth, kicking and bucking in their exuberance.

Here I am, a city-bred person who always longed for the country. I love, even need, the companionship of friends and the activities which take me away to town. Nonetheless, I am never more content than when I have a day or two right here at my window to enjoy all this, and make yet another vain attempt to catch up on that paper work.

# Paychecks

NANCY GENN

# Light Struck

Painting. The broad-brush strokes capture the essence.
Using transparent color to fold the shafts of light onto paper,
Rough, handmade paper or a sheet made smooth by steel rollers,
Absorbent, accepting.
Geometric forms surround the painted plains of light
Stacked into an architectural assembly of rich color,
Alizarin crimson, vermilion, ultramarine blue and mars violet.
Pencil lines, scratched and tentative, emphasize details.
To complete the image, a vale of shimmering litho ink,
The translucent layer that gives a random texture.
The plate mark subtle, adds mystery.

JEAN-LOUISE N. THACHER

# Fort Huachuca 1944

ON A SIGHTSEEING TRIP in October 2000, we crossed the Mexican-US border on the way to Tombstone, Arizona. To the left of the highway was a road sign that brought back a stream of memories. It was a simple gray wooden arrow pointing to a dirt road across the flat orange desert with black mountains in the distance. It read Fort Huachuca.

When I finished college in January 1944, the war was still going on. With a degree in psychology, too young to go overseas and having worked as a Red Cross nurse's aide, I joined the Red Cross again, this time as a psychiatric social worker, and was trained at Walter Reed Hospital in Washington, D.C. I was posted to Camp White in Medford, Oregon to work in the military hospital. Some of the patients had been in a tank corps in North Africa, most had been in the artillery in Europe, almost all were native Oregonians. After a few months, I was transferred to Fort Huachuca, Arizona.

On the way by bus, I stopped to see the Grand Canyon. It was snowing on the rim. I hired a donkey and followed a trail down to the Colorado River where it was very hot. The earth colors were in brilliant layers of copper, rust and brass. The Colorado River was a

rushing torrent. I don't remember any vegetation except tough little desert flowers.

As I rode down, I began thinking about my new assignment. All I knew was that the soldiers I would be caring for were a mixed group. Some had been overseas, some had not and all were being trained for desert warfare in North Africa. The army was anxious to get them trained, and Fort Huachuca was the only place in the U.S. where this training was possible. I would be working in the hospital.

When I got back to the rim of the canyon, I took a train for Huachuca. When I arrived, I assembled my luggage on the platform and looked for someone in uniform to meet me. As I was in my Red Cross uniform and not many people were getting off, I didn't think I would be hard to find. I saw a Negro in Red Cross uniform obviously looking for someone. She passed me before I could speak to her. She went to the end of the train and came back.

"Pardon me," I said, "can you tell me how I can get to Fort Huachuca? There don't seem to be any buses." She looked startled, "Oh my, are you Miss Naffziger?" I told her I was. "Well," she said, "Welcome to Fort Huachuca." Then she looked at me very thoughtfully and said, "We better go out to dinner! I'm Marjorie Hayes." "Delighted to meet you!" I told her. Marjorie Hayes was the Red Cross Field Director at Fort Huachuca. All I had been told about my new assignment, other than its location, was that I would be working in the hospital under her direction.

At supper in Nogales, Marjorie Hayes told me that Fort Huachuca was an Army tank training camp for Negroes. She didn't look directly at me as she spoke. She said there was some mistake in my being sent there, for the entire Red Cross unit was black, as was the deputy commandant of the fort and most of the doctors. It was a difficult moment. I was silent, thinking. Marjorie Hayes said I was to work in the hospital with the psychiatric patients who had just returned from overseas and assist the psychiatrist as I had been doing at Camp White. After a moment, I told her that was what I expected and had been trained to do. "Were there any Negroes at Camp White?" I assured her there were. She was very persistent. "Yes,

many of them came from Portland." I didn't tell her they weren't patients or soldiers but swept the floor and cleaned the barracks. I wanted to work with Marjorie Hayes. She had a lot to teach me.

I thought for a moment about Camp White. One of the Negroes at Camp was called Tom. He cleaned my cabin and we had talked about his future. He planned to be an undertaker's assistant "because the guys you work on never talk back!" He was the one who found the kittens born in my closet and named the one with the orange ear "Jellybean." Thinking about Tom made me smile. I didn't tell Marjorie.

Over coffee Marjorie told me that she had gone to college at Columbia University in New York and had worked in a hospital there. She had wanted to go overseas when she joined the Red Cross, but they had a position to fill at Fort Huachuca and wanted her to take it. They explained how important it was. It involved the only Negro tank-training unit in the country, and the men were being trained for desert warfare in North Africa. She told me the commanding officer was white, his deputy black, and the doctor I would be working with was black. She stared at me as she spoke.

"I—I don't know how good I'll be," I said hesitantly. "Other than Tom I have only known one other Negro well. She was named Agnes. She washed my mother's hair and that of her friends." Marjorie didn't say anything. "My father called her the Black newspaper. She told my mother gossip as she dried her long hair in the sun pouring through the bedroom window. I loved her; she was so funny and warm." There weren't many Negroes in San Francisco before the war.

Marjorie spoke again, "These Negroes you will be with are very different from Agnes and Tom. They are educated, hardworking. Are you sure you don't want a transfer? There would be nothing bad in your record, just something like an error in posting or something like that." I thought for a moment or two and said I would like to try it if she would help me. If I was going to have a career as a psychiatric social worker, I had to be able to work with all kinds of people. Staying at Fort Huachuca would be a good way to find out about Negroes and their problems.

Our drive to the Fort was quiet as I stared out at the treeless mountains beside us, bordering the pale desert with its leafless bushes brown in the moonlight. This kind of desert was unfamiliar to me; I couldn't visualize horses rushing over it with cowboys swinging ropes. Perfect tank terrain I guessed. Marjorie said she thought there was a single room under the roof in the barracks that was vacant or that I could try a larger room with a roommate. I told Marjorie I was a loner. When we arrived at the barracks, no one was around. Marjorie showed me my room and said she would see me in the morning, to sleep as late as I wanted.

When she left I went to find a pay phone to make a collect call to my parents who were staying at the Desert Inn, in Palm Springs. I wanted to tell them I had arrived safely and what my new address was. The operator refused to take a collect call from Fort Huachuca! "I can't take a collect call from Huachuca. I'd never see the money again!" Shocked, I searched around in my pockets, purse, and bag and finally found enough money to put in the pay phone. When I got my parents, I was out of money and asked them to call me back. I found out much later that the telephone operator told my father I was at a Negro camp. He didn't mention it to me, and I'm not sure when he told my mother. I think he was proud the Red Cross thought I could do the job.

The following morning, dressed in my gray Red Cross uniform and white stockings, I headed for the mess hall in the nearby barracks. I walked down a long corridor where, hanging on the walls on both sides of the hall, were posters of Negro entertainers encouraging people to buy war bonds: Lena Horne, Joe Louis, Duke Ellington, Bill Bojangles Robinson, Hattie McDaniel, Eartha Kitt, Ethel Waters, and Paul Robeson. When I reached the Mess Hall door and stood there looking for Marjorie Hayes, there suddenly was a dead silence as everyone stared at me. Marjorie Hayes hurried to my side "I didn't think you would wake up so early. I was going to bring you over the first time." "I got hungry," I explained.

Marjorie introduced me and showed me around. The rest of my memories about Fort Huachuca are disorganized. I remember being

so surprised that none of the Red Cross aides could ride horseback, or play tennis, or even wanted to play ping-pong but only listened to music, and looked for rides into Tombstone. They were all saving money. I was stunned to learn they were sending it to their parents for their own funeral expenses. They came from New York and Boston and Philadelphia and Richmond and Charlottesville.

Marjorie took me to meet the white commandant in charge of Fort Huachuca and the 92nd Battalion. Colonel Johnson looked me over so slowly and carefully, I felt like an Arabian mare being offered for sale. Col. Johnson was big and heavy. He stared at me. "What kind of name is Naffziger?" I frowned at him thinking that it was none of his business. "Bavarian," I answered. "What?" "Bavarian," I repeated. "My God where is *that*?" This idiot, why should I say Germany and get him all stirred up? "In Europe." "Oh," he said. "Well, there is a lot of work for you to do at the hospital, Miss Naffziger. I want to dance with you at the club very soon. The beer is just great." He leaned over his desk, giving me an enveloping smile. I almost pushed Marjorie Hayes in my haste to get out of his office.

I admit it was a while before I went to the Friday night dances, but I did enjoy the Thursday movies. Before the movies, popular music was played on phonograph records. Also the Red Cross provided small white records, which were put in a machine, and the soldiers could record messages for their loved ones. This was quite a popular activity. One night when everybody was at the movies, I went in and recorded and sang a song that a boyfriend had written for me. I was called away just as I finished. When I returned the record was gone. I looked and looked but couldn't find it. The following night when records were being played before the movie, the corpsman in charge announced the arrival of a splendid new record by a new star. I was sitting by a patient in a wheelchair when an all too familiar voice was heard singing, "Darling, I wasn't born a king to share expensive things that wealth and money bring me. Darling, my triumphs won't go far, for I have touched my star, your love's my legacy." I was out of my chair in an instant and off to the projection booth where the corpsman's grinning face was pressed against the

glass. He was grimacing with laughter at my embarrassment. The patients thought it was so funny they would request it every night till I managed to retrieve it.

When I first arrived I had to do typing and fill out forms and other clerical tasks. I guess Marjorie Hayes figured I wouldn't be there too long. I was fascinated with the carelessness of some of the soldiers about their next of kin. "Well—yes, she the mother of my boy but I don't love her, I love Mabel. I met her in Tombstone. Well—but I want Mabel to have fun with my insurance money. After all, I earned it and should be able to decide what to do with it!" After a few clerical work disasters, to the point of messing up a shoe rationing application and allowing a private three shoes, I was put to interviewing the soldiers and hearing about their problems. Even today, these stories are deep in my heart and are the reason that after the war I couldn't go on with psychiatric social work and went to work for a book publisher in New York.

The head psychiatrist, Dr. Woodson, was a gentle looking, gray-haired Negro. He was a very kind, patient man who would listen to my worries and concerns about my patients and give me sound advice. I learned later that white officers who had made serious mistakes were sent to Fort Huachuca. The black second lieutenants considered bright and able were promoted to first lieutenants and transferred to more competitive surroundings. The senior Negro officers were mainly able, educated and experienced gentlemen.

Dr. Woodson told me about the patients I would be seeing, mostly enlisted men injured overseas and a couple of officers. All had been injured in North Africa. One had been pulled from a burning tank and refused to go to a special burn unit in Maryland. Jason Jayson wanted to stay with his men, six of whom were in the hospital. He was often in terrible pain, and the first time I entered his room he shouted at me to go away. He was connected to all sorts of bottles and hoses and had to be helped to move.

Most days he would ask me to go away. Then one day he asked me to sit down. "I guess you wonder why I'm here. I don't have to be!"

"Oh," I said surprised.

"I wouldn't be anywhere if it weren't for my men!" There were tears in his voice. "Don't," I pleaded. "Don't." I was no help. I, too, was in tears. Jayson's story had been told over and over. He had climbed on top of a burning tank to open the hatch and let the men out. Then he fell off and was so badly burned that they had left him for dead. The next morning when they came out to collect the corpses, someone had seen him move. He was the hero of the 92nd. He was doing pretty well but often he became depressed and bored. Several times he had gotten an infection and almost died. He had so little resistance.

When I first saw Bruce I wondered why he wasn't out playing basketball. He had a long build and long arms and a graceful way with his hands. Even when he was sitting he had the look of a basketball player. I asked him about sports he liked and wished I hadn't. He had shattered his spine jumping from a burning building with a four-year-old Sicilian girl in his arms.

Then there was a Tarahumara Indian who wanted to be a neurosurgeon and who asked for all sorts of information. I was very worried about him because I didn't think he had the patience or coordination, and because of the injury to his arm, it was hard for him to keep his hand steady. He called me Bedabayenbayeh, the The Long Red One in Tarahumara, because on cold mornings I would sometimes wear my red coat lining over my gray uniform to keep warm, not recommended behavior. I had trouble sleeping at night, thinking about my patients and how little I could do for them.

One weekend two of the other Red Cross aides and I went in to Tombstone. We wanted to go to the Desert Museum and see the sights, I thought. They wanted to go to a bar and look over the scene. I returned to the hotel and went to bed. The next day we did see the Desert Museum.

When we returned to Huachuca, I rushed to the hospital. I had to see Jason. He was much on my mind. I went to his room. His bed was empty. I waited for him until one of the nurses came down the hall. "Looking for Jason?" she said breezily. "He's in the icebox."

She walked away. I was stunned and speechless. A magnificent human being, gone like that. I was dazed. I couldn't speak. As I left his room, I noticed his name on one of the large file drawers in the hall refrigerator. Marjorie Hayes passed by just then. She put her arm around my waist and said softly, "He was very special." I cried all the way back to my barracks.

I stayed at Fort Huachuca for another three months until the 92nd headed for Oran, Algeria. I learned a lot and even danced at the Officer's Club. Then one day Marjorie Hayes said I was going to be transferred, perhaps to the hospital at San Diego or Letterman in San Francisco. The staff was to be cut, she had no complaints about my work. I was sent to Camp Shoemaker, which lacked the variety I'd become used to at Fort Huachuca. Marjorie Hayes and I exchanged Christmas cards for years until I lost my address book in Baghdad.

Now, fifty-five years later, here I was seeing the familiar sign on the way to Tombstone with no time to visit Fort Huachuca. When the bus arrived in Tombstone, I raced for the main street searching for a store that sold postcards. No one had a picture of Fort Huachuca. In the very last cigar store I visited, the lady behind the counter asked why I wanted such a postcard.

In answer, I told her perhaps more than she wanted to know. She smiled at me and told me that her husband worked there now, that it was a vital, top secret Army communications and intelligence center. After the war it was closed for five years and was never again an all Black camp. Right now they were tearing down the old barracks and building new offices. She also told me that the Huachuca canyon was considered one of the most extraordinary bird watching spots in the country. Before I could find out why, the bus driver marched in and announced that everybody was quite angry because I had been keeping them waiting for so long.

I didn't bother to explain. It would take too long.

BABS WAUGH

# The Work of the World

WHEN I WAS growing up, I heard my father speak often about advice his father had given him, that he must prepare himself to do his part of the work of the world. I believe that my grandfather viewed this need first as an obligation, second, as a privilege, a chance, while taking on the burden of work, to make one's mark. I loved the sound of it—the work of the world—but it seemed to be something reserved for men. I never thought that this advice applied to me, nor do I think that my grandfather intended that mothers, wives and daughters take on any part of what he thought of as "the work of the world." We women were to support our brothers or our husbands as they tackled the job, and prepare our sons to follow in their footsteps.

I must give credit, though, to my father, and probably my grandfather, too, for valuing the contribution of women in a different domain. My father's theory of western civilization, an idea he advanced often during my formative years, was that its progress was primarily the result of the women who saw to it that children were raised properly. I sensed that he never quite equated keeping house and rearing children with the real "work of the world." It was the men

who must "amount to something" in life. Had I had brothers, the pressure to amount to something would have been heavy on them.

I certainly wasn't thinking of doing "the work of the world" when, still in high school, I applied for my first job. I'd packed apricots one summer on my Grandfather's ranch near Escondido, but that was more of a vacation than a real job. It just seemed time to try, and since it was easy to get a job in Los Angeles during the war, one summer I applied for work as a salesgirl. I was hired to work at Bullocks downtown, and, after a few hours of training, I found myself assigned to the silver department. I was thrilled, for I loved the idea of being surrounded by such gorgeous stuff: ornate pitchers and candelabra, platters and bowls—hollowware, I learned to call them—and acres of place settings in all their multiplicity of patterns, most of them with many more scrolls and flourishes than my mother's comfortably plain silverware at home.

The silver department was a rectangularly shaped room with displays around the wall and cases in the center. It seemed cold and hard, like the two saleswomen, dressed in black, whose domain it had been for years. They sat in chairs in the far corner near the cash register waiting for the rare customer to come through the archway into what I came to think of as their inner sanctum. What must they have thought of this eager greenhorn?

During the two weeks I lasted there, I, too, sat waiting for customers as the minutes between breaks ticked slowly by. When a customer did venture into the department, one of the women, the more senior of the two, raised herself slowly and stalked across the room, her thin legs on their high heels bowing slightly at the knees. Only if both women were occupied did I have a chance at a potential customer, for I was aware that a polite but fierce battle for commissions was being waged. I don't think I made even one sale during the two excruciatingly boring weeks I was there.

"They've both been there so long," I said to my mother, one night. "How can they stand it?"

"They have to make a living," she said. I could tell that my mother felt sympathy for these women and for working girls in

general, those unfortunates who had no husbands to support them. In the thirties and forties, you went to work only if you had to; certainly, during the depression, you didn't take jobs away from the men, for many were out there, desperate to find work. And after the war, when the men came pouring back into the work force, only the GI Bill designed to encourage further education kept the job market from being overwhelmed.

Sometime toward the end of my second week as a sales girl, I went to my supervisor and asked to be transferred to another department where I would be busier. The sweater department, I suggested, would be nice, but when I came to work the next day, I discovered that I'd been assigned to men's socks. When my two colleagues in the silver department learned of my imminent departure, they assured me, one nodding as the other spoke, that I would like my new post very much and they were right. On the ground floor there was lots of traffic, and if I didn't make huge numbers of sales, at least I was busy arranging and rearranging the merchandise. I got to know my socks intimately and learned truly to love them as you are supposed to do to be a good salesperson. As the days passed, I tended to point out to my customers how beautiful this pattern was, or that shade. My enthusiasm knew no bounds. One day, as I went on about the beauty of a particular pair to a woman about my mother's age, she listened for a moment, and then said, "You know, they're just socks." I stopped short, feeling ridiculous.

Sometimes I entertained myself by trying to discern patterns of taste among my customers. Older people tended to buy socks with small patterns. Did African Americans buy more brown than black? For a moment, I thought I'd discovered a pattern there but another buyer disproved my stereotyped notion.

Sadly, I don't remember having any special fun with the money I earned. Perhaps it went into a college fund, or simply into my savings account. Money was not of great interest to me then, possibly because my father, who didn't believe in allowances, would give me money whenever I asked for it.

I felt differently about the first money I earned some twenty-five

years later. During the intervening years, I had finished high school and college and two years of medical school. My plan to become a doctor had been cut short by marriage and a first baby. I never thought about medicine in terms of the money I'd make. I always knew I'd have a husband who would support me as my father had supported my mother, and whatever money I did bring in would just add a pleasant superfluity to our lives while I "made my contribution" to the world doing what I loved.

After college, some of the girls I knew found jobs in San Francisco and lived what I enviously thought was a delightfully Bohemian life. One was a hostess at the Shadows Restaurant on Telegraph Hill while she attended the San Francisco Art Institute. Another entered a training course for department store management. A third, also an artist, scheduled clients at the Arthur Miller dance studio. All of us were, in a sense, waiting for suitable husband material to show up, but they, at least, were getting a taste of the "work of the world." Because I went directly from school to marriage to motherhood, I never really had a job until my children were well along in their schooling. During the interim, I happily occupied myself the way most of my peers did: as an at-home mother while my children were small, becoming involved in their school activities as they grew, and working concurrently as a volunteer.

By the late sixties, though, I was a forty-one-year-old restless mother of teenagers and I decided to look for a job, and not just any job, but one within the scientific community. My undergraduate years at Stanford as a biology major and two years in medical school at the University of Pennsylvania began to loom large in my thinking; it seemed a shame not to try to do something with all that education. In an ill-defined way I was beginning to apply my grandfather's and father's feelings about "the work of the world" to myself. I suspect that I was influenced, too, by the burgeoning women's movement that would become full-blown in the seventies. Women were beginning to demand access to the working world on equal terms with men. The old equation was changing. Advanced degreeless as I was, I would try my wings.

Through one of my husband's associates at Presbyterian Hospital, now California Pacific Medical Center, I heard about an opening in the affiliated Institute of Medical Sciences. I retrieved my twenty-year-old transcripts from my files and went for my first interview. It was a complete failure. My potential boss deemed me "overqualified." On my second try, I did land a job in the Heart Research Institute, for which I was supremely *under-qualified*. My boss, Keith Cohn, a cardiologist in the Division of Cardiology, gave me the rather grand-sounding title of research physiologist. The job required a technological expertise that I was to acquire entirely and painfully on the job. In the words of my daughters, who used to refer, ironically, to lessons painfully learned along the road to maturity as "learning experiences," this was the mother of all learning experiences.

In those first weeks, I felt as if I had been dropped into a foreign city and forced to find my way without knowledge of the language or map to guide me. School was easy; you went from A to B to C and so on. Here I started in the middle of the alphabet and the letters were all a jumble. I spent the first weeks watching cardiac surgeons in the lab and trying to make sense of monitoring equipment that looked like high, black kitchen cabinets. Their multi-channel recorders were alive with rhythmic records of heartbeats. Their numerous toggle switches spewed wires that went to transducers, pumps, and other machines I didn't recognize. One day, a messenger happened into the lab just as one of the surgeons nicked an artery of the cow he was operating on. There was a sudden geyser of blood six feet high.

"Gee," the messenger said, stopping in his tracks, in awe, "this is just like MASH."

I, too, was in awe of this place I'd happened into, and it was weeks before I reached a level of comfort that would allow me to be of any use to anyone. One morning Keith and another cardiologist came over to see how I was doing, and while they watched, I managed to inject the liquid in the syringe I was holding into the air rather than into the tube where it belonged, then drop the syringe

on the floor between us. They both sat looking at me without a word and I fancied they would like to call a halt to the whole business. Finally they left. I cleaned up my mess and Keith and I continued as before. The strangers in the lab who would become my mentors were patient and kind, and gradually I found my way.

I helped Keith investigate the effect of commonly used antiarrhythmic drugs on mechanisms of ventricular arrhythmias. The results, later published in *Circulation*, gained us an invitation to present the work in 1971 to the American College of Cardiology in Anaheim. I was touched and honored when Keith asked me if I would like to present the paper to what we both thought would be a group of forty or so doctors in a comfortably informal setting. When he learned that the paper was scheduled for the main hall before several thousand cardiologists, he never once suggested that I not present it, but instead spent time helping me to prepare. I shall always be grateful for his generosity.

The National Institute of Health grant that supported our research projects was minimal, perhaps justifying my pay which, by today's standards—and standards then, for that matter—was a mere pittance—$850 a month. How pleased I was, though, when my first few paychecks arrived. Like a future millionaire framing his first dollar, I thought of saving the salary forever. Instead, I decided to buy my husband John a watch for Christmas. Sometime in October, I went into Shreve's and arranged to buy a Rolex on the installment plan. When I emerged onto Post Street that crisp autumn day, I felt lighter than air and my feet barely touched the ground. I think for the first time, I was enjoying that whiff of independence money earned makes possible. I think I began to understand how wonderful it would be to feel self-sufficient.

After several years—and long after I'd become adept enough at my work to justify my modest wage—I timidly broached the possibility of a raise.

"Why, Babs," Keith said, blithely, "I didn't think you were in this for the money."

Pushover that I was, I let the matter drop, for I had to admit he

was partially right; I hadn't thought much about money when I went looking for work. I knew, down deep, that I was lucky I didn't have to.

Several years after I started work, a conscientious objector turned up in our lab to fulfill his humanitarian work requirement and was offered to me as an assistant. He was a Harvard student, very smart and very liberal. In the waiting periods during an experiment, we often talked about the world and politics. I truly shocked him, one day, when I said that I didn't think it was unfair for women to receive less pay for the same job a man held because most women had husbands, who, after all, were the providers. I can hardly believe I held such a viewpoint then.

In 1973, my husband John and I took a year off. It was a wonderful break, but I was glad to come back to San Francisco, and soon became involved in a project that gave me the most satisfaction I have had in my working career. It was work I did for no pay at all, and it involved starting MAP, a medical career exploration program for high school students under the umbrella organization, Enterprise. As a laboratory researcher, I had had several college students come into the lab as assistants and I enjoyed teaching them what I was doing and having their help. I saw no reason why bright high school students could not be of equal value to medical researchers and it was with them that I started. I felt it was important that the students be in place long enough to establish a connection with the professionals with whom they worked. I believed that the true value of the program would be to give such opportunities to those young people who would not ordinarily have the chance to meet professionals in a field they might consider as a career.

"What *do* you do all day?" John asked during that first year.

"I talk on the telephone," I said, and I really did, for as I began to develop the program, I made call after call to former colleagues in my lab and to other doctors I knew to persuade them to take a student for the summer. It was a selling job, plain and simple, and I was as enthusiastic about selling the idea of my nascent program as I'd been about selling socks at Bullock's. I knew how much I could have

benefited from having a window into medicine while I was still in high school.

Curious about how students in the program remember their experience, I spoke with Niki Tede, a MAP student in 1977, who worked in the laboratory of the Drs. Arnaud, clinicians and researchers in endocrinology at Fort Miley Hospital.

"We were studying Vitamin D and parathyroid hormones in chickens and monkeys," she said, "and it was a far cry from what I thought being a doctor was like. I was glad to have the chance to work with a woman doctor, too." Dr. Tede, who kept in touch with the Arnauds through college, did go on to medical school and is now a pediatric cardiologist at California Pacific Medical Center in San Francisco.

Eliza Busch, also in the program that same year, worked in pediatric oncology with the assignment "to develop recipes for kids who got nauseated on chemotherapy. It was not terribly satisfactory," she said, "but the experience had an enormous impact on me. I saw the toll it took on families, and I've always thought about the kids." She went on to get an MBA in health management and works at UCSF. Not all MAP students went into a medical field. One girl, who was placed with a medical social worker, decided she didn't want any part of medicine, an outcome I view as positive, also.

My friend, Kay Forster, who followed me as program director, told me recently it was the most satisfying job she had ever had, too. I loved everything about my experience with the program, especially the people I worked with. Dr. Bruce Spivey, an ophthalmologist at Pacific Presbyterian, who later became administrator of the hospital, advised us to have as part of the students' experience a chance for them to come together at regular intervals to discuss their experiences. "In a hospital setting, they'll be seeing some things that are hard to take," he said, "and they need the opportunity to talk about them." As a result of his advice, I asked William Harliss, a Ph.D. educator, to lead periodic sessions those first years, a valuable addition which is still part of the program.

Several years later, and with the infusion of funds and energy

from the Junior League, we were able to expand the program to encompass careers in many fields beyond medicine. I take great satisfaction in knowing that the program still continues some twenty-five years later.

In the mid 1980's, I headed an adult literacy program for the San Francisco Public Library, this time a paid job. I had started working as a volunteer on a literacy needs assessment project for the Friends of the Library, but when the grant proposal I wrote resulted in the largest of twenty-six Federal grants awarded in California, I decided to apply for the job as director and was hired. Though my salary was gratifyingly more than it had been in my research days in the lab, I wasn't in it "for the money," this time either. Without compensation, however, my position would not have been credible in the eyes of the library staff, or the other literacy program directors throughout the state. I stayed with the program for five years, then, when John retired and moved up to the ranch, I dropped back to part time, a truly bad idea. I wish now that I had dropped everything and gone with him, but instead, because I truly loved what I was doing, I tried to compromise. I soon found I was working more than half-time, and wasn't having any fun at all now that I wasn't running the whole show.

When I did retire, the library hired an extremely competent woman, Ana Linder, who was even better than I was at extracting money from the Feds and the city government. What my co-workers and I had begun, she continued until the program, just barely tolerated by some of the librarians in its fledgling stage, is now an integral part of the library—and its budget.

So, this patchwork quilt of a career I've had, this potpourri of work I've done, though different from the way my grandfather thought of "the work of the world," has given me some of its rewards: engagement in the world beyond my little coterie of friends and family; hard challenges that stretched my mind; at times, a pleasant sense of accomplishment; always, enjoyment in the doing. How entertaining it all has been. What a splendid ride I've had.

MARGARET GAULT

# Tough Love

IN 1982, I made a mid-life career change from high school teaching. Because my mother had suffered a paralyzing stroke, I had taken over management of her financial affairs and had enjoyed the activity. Then, too, I had been an investor since college when my grandmother gave me a little stock as a graduation present. During the time I dealt with my mother's affairs, I found that more and more people asked me for advice, guidance, and help with implementing their own financial responsibilities. It was clear that many people were unprepared to make their own decisions about money. I knew they were at risk of fraud and trickery due to ignorance. As I tossed off opinions on "Should it be stocks or bonds?", "Should the estate be a trust or go through probate?", I realized these were weighty issues, not frivolous opinions, and I began to charge for my time and to consider myself in business.

When I heard that a new profession had been created, financial planning, I knew what a need this service would fill. I went into business for myself, opening an office in my house (formerly the au pair's room). Through correspondence courses and examinations I became a Certified Financial Planner, a brand new profession then,

ubiquitous and essential to everyone now. In time, I added service as a Registered Investment Advisor, or investment manager, to my business.

In the beginning, I charged an hourly fee for meeting with clients in my office and doing research and analysis necessary to meet their needs. To my great surprise, the business was successful from the start, and I soon had as many clients as I could handle. To keep it within bounds (because I did not want to have a staff and rent office space downtown), when things got hectic I raised my hourly fee. In time, the fee went up from $35 an hour to $250 an hour. If I still worked on an hourly basis instead of charging a percent of assets, today my fee would be $350 an hour. I chose a profession to sustain me in my old age which is today recognized as the most successful profession, better than doctor, lawyer, or accountant. When I say "sustain me," I do not mean financial support although I enjoy making money. My husband has always supported me and I have family inheritance to fall back on. "Sustain" means giving me entertainment, mental challenge, and the self-confidence that comes from having people willing to pay for what I have to give.

Everything about the work has been interesting and gratifying except two things. First, I had to figure out how to organize the office and business. Since I was a pioneer in the financial planning field, there were no models to follow and I made and continue to make inefficient mistakes while learning from experience. Second, I was baffled by the intimate relationship which the discussion of money created between my clients and me. I did not expect this intimacy nor the opportunity I was offered for counseling by my clients' neediness. Talking about the realities of one's financial situation appeared to be an emotionally fraught experience, particularly for women, who totaled more than half my clients. I began to see the damage to women resulting from the social taboos related to talking about money. I have tried to point out the senseless suffering this taboo imposes but no one believes my crusade is important. I have asked friends, who I knew had serious money problems, if I could share their names with others in the same situation, others whom

they knew and trusted, hoping they would form groups for discussion and shared experience. No one has ever been willing even to have her name given. Instead of coming to my office and paying me thousands of dollars, people could learn and benefit just as much or more by getting together with one or two good friends and laying out their financial circumstances and concerns openly and completely. They could teach each other. Why don't they do this? The teachings of childhood and what "nice people do" are powerful, more powerful than my crusades.

I could fill a book with what I have learned in my financial career, the "Daddy's little girl" syndrome, the "Buying stuff as an addiction" syndrome, the "Gift Giver" syndrome, the "Aging Gigolo" syndrome among many, many others. Daddy's little girl refers to the way so many woman have been brought up. "Somebody is always going to take care of Daddy's little girl." The woman finds herself widowed at age 50 with children in college, credit card debt, a mortgage, no work experience of any kind, and no one to take care of Daddy's little girl. I always refer these women to *Prince Charming Isn't Coming*, a good book by Barbara Stanny.

Buying stuff as an addiction often replaces an addiction to alcohol or drugs but not always. Some people express themselves through what they buy. That's fine if there is money to pay the bills but the seven or eight maxed-out credit cards with their accompanying huge interest debt push an individual sometimes to the breaking point.

The Gift-Giver is related to the Spending Addict. Some people feel that it's okay to buy what they want whether they can afford it or not if they buy something for someone else at the same time. I see people who cannot even afford an IRA as a savings vehicle buying insanely extravagant gifts for people.

The Aging Gigolo is a man who has depended during his adult life on women who have enough money to support his life style. This usually begins with marriage to a well-off woman. The wife dies or divorces him, and the man, usually well-educated, sophisticated, is stuck without means of support for the life he considers his

due, the clubs, the cars, the trips. I see these men when they are try-ing to hang on until the next lady shows up. But these men are aging and the lady who will find them attractive is in a wheelchair or oth-erwise in desperate need of assistance as a trade-off. The "Aging Gigolo" isn't interested.

The money aspects of divorce have illuminated my understand-ing of men's and women's relations at this desperately traumatic time in a person's life. To illustrate what I mean, here is a fictional couple, Jane and Joe:

Margaret (opening the door at her office entrance): "Come in, Jane, I am so glad we could get together quickly as you seemed to have an urgent concern when you called for an appointment. I hope my ser-vices are what you are looking for."

Jane enters, an attractive, rather matronly youngish woman in casual but neat sports clothes. She sits down in the chair opposite the desk and bursts into tears.

I continue, "Here is some Kleenex and I am going to bring you a glass of water. If you feel like crying, that's what you should do and then we can talk."

"I am so sorry. What a stupid thing to do! How can I be so silly? I wanted to come to see you because my husband wants a divorce, and the lawyer thinks I should talk to a financial planner before the marital settlement agreement is signed."

"You say the lawyer. Is this your husband's lawyer or your lawyer?"

"Both. My husband thinks that to save money we should use the same lawyer."

"Are you paying the lawyer or is your husband?"

"Oh, my husband, of course. I have no money except the allow-ance he gives me."

"What services does the lawyer want you to get from a financial planner?"

"I have to make a list of all my expenses for the past year so that we can estimate how much child support and spousal support I should ask for. But I want you to know that I hate all this talk about

money, I hate having to figure out what to ask for, and I want this divorce to go smoothly and quickly so that my husband and I can always be friends after it is over."

"Would you mind telling me why your husband wants to divorce you?"

"No, I don't mind telling you. He is a doctor and he has fallen in love with a patient and wants to marry her. She has never been married and is twenty years younger than I am." Jane stares blankly at my face during this revelation, speaking of a situation she still cannot believe is real.

"Tell me a little about your life and your history. It will make my job easier if I feel I know you better."

"I grew up in the East and came to California to Mills College. I met my husband when he was a senior in pre-med at Berkeley. I fell in love with him and left college after sophomore year to get married when he graduated. I worked as a file clerk to put him through medical school. We waited until he had finished his internship and residency to have children. He always said he wanted to be established in his medical practice before he became a father, and that's what happened. So we have been married twenty-two years but our children are twelve and ten."

"Have you any idea how much money you will need when you live as a single woman bringing up two children? Don't forget that you will be paying taxes, expenses of travel and entertainment, children's activities and also their schooling perhaps, expenses that your husband may pay now."

"Now I pay for food, household sundries, the cleaning woman, small repairs, and my own expenses like haircuts. I don't know how much our taxes are and what the credit card bills are."

"The lawyer may have thought you should come to see me to explain these things so that I can figure out for you what a reasonable budget will be for your new life. Please tell the lawyer to have your latest income tax return and copies of credit card bills for two years sent over to me."

"My husband won't like that."

"Why not?"

"He has always said I shouldn't worry about our income taxes and has me sign the income tax return before anything is filled out."

"You sign a blank income tax return? I think that is probably illegal and certainly it is unethical. You are just as responsible for what is on that form as he is. This year, do not sign it until it is complete and you have read it before signing. Anyway, you tell the lawyer directly what I want to see. From now on, do not talk to your husband at all about anything to do with the divorce. If he begins to talk to you about it, tell him to talk to the lawyer and you will get the information that way. There is no reason for you to explain or defend anything to your husband ever again. What about your house? Will it have to be sold?"

"My husband wants me to keep the house because it will give the children a sense of security not to change where they live. In return, he will keep his retirement plan for himself. He says that's fair because when I am sixty-two or sixty-six, I will get Social Security."

"He will get Social Security too, a lot more than what you will get! Do you estimate that the house and the retirement plan have the same value?"

"The house would sell for about $600,000, my friends think, and we have a $200,000 mortgage. The retirement plan is $400,000."

"Have you thought that if you sold the house, you would have to pay tax on the profit if the profit is more than $250,000? If you paid $250,000 for the house when you bought it, and you wanted to sell it soon as a single woman, you would pay about $40,000 in taxes. If that were the case, your husband would end up with $400,000 in the retirement plan appreciating tax free until he retires many years from now and you would end up with $360,000 from the sale of the house. It isn't fair to divide things that way unless you figure out what is called the tax liability. And, believe me, lawyers and judges do not understand these concepts.

"I can see your eyes beginning to glaze over. Shall we end our meeting for today and schedule another one after I have done my work with the tax return and the credit card bills?"

"I thought we could do all the work and make all the decisions in one meeting today."

"In my opinion, that would not be wise even though I know you hate this kind of discussion and don't want to prolong it. What we are talking about is a plan which may affect the whole rest of your life financially, the difference between being comfortable and being poor. We need to get all the facts, you need to forget your aversion to these matters and begin to understand them since you will be taking care of the finances for yourself and your children. This is a legal issue, you vs. your husband, whether you like it or not. He has brought upon you and your family one of life's truly enormous changes and he has a responsibility to leave you in financial health. He will not do that unless you are forceful and positive, no matter how much you hate being that way."

"I want to get this settled quickly without any anger or resentment on my husband's side."

"In a divorce, the person who wants to settle quickly is the one who is likely to give up money or rights which turn out afterward to make all the difference. Then you have to go to court to change things, and most people do not want to do that because of the rancor and the expense. Get it right the first time no matter how long it takes. Let your husband be the one who is in a hurry. You may be surprised at his attitude toward you if he sees a Jane he has never known before, a Jane who knows what she wants and doesn't back down. I know you want to go now and you should. Just give the lawyer my message, please, and I will call you when I have finished my analysis of what support you will need."

Jane gathers up her purse and shopping bag filled with new file folders.

"All right, I will wait to hear from you and I will tell the lawyer what you want to see. Goodbye."

As she walks through the doorway, Jane looks back at me with a disappointed smile, good manners but a suspicion that working with me will mean more difficulties, not less, more hard work and heartbreak, not less.

*  *  *

Next day the telephone rings.

"Hello"

"Hello, is this Margaret Gault's office? This is Dr. Joe, Jane's husband speaking."

"Yes, this is Margaret, how do you do, Joe?"

"I heard through our lawyer that you asked to see our tax return and our credit card bills."

"That's right, I need them to estimate an equitable amount of child support and spousal support for the Marital Settlement Agreement."

"Well, I am calling to tell you that won't be necessary because I am planning to take good care of Jane after the divorce. She will not suffer financially in any way. I want to make almost the entire support payment spousal support because I can deduct that so it won't cost me so much, and she can pay the taxes. It will be a generous payment, don't you worry, Margaret, and the payments will continue for eight years until our youngest is college age. Naturally, I will help out with college when that time comes. I feel sure that during that eight years Jane will have found the right person and have re-married. She is an attractive lady and there are zillions of guys out there who will get on the phone as soon as they hear she is free."

"Joe, I must tell you that if Jane has come to me at your lawyer's advice, it would be a conflict of interest for me to talk to you about these matters. She is my client and I will deal with her and with your lawyer. Please tell your lawyer to communicate with me if the lawyer thinks what you have to say is pertinent to my work."

"Well, to save time and money, I thought talking directly to you was the better way, but I can see that you are not going to cooper-ate."

"I have to cooperate with my client first, but thank you for call-ing. Let me know through the lawyer anything you feel is impor-tant. Goodbye."

In a few days, the tax returns and the credit card statements ar-rive by special messenger. I devote several hours to figuring out a

clear picture of the family's living expenses, which imply the level of their standard of living. The marital settlement agreement between Jane and Joe should ensure continuity for Jane's and the children's standard of living. I schedule a return meeting with Jane when my conclusions are in a written form the lawyer can use but also which I hope Jane will understand and agree with. Jane has a copy to read before our meeting. She returns to my office but her attitude is unchanged: the figures I calculate are way too high. Joe will not like them and the conclusions will anger him. She will tell him directly in a phone call that she is willing to settle for considerably less. I plead with her to at least communicate through the lawyer but it seems she wants as many excuses as possible to connect directly with him. I know she does not even understand my scenario starring "the new Jane" and she does not want to be a new Jane. She wants to stay the same person as always and she wants her life to stay the same too.

How did the story end? The couple divorced, the family broke up, and Joe undoubtedly started a new family with his young wife. In time Jane sold her house and moved to a smaller one in a less desirable neighborhood, using the money gained from the sale for the children's schools and activities. It was impractical and unprofitable for her to work in the unskilled jobs she qualified for.

Fortunately, my clients and I have usually been in agreement as to financial objectives and how to implement them. It is a great pleasure to work at a career where one's plans and forecasts become reality as the years roll by. Twenty years ago I began with some clients to plan for their children's college educations, a comfortable retirement, and a smooth transfer of property at death. Some of those plans are complete now and I am working with the children of those early clients. The personal relationships that build in two decades and the satisfaction when things work out as prophesied make my midlife career change a decision I have never regretted.

ROSEMARY PATTON

# A Gift

I

THE YEAR I STARTED graduate school in the English Department at San Francisco State, acquaintances sprang to one conclusion. Gray and Rosemary's marriage must be in trouble. In 1974, when a conventional doctor's wife with two teenagers and a ten-year-old turned back to the college campus, there had to be a reason. The restless wife syndrome was the most obvious. The truth lay elsewhere, as the years were to reveal.

Friends who had already returned to the college classroom were urging me to give scholarship a try. One extolled the rewards of teaching. Another brought me a course catalogue from State, telling me how enriched her life had become, how intellectually stimulated she felt.

"I'll think about it," I said, not sure I was ready to give up what was a terrific life for unknown territory. My "work" as a volunteer docent in the Asian Art Museum alone was enriching and challenging.

Since arriving in San Francisco thirteen years before, I had engaged in hours of volunteer work: positions of responsibility in the

girls' schools and on museum boards; community service in hospitals and the Edgewood Children's Home; extensive study before leading museum tours. I'd taken a couple of classes at UC Extension. But these hours had always been set around our daughters' schedules, subordinate to their needs. For women who finished college in the 1950s, this was the norm. Only a very few sought professional lives. I thought my career began and ended with the two years I worked, first in public relations at Blue Cross, then in admissions at Duke, while Gray was a resident in pediatrics.

But perhaps I was dimly aware that the path had already been cleared for me. I'd seen my mother start an interesting work life when she was widowed in her mid-forties, still raising my much younger brother and sister. Her mother had to start running a small family inn with my grandfather during the depression 1930s. All three of my sisters were by this time pursuing careers, juggling marriage and children. I couldn't consider myself a pioneer.

With college approaching for Mary, our oldest daughter, and her two sisters following behind, I began to see the value of a second wage-earner in the family. When I graduated as an English major from Duke University in the 1950s I scorned the credential program. I chose my literature pure in those young and innocent days. I pored over Milton, Shakespeare, Donne, Austen, T. S. Eliot. Perhaps when I really grew up and had the time, I'd become a writer. Teaching seemed a dull alternative. But recently I had been inspired by Professor J. J. Wilson from Sonoma State, who led a book group I belonged to. Conducting adults and children through the cultures of China, Japan, India, and Southeast Asia at the Asian Art Museum and running their in-school program was also showing me that "teaching" was heady stuff. The signals were coming from many directions. Suddenly I was ready to enroll in the credential program.

"Gray, how are you surviving with Rosemary back in the classroom?" More than one friend offered Gray deep sympathy for the loss of a wife in the fall, 1974, when I entered San Francisco State.

Gray would smile. "I'm enjoying my new life," he'd answer. He was recognizing that my schedule was, for him, a gift of time and

tranquility. For years he came home dead tired from twelve hours at his pediatric practice, often having been up the night before. Far too frequently he found me ready for dinner out with friends, Wednesday nights at the Opera, our regular theatre gatherings for the American Conservatory Theatre, a movie, or the table set for dinner guests at our house.

Often I had the calendar out, question ready. "Could you talk to John and see if he could swap call next Saturday for Sunday, Wednesday for Tuesday?" The complications of that frequent call schedule bedeviled our lives. But it didn't seem quite so pressing once I had my own life filled with responsibilities outside our home. Not until I started graduate school and then an actual work routine did I discover how jubilant he would be to have his evening social life cut in half. I soon found that I couldn't keep up the former pace when I had homework and early classes, first as a student, later when I began teaching. So, as the household social secretary, I altered the rhythm of our lives. Our marriage was far from suffering.

Did my new commitments diminish Sarah and Suky's lives after I went into the world? I continued to juggle car pools, attend school events, and maintain an interest in their friends and homework. In the early years I tried to be at home when Suky arrived from school, although I remember a semester when Sarah was in charge of two dinners each week. I don't think she loved that responsibility. I no longer spent much time volunteering at their schools, writing minutes for parent board meetings, gathering goods for fund-raising events. When I asked them recently whether my new career created problems for them, they both surprised me with how little they felt the change. Sarah said her only memory of complaining about my absence came earlier when I would go off to my volunteer hours at the Museum. As a teenager, she enjoyed time with less of a mother's supervision. Suky remembers the pleasure of talking to me about my experiences in "school," a subject she was deeply interested in too. Both confessed that the only profound memories of my professional life were of the times I suffered disappointments—when my student evaluations from student teaching were not as strong as I hoped, and

when I felt I hadn't done as well as I should have on my MA orals. I was touched that my happiness seemed a significant factor. Perhaps the change was gradual, first graduate school, then only part-time work as a start. But I don't know how to measure the value of a mother's full attention to her children once their obvious needs are met. Mary was in college and then medical school, unperturbed by the shifting landscape at home. I do know that, unlike many mothers today, I was never super-woman. I'm sure Suky was sent to school with various maladies. I rarely watched her athletic events. Although Gray was an attentive father, his life was so stretched with his practice that it would never have occurred to us that he might fill some of the parental gaps.

After I completed my student teaching, I had to concede that for me a full-time high school position was not a good choice. The relentless pace of five classes five days a week would, I knew, rob me of all creative energy and leave me lifeless at the end of the day. How fortunate I was that Gray's career allowed me choices. I went on to earn an MA in English and a certificate in teaching college composition under a graduate program inaugurated by an innovative, demanding professor, William Robinson. It was that certificate that permitted me to teach at the university level without going on for a PhD. I was forty-two, pretty sure that I wouldn't be accepted at Berkeley or Stanford, the universities within reach that offered doctorates in English. When and if I finished, who would hire me? The job market for university professors had suddenly taken a nose-dive with a dip in the college-age population. John Edwards, at the conclusion of a graduate seminar in 1976, warned his students, "Don't expect to land a job teaching English literature in a university until the 1990s." And anyway, wasn't the major purpose of this enterprise to put me to work now, not to see me tied up with more heady years of graduate study?

## II

My first position at SFSU, earned after a grueling hiring process, was part-time, but teaching in William Robinson's composition

program turned out to be an all-consuming occupation. Our students were the center of the curriculum, their papers never ending. Bill was himself a charismatic teacher and mentor who inspired those of us who stuck with this brand of rigor. It was he who had created a fresh approach to teaching writing and the exacting courses that led to the certificate. He had been influenced by what was termed a process-oriented rather than a prescriptive, rule-bound approach to writing. He had also devised a grammar based more on rhetoric and usage than on nit-picking details. The sentence was a vehicle for developing ideas, not just for correction. Writing and actually using language took primacy over memorizing grammar rules; generating ideas on paper came before refining the prose. His methods, both liberating and empowering, fed my love of language and opened my eyes to creative ways of encouraging the writing skills of inexperienced students. His approach took me far away from the "correct" form through grammatical drills that had characterized my own education. The social revolutions of the 1960s had brought new attitudes and new populations into universities. It was obvious that traditional models wouldn't fit the requirements of this diverse student body. I was thrilled to have the chance to put my new-found wisdom into practice.

When, in 1978, I stepped into my first classroom, I quickly found that nothing had prepared me for the excitement, the gratification of the rooms filled with as various a group of students as one could find anywhere on the globe. A lesson in political geography lay ahead as I met not only diverse Americans, but students from China, Japan, Burma, Vietnam, India, Afghanistan, Nigeria, Mexico, El Salvador, the Soviet Union, many countries in Western Europe. One semester, my official roll printout included In-the-Woods, Bryce, a quiet-spoken Sioux who came silently to class on bare feet.

Despite the charmless utilitarian architecture of San Francisco State and the fog that chilled its southwestern corner of the city, the bustling campus radiated energy. It was far from the towering gothic and Georgian style of Duke, but it was surprisingly verdant—a compressed urban setting with modest stretches of grassy lawn, a few

stands of tall pines, and occasional flashes of bright flower beds. I found the odd jumble of classrooms, the striking age range, and the rich ethnic mix of the students exhilarating. At 8 A.M. on my first day, I entered a room in the semi-basement of the humanities building and found thirty students, mostly African Americans, a few Asians and Latinos among them, silently waiting for me. All had entered San Francisco State under the Equal Opportunity Program and were preparing to play catch-up in this required writing class. I found out how it feels to be in a distinct minority.

One young African American woman, always present, always prepared, destined to be one of the successes in this group of marginal achievers, disappeared from class for more than a week. I phoned her.

"I'll be back in a few days," she said. "My grandmother died with Reverend Jones in Guiana and we've been grieving." When she returned, she thanked me and told me that no teacher had ever called her before. She said she had been too ashamed to return after so long an absence. At the end of the semester she gave me a hand-crocheted yarn doll, made by the grandmother she had lost.

I remember the sleepy face of a Japanese-American boy (he was in college, but he wasn't yet a man) trying to stay awake. He worked nights in a Japantown grocery. One morning, I watched helplessly as he slowly slid from his aisle seat onto the floor with as much of a thud as his slender body could make. I began to see just how precarious the lives of these young people were, how different from the relative privilege of those with whom I'd gone to college in the 1950s. Many of us worked then, but never at late night jobs. Many of us lost family members, but not in remote jungles following cult gurus.

I wish I could say that my early students turned miraculous corners in their use of the English language. A few, in fact, did. For the most part, however, more learning came my way than theirs. Still, I never lost the sense of making a difference, albeit small, in the education of many Bay Area students. Some of the them spoke English as a second language—Asians and Latinos for the most part. A few

used Black English with a grammar all its own. Most had left high school woefully unprepared for even the most elementary demands of college. But the vast majority were courteous, eager to learn. I acquired the art of listening to them, of putting them as individuals first, my carefully honed curriculum second. I discovered that teaching was far from the potentially repetitious and boring exercise I'd imagined. The papers the students wrote also gave me a privileged window into their lives, their special worlds, and how they thought about their lives, many so different from my own.

To my surprise, I discovered that teaching contains an erotic element—part acting, part projecting oneself, part caressing the space between teacher and student. An engaged teacher sits or stands or strides before her class, working that space. If she's successful, she seduces their minds, capturing their attention, their interest. Learning takes place in a dynamic atmosphere.

One day two lively young African American women arrived for a conference in my office. Laughing, one said, "Law, Miz. Patton, your hair is just like ours. Why don't you let us do it in corn rows?" I declined their offer although they were right about my curly hair. I knew how ridiculous I'd look.

One young man, tall and Black, stood up in a remedial writing class and asked permission to make an announcement.

"I've learned from the Educational Opportunity office that only nine percent of those of us admitted under their program [most of whom were minorities] are expected to graduate." He looked forlorn. The class was silent. I was caught without words for once. But just before he graduated, he came to tell me that he'd made it, that he was working at the *Oakland Tribune*, that his future looked bright.

Glenn, also African American, started our freshman writing sequence with the lowest score possible on the placement test. He sat, day after day, through three semesters, struggling with the written word, determined to improve. After one test, he looked at his work, then up at me, and said for all to hear, "I should have knowed that." And eventually, he did know it. Four years later I saw him walking across campus, dressed in a business suit, carrying a briefcase. He was

about to graduate. He told me he had a job at Bank of America, that he was married and had a little daughter named for him, Glennisha.

A shy young man from Vietnam, puzzled after hearing a student read Gwendolyn Brooks' poem, "We Real Cool," came, head down, to my desk at the end of class. "What is this cool?" he asked sheepishly. I turned to some of the departing students. "Could one of you help Ahn with a definition of cool?" Several of them simply shrugged, suggesting the meaning even as they were unable to find the words.

In a sophomore writing and literature class, I decided to assign *Hamlet* in preparation for a performance of the play on campus. I was so familiar with the play that I had quite forgotten how difficult it could be on a first reading. Was it a huge mistake to offer such a challenge, I wondered? We worked on dramatic readings, discussed pivotal scenes in small groups. I suggested various movies to help them master the plot. They wrote their papers with varying levels of success—or, in some cases, failure. They enjoyed the performance. The last day of the semester, two very young Chinese-American women came to my desk.

"We want to thank you for introducing us to Shakespeare," one of them said. "In our high school no one thought we were capable of understanding his plays."

Not all were success stories. Roni, an intense young Guatemalan with a face like a Mayan sculpture, worked hard in class, but his fierce political agenda offended some of his subsequent teachers and classmates. He liked to sit in my office, explaining why learning English wasn't always the top priority for Spanish-speaking students, discussing the plight of his once-educated family, decrying the discrimination he felt all around him, and bemoaning his German last name. Hoping to win me to his culture, he brought me copies of *Low Rider* magazine.

"Our troubles stem from U.S. political actions in Latin America," he said. "We don't all want to live here and adopt the Anglo culture. It has been forced upon us. Don't forget that Spanish was spoken in California long before English took over."

One week he vanished. When he returned, he explained that he had been away at a parole hearing. He'd spent time in jail for drugs, but now a husband and father, he was hoping to reform. I ran into him a year or so later, high and stony-eyed. An instructor in Ethnic Studies, who had befriended him, told me that Roni has been having trouble "realizing his dream." I understood what he implied and feared for Roni's future. I never saw him again.

My most frustrating experience came several years later. Chauncey, somewhere in his forties I would guess, turned up in a course in grammar and rhetoric required for the same composition certificate I'd earned a decade earlier. An eager returnee to the class-room, he'd been living in Africa as a white Christian missionary. He was a curiously wizened little man, full of fervor. The class was no-toriously difficult, but he was self-assured about it—until the first test. He failed woefully, as he was to do throughout the semester. No amount of tutoring helped on the second attempts. His papers were impenetrable and no rewrites improved them, mainly, I came to think, because they'd all been copied from a number of sources in bits and pieces. But Chauncey would not accept failure. He began leaving single, long-stemmed roses on my desk before each test or with each paper. Toward the end of the semester, he found my phone number and began calling me late in the evening, insisting that he had to have an A in the course. No amount of explanation could placate him. He went to the chair of the department, he went to the Dean of Humanities. He received a well-deserved F. By the end of the semester I had no regrets. I just wanted him out of my life.

A few weeks later I had calls from the department chair and the dean asking me to change his grade to a "credit." I said that it was impossible and that I'd be happy to present my justifications—easy in his case. Although both were my friends, they persisted. Eventu-ally, I was forced to capitulate. I demanded that at least they promise that Chauncey would never be able to sign up for any of my classes again. Blessedly, he never returned. When I asked what dire threat he hurled to make these usually sane administrators bow to his

demands, they remained vague. Were they protecting the university, or possibly me, from violence?

### III

Although San Francisco State welcomes many poorly prepared or exceptionally odd students, they are not the majority. Class after class introduced me to hundreds of delightful, smart, responsive young men and women. Quite a few were my age or older. And to my delight, Gray shared the pleasures—and the difficulties—of my evolving career.

In time, I came to teach advanced composition and then graduate courses like those I had once taken to prepare for my certificate. Here, I encountered true brilliance. I wish I had kept a roster of exceptional minds and extraordinary writers it was my privilege to know. Adam's convoluted style reflected his remarkably complex thought process and challenged me to read student work in a whole new way. When he earned his PhD at Harvard and wrote about ethics and literature he found minds equal to his own.

Kevin's revolutionary ideas toughened him to poverty. He rarely had an apartment, usually living in his little van. But his exceptionally perceptive, thoughtful papers quickly caught my attention. As a graduate student, he was adding the composition certificate to his literature MA, as I had done some years earlier. He was an original. His papers were stained with coffee, his rangy blond self often disheveled, but his work always stellar, his sense of humor wise and witty. It was refreshing to experience a truly radical mind in so articulate, engaging a person.

Before I moved up to teaching graduate writing classes, I had the good fortune to help design a class in argumentation and logic that fulfilled the new critical thinking requirement on the State University campuses. Although critical thinking was originally the territory of the Philosophy Department, interdisciplinary courses were also approved. Sheila Cooper, a friend and colleague from Berkeley, and I created our class, Writing Logically, for the English Department. It was a rocky road. The chair of Philosophy objected on the

grounds that we were not qualified to teach such a curriculum. He called us into his office for a chastening rebuke. With our mentor Bill Robinson defending our position, we were permitted to proceed, although Sheila and I had to agree that we were, in fact, unqualified.

I launched the class in the early eighties; the next semester Sheila and I were both teaching a section. It was soon a sell-out course. We worked overtime to prove ourselves. We attended summer conferences. No newspaper or magazine at home was safe from my scissors as I searched out controversial arguments. I remember one student, Laine, jumping up and down and cheering when her name was drawn from the wait list. She set the bar high for me that semester. Writing Logically was the one course for which we frequently received administrative accolades when students repeatedly referred to its value.

Sheila and I had enormous fun. The course attracted some of the best students on campus, challenged us to our limits, and led to the book we would ultimately publish ten years later, *Writing Logically, Thinking Critically*. We refined and re-refined our materials. Best of all, Sheila and I became the closest of friends, spending days together working on the course, then on what grew into multiple editions of our book. In celebration of our book's success, modest I must admit, Sheila and I took our husbands to Hawaii for a week in 1998.

## IV

Along the way I had also come of age, so to speak. It was a time when women all over the country were taking charge of their lives—the seventies and eighties, post Vietnam, a period of ongoing social change. What luck I felt to have caught those waves. The women's movement was in full flower. Women's Studies programs were springing up on campuses. San Francisco State was in the vanguard. My eyes and ears were filled with new ways of looking at how girls and women had been viewed and treated, even though I had been fortunate growing up in a family filled with strong, independent women.

It was a thrill to find myself mentoring so many bright young women in the classroom, serving as a model, so some said, for their own professional roles. Many, like me, were returning to school. I learned how difficult some of their lives had been, what luck it was that now, at last, women had choices. Without the widening ripple of the woman's movement, would I have ventured out myself?

When I began my career, I was using a typewriter, the whiteout bottle, and purple dittos. Gradually we switched to computers. The Internet crept into student research. The tech age blossomed alongside me. I had gradually increased my course load until by 1986 I was full-time, a punishing schedule in the Humanities at our State Universities, particularly since student papers were central to most of the classes I taught. I began to assume more administrative positions. No doubt the years spent running volunteer projects helped prepare me for this new phase.

I assumed the chair of the graduation writing test, the much dreaded JEPET. It was this job that led to my only life-threatening experiences. One memorable young man, his accent slightly foreign, his nationality gone from my memory, had failed the exam (miserably, as I recall) and thus couldn't graduate a few weeks later. He sat in my office around 7 P.M. and raged at me.

"You've ruined my life. I must turn down a job waiting for me in Belgium. I will be out on the street with my wife and child. You'll pay for this." I was terrified. As I might have expected, there were many such harangues. My knowledge of human nature in all its variables broadened. My skin slowly grew thicker.

But there were unexpected perks to compensate. Gray and I could be sitting in a restaurant and find a drink from the bar or a bottle of wine appear at our table. Waiters at Zuni, Stars, and other Bay Area establishments could find us a table when all seemed hopeless. Clare, her dark Irish face inscrutable in class, was generous when she worked for the Landmark theatres and then at Peet's Coffee. I had been used to adoring greetings and gifts from Gray's patients. I was surprised to find that for a few years I too had a following. When I retired, it was hard to give up that extra, just as it was

sad to leave the appreciation only students can bestow. No matter
how devoted, a family tends to assume a mother's strengths, a wife's
affection.

My last two years I administered the vast composition program
within the English Department and taught only two classes. I was
alternately pleased with the successful arc of my career and exhaust-
ed by its demands. When state budget short-falls bedeviled our ef-
forts to run the program smoothly and a sweetened retirement offer
came my way I decided quite precipitously to start another life in
San Francisco.

## V

While I'd been gone I had become a different person and I am
grateful. Teaching at San Francisco State changed my life, opened
me to worlds I'd scarcely imagined, expanded my mind beyond what
I'd thought possible when I'd taken the first steps toward a teaching
career in 1974. It brought me a rich assortment of friends among
both colleagues and students. In addition to much-appreciated in-
come in our expensive city, it provided a modest pension and liberal
health insurance for Gray and me. "A paycheck of her own" had
been a tenet of the women's movement, and I found that it does
matter.

As my friends had promised, it was indeed rewarding to enjoy a
profession, to learn how to read more profoundly and think more
critically about the world, to feel the meaning of "diversity," to con-
tribute some small measure of myself to others, and to enjoy an ex-
panded sense of self-worth. That Gray shared in these rewards was
an added dividend. My career proved an extraordinary gift.

SUSAN RENFREW

# Daily Accounts

*I wrote the following piece based on conversations with my daughter, who is a teacher in Hunter's Point in San Francisco. All the incidents are true but I've arranged them as if she'd written a journal during the spring of 1999.*

3/23/99 Today the San Francisco school district celebrated the changing of our school's name from Sir Francis Drake to Malcolm X Academy with a special ceremony. After many parent/teacher meetings it was decided that most parents thought Sir Francis Drake was not an appropriate name for a grammar school in Hunter's Point. They said he was involved in the slave trade. Malcolm X's daughter spoke at the event. She said how pleased she was to see children from so many different ethnic groups together. She said, "This was my father's dream." It's true. Ever since busing began, there have been Cambodian and Laotian kids from the Tenderloin here in addition to the majority of African American children.

3/24/99 I was thinking about the diversity at school today. We have some Samoans, a few Hispanics and one white boy plus all the Asian children who are bused in. The problem with this seems to be that the Asian children are in *English as a Second Language* classrooms so they aren't mixing with the other children. Only a few speak English well enough to be in regular classes. I do have my dear shy Tai. What would I do without him—his wise, quiet words; his sensitive drawings of Cambodia.

163

I think having a new name for our school and optional uniforms is a good idea. Now parents who choose can ask for a school uniform. Most look well in maroon plaid skirts or dark pants with white shirts and maroon sweaters. It does give parents who can't afford new school clothes all the time an option. I wish we had a washing machine here though. I'd pop in Delmar's dirty old shirt during recess. He is embarrassed to take off his jacket because his shirt isn't clean.

3/25/99 Malcolm X's daughter would be pleased to know that every few months different cultures give a performance in the auditorium. I was so proud of the children at the one given by the Cambodian families. The Asian children joined by two of my most energetic little African American boys practiced their elaborate dances with those graceful hand movements for weeks. Men from the Buddhist temple came to play huge brass drums. At another event, a group of fifth graders in green, red, white and black did African dances to celebrate Kwanzaa. Some of the girls look like mature women already. Families brought their native food from all the different countries for a potluck supper.

When events like this happen, I feel encouraged that people will begin to understand each other and value the different cultures. This is what keeps me teaching second grade after ten years at the same school.

4/1/99 Last night Mom went to a dinner party where the guests started talking about schools in Hunter's Point. Most of the people at the table had an opinion and most were critical. "Why waste money on those people." "Where's their initiative?" "They don't even help each other." "The first thing they do when they get money is leave the community." "Oh, their money comes from drug dealing." One man spoke on the positive side as if he were an authority, and though Mom was proud of him for speaking up, she realized that what he was saying was exactly what she had told his wife weeks before. The hostess finally said, "Well, Sue's daughter teaches

there. Maybe she can give us some insight." They never missed a beat. Kept right on talking. Mom was so discouraged.

So many say when they find out where I work, "How good of you." But what they are really thinking is "She can't get a job anywhere else." To them these are "throw away" kids. Hopeless. "Look at their test scores." And these people have no idea what their lives are like. For instance, just yesterday there was a loud bang and all my children hit the floor. We are right in the midst of Big Block and West Mob territory where there have been forty murders in the last two years. Almost all were teenage boys. These affluent people can't understand why these children might have other things on their minds than bubbling in answers on score sheets. In fact, I feel sorry for them when they take tests. They are so afraid some scrunch up in a ball and cry. If they aren't absolutely sure their answer is right, I can't get them to take a chance. I tell them to make a stab at an answer because they aren't penalized for incorrect answers and they might even get the right one, but they are afraid to risk. After all, they are so young. Some have trouble finding the correct row to bubble in their black mark. Many feel like failures by the time they are seven. *Death at an Early Age* warned about this twenty-five years ago. Yet the same problem continues.

4/5/99 I'm tired. I just want to climb in the tub with very hot water and read. I had to carry Ely to the office three times. Each time I tried to teach a lesson he'd jab the girl near him with his pencil or mimic everything I said. I know he's upset because his mother is in jail and his grandmother has more children than she can cope with, but why should he spoil it for all the other kids? When I asked him to behave, he lay on the floor by the hot air register and wouldn't move. I had to drag him down the hall to the office. When I left, the other children started running around the room. It took so much effort to get them settled down.

Yesterday, in desperation, I said when no one seemed to be listening, "Have you ever heard the expression 'the lights are on, but nobody is home'?" I was trying to explain how the part of the plant

that makes the seeds is the flower. It seemed as if I had finally gotten through to them and asked, "Dominic, where are the seeds made?" His answer: "Sorry, Ms. Ingham, nobody is home."

4/6/99 Parent and teacher conferences. I never have trouble with parents. They seem to be able to tell me their problems. I would like to see all those critics of the school system cope with what these parents live with day after day. No money, parents out of work, sickness, drugs, no safe place to be. At times, an older cousin or sibling will come to the conference to check. "How's he doin'?" They do care. It is difficult for most of the parents to leave work to come to school. But that isn't true of all of them. One foster mother is there every day to help her little boy with his work. She sits beside him and quietly listens to him recite.

4/9/99 My poor lovely Kayla. She came to school today with a knit cap pulled over her ears, her black fringe of lashes wet with tears. I saw her sister in the hall with a similar cap. Later, someone told me that all three sister had to have their beautiful long black hair shaved off because they had lice. It doesn't matter if the school sends home notices about the kind of medicine that they can use to treat it, if the parents feel the only way to solve the problem is to shave their heads. She is the sweetest little girl. I found a book about a Samoan boy who lived the way her family lives here. The father is the head of the household. His word is law. They leave their shoes at the door the way we did in Hawaii. The family includes several different groups of relatives so an auntie might come for a parent conference rather than the mother.

4/12/99 Yesterday was quite a day. Early in the morning long before school started a strange woman walked into my classroom. She was scrawny, wore a denim dress and a watchman cap. She asked me the way to the kindergarten and before I could stop her, she grabbed my purse from my desk and took off down the hall. I suppose it wasn't all that wise, but I was so angry I yelled, "fuck you" (fortunately, no

kids were around) and chased her out the back door and into the backyards by the boarded-up housing. I had to climb over fences, but I wasn't going to let her get away with my cards and money. People in the apartments on the other side were at their windows. Some called out suggestions. "She turned left." "Not that way." I fell and skinned my knee. Finally, I had to give up. Later that morning, an old man who looked "strung out" came to the office with my empty purse wanting a reward. I gave him $25. Today he was back wanting more money but I said no. He frowned and left. The police arrived with mug shots to show me so I could point out the thief, but all were of men. It turned out she was a he, known by everyone in the neighborhood. I wonder what will happen?

4/15/99 The para that comes every other afternoon for an hour or two to help with the students is a young African American boy who, instead of helping the children with their work sheets, is busy answering the questions on his own sheet. I wish I had Ruby back. She really knew how to get the kids to do what she wanted. She would yell, "Get yer biscuits in the chairs or I'll take you in the bathroom and teach you rit from wrong. I talked to all yer mommas and they said I could." Now she is driving a bus and I bet she gets all the passengers to do what she says.

4/16/99 Before I left this afternoon I found a letter addressed to me on my desk:
"Dear Ms. Ingham, You are my favorite teacher. I like the way you dress. When I grow up I want to be a teacher like you. I want to go to college. I am not going to fight. I want to make this a safe world for everyone. I love you. Candace" I had tears.

4/17/99 I feel so depressed. I just learned thirteen-year-old Andre killed himself today. Six years ago I encouraged his mother to try to get him into a more challenging school. He was so smart that I was afraid he would lose interest if he stayed here. She did. And I would hear from time to time how well he was doing and then this. His sad

eyes made me feel he had troubles I didn't know about, but never thought this would happen.

4/20/99 I get tired of negative attitudes from people who know nothing about these children's lives. If they could just see how smart they are. For example, I had a great success today. I tried a new way of teaching called KWL. We are studying nature and today octopuses. We discussed what we knew about them. This is called the knowledge part. Then I had them write down what they wanted to know and collected twenty different questions from their papers, all excellent: do they have eggs or live babies? Do they sleep at night? How long do they live? How large is their brain? The next day we answered the questions, the learning part of the program. The lesson is about critical thinking but the standardized tests they are required to take don't test this.

4/21/99 Today the children sat on the carpet in front of me while I read them a story. Their most demanding task is to sit quietly and listen. They keep talking and wiggling or raising their hands to tell me every thought in their head. It had been a hard day, but I was determined to read one fairy tale straight through without being interrupted. They kept raising their hands and saying "Ms. Ingham." I ignored them as long as I could and finally, exasperated, said, "Well, what?" It turned out several buttons on my blouse were undone.

4/26/99 Every day I eat with them in the lunchroom. No one sits for more than two minutes. Most are talking with their mouths full, yelling back and forth. When I correct them no one seems to hear. I decided I had to do something about it so we had a lesson on manners. I told them when I was a little girl, my mother taught me how to set a table. "Everyone take a pretend fork, spoon, and knife out. Now take a plate and put it in front of where you will sit. Put the knife on the right side of the plate. The spoon goes next to it on the outside. On the left put the fork. Beside this you put the napkin. When you eat, you put the napkin carefully in your lap. Now

pretend you are eating. Take little bites and never talk when your mouth is full."

At lunch, they called to me. "Ms. Ingham, I am setting my place. And I remember about not talking with my mouth full." Tomorrow, we want to work on clearing the table and how to remember the secret code RR, or remove from the right. I can see how eager they are to learn.

5/11/99 Another hard day. People who aren't involved in teaching children don't realize what a complicated process it is. Few know about Harold Gardiner's book on the several different kinds of intelligence and the seven different ways to learn. A good teacher needs to keep this in mind. I try to present something new in several different ways.

5/12/99 A group from the symphony came to school to teach the children about musical instruments and they went wild, kept time banging their hands on their tables. I love their enthusiasm. They will ask anything, try anything—if it is not a test. I remember once when an African American woman came to visit our class, one of them said, "Are you Shirley Chisholm?"

He thought he'd seen her picture in the border I have above the blackboard of famous African Americans. She was flattered. I am so proud of them. Every day I feel their love. It doesn't matter how hard life has been for them. They can still love.

5/14/99 I think "capping" has reached an art, though it is a cruel one. Today Jerome told Leroy, "Your mamma is so fat she can't even fit on the seat in the bus." "Well, your momma's so thin she'd slip through the crack in the door." One of the worst things you can say to someone is "You're white." Even worse is calling someone "a white honky." I get so tired of hearing that. Today when Samilia said another girl was a white honky, I stepped in. "What is so bad about being white? I'm white." "You are?" I realized she had no idea what white meant. It was just a negative word.

5/19/99 The stepdaughter of a friend's Russian cousin came to visit class today. She lives in South Africa, but is from Uganda and was traveling in this country before starting college in Canada. I had checked out about fifteen books with African pictures and stories from our library and read them most of the books. The guest arrived wearing bell bottoms, a cute little tank top and wedgy shoes. She talked a little bit about her country and then asked for questions. "Are there cars there?" "Do you have food stamps?" "Do you wear clothes at home?" "Is everyone there as black as you are?" She weathered the fourth degree pretty well and agreed to read one of the stories. When she left, I realized many of the books I had collected were African folk tales with drawings of people in tiny loincloths, bare chests and face paint. Of course, none had cars in the garage. No wonder the children were confused.

5/23/99 Our buddy class came in for art. They took turns drawing their partners. I love the way the fourth graders treat my seven year olds. I hung their wonderful portraits on the clothes line I have stretched out from one wall to another. I use the line a lot for their art work. We illustrate their stories or make covers for the journals I have them write almost every day. My favorite project at Christmas time is making gingerbread houses using little cardboard milk cartons. Now that their milk comes in plastic bags, they aren't that easy to find. We take squares of graham crackers and paste them with frosting to the four sides of the box and on the top for a peaked roof. Mom comes in to help when we make them. She goes from child to child encouraging them. "You have too many M and Ms on that side. Try to balance them. The wall might fall off." "Oh, what a pretty door." "I like the way you've decorated the window. What a good idea."

5/24/99 I had a scary thing happen today. When I went out to get my car in the parking lot, a group of older boys yelled at me. They were angry because a teacher had seen them in the school yard after hours staging a pit bull fight. She screamed at them from her

window that she would call the police. They thought I was that teacher, but one of them who was the older brother of a child in my class two years ago whispered to me, "Get out of here as fast as you can," so I did. When I got home I could see they had stomped on the roof of my car with their dirty shoes, but had not done more damage.

5/30/99 Charnee cried all day and couldn't tell me why. I think it is because she doesn't know where her mother is. She lives with her grandmother who hasn't a phone, so I couldn't call her.

6/1/99 We had a field trip today. What a job to take twenty-seven kids to the Exploratorium on the muni bus. It's such a huge space with a million places they can go, but I solved the problem. Thought I was so clever. I kept their lunches with me so when they were hungry, they came to look for me. In fact, some even told an attendant that their teacher was lost.

It reminded me of the time last year when Mom came to help with art. Just as we were beginning to do a project, the office called to say my bus had arrived to go to the Josephine Randall Museum. Weeks before, I had signed up for a field trip, but the office never let me know my request was granted. And here was the $100 bus. None of the children had permission slips. It was an awful situation, but I decided to go anyway. They would completely miss lunch so Mom rushed home to make enough peanut butter and jelly sandwiches for the whole class and brought them to the museum in time for them to eat on the way back to school. They loved the museum. There were live creatures: a crow, a raven, an owl, a hawk, mice, snakes, racoons and possums. It was a wonderful trip, and no one sued the school.

6/3/99 I just got my next fall's class list from the office. The girls' names are the hardest—Che'Groflany, Chinaererem, Brianna, Raven (at least I can spell that) and Jeni. What I do is put a sticker with each of their names on the chairs, and when they come in and sit I

listen to what they call each other so I'll know how to pronounce their names.

6/2/99 Today someone wrote on the board: "Ms. Ingham Rocks the World." I was so touched. I can see I'm needed and that I can make a difference no matter how small it is.

6/5/99 The school year is almost over. I spent two days boxing up all my supplies. I put the bleached bones, the bird's eggs, the shells, the robin's nest from the science table in the closet, filled the doll house with pieces of furniture, cleaned off my desk and gathered up all my extra books. I must have a hundred. I can't seem to resist buying new books because I can see how they might lend themselves to new projects. I think teachers must be pack rats. Any kind of material, old snips of fabric, odd bits of paper, left over ribbon, cookie cutters, egg cartons, dried flowers, lace. I have boxes and boxes of treasures at home, just in case.

I don't know who will teach summer school in my room this year or whether my things left in the cabinets will be safe. Right now I would like to spend the whole summer either in bed reading, in the tub reading or in the back yard on a lounge chair though there isn't much sun in foggy San Francisco. By fall, I will be ready to return.

SALLY McANDREW
# Not Too Late

I

GROWING UP I never dreamed I could have a career. That was for other people, different, smarter people. I looked in awe as college classmates signed up to interview for *Vogue Magazine* or the CIA, the two recruiters who, in 1952, most often showed up at Vassar College. I didn't think I was capable of doing anything well enough to be paid, probably because I hadn't been brought up to consider that paid work for women was a worthy goal—according to my mother, the only women who worked did so out of necessity. At home no one worked and everything was done for us, including being driven by a chauffeur. I hated the isolation this brought and looked wistfully at "ordinary people." I suspected that having money I earned myself could be a good idea but with no role models or encouragement, I became convinced that a career wasn't in the cards for me.

When my husband Larry and I moved to San Francisco from the east in 1952, I threw myself into volunteer work in order to meet people and help make a place for us in our new community. Larry held the paying job, and my job was to keep house, cook, mother the children and make friends. When my children reached junior high-

school age, however, I began to wonder if the volunteer part of my life was enough. I never felt I belonged at the organization, and I resented the way the paid staff treated the volunteers, in an ingratiating yet resentful manner. Perhaps it reminded me of my childhood when I always felt like an outsider. I wanted to be someone myself, not just Larry Blair's wife, mother of two daughters and community volunteer. I was struck by a song sung by Peggy Lee,

> *Is that all there is?*
> *If that's all there is, my friends*
> *Then let's keep dancing...*

That's what I'm doing, I thought, dancing.

In the mid-sixties two friends became school teachers with the San Francisco Unified School District (SFUSD). Maybe if they can have a job, so can I, I thought. So in 1968, without knowing what I really wanted to do except that it had to be meaningful, I signed up to become a secondary school teacher in San Francisco.

I took my training at a local Jesuit university with a convenient class schedule. Nothing I learned there, however, prepared me for the actual experience of teaching in a San Francisco public high school in the 1970s, especially since I had never attended a coeducational or public school myself.

When we were deemed ready to student-teach, I still lacked enough confidence to choose Lowell, the honors high school, where my friends had taught. Instead, I opted for Lincoln, a high school in the Sunset District which, along with the other District schools, had been introduced to busing several years before. Integration had not succeeded in this predominantly white, blue-collar school. Now the multi-racial teachers and students were pitted against each other bitterly. The hall guards sold drugs, and the more militant Black teachers shouted insults down the corridors at other teachers. There was a confrontation in the cafeteria when, after being hit in the head by a flying chair, the principal had to be hospitalized. I was thrown into a maelstrom I had never imagined existed.

Discipline didn't exist. Decisions were made at the convenience of the administrators and the students' interests came last. Several of my fellow student teachers quit after a few weeks, but something in me made me determined not to let the situation defeat me.

I was assigned to teach Art History and sophomore English. All the students in the art department had to take art history in order to graduate, and since most of the art majors had been assigned to art because they couldn't read, they were stunned to find themselves in an academic class, as history of art should be. My master teacher was delighted to rid herself of the class and threw me into the classroom with the words "Good luck!" She then claimed disability and spent the semester at home, painting, in preparation for an art show she was having in the spring. I discovered there were no slides, and the textbook, with its dull black and white illustrations, was too hard for the students. After a great deal of effort, I obtained a new textbook with color illustrations and larger print, and slides kindly lent me from the Humanities Department at San Francisco State. I supplemented slide lectures by lugging in stacks of my own art books for the students to study, and I had them do as much hands-on work as possible, copying paintings, and making maps of the areas we were studying. We took field trips to museums, had speakers and somehow limped along to the end of the semester. Out of the class of twenty-five, three were motivated and capable, many never attended, and since it was the last class of the day, a few would arrive under the influence of something and sleep through class with their heads on their desks.

In English class my master teacher was equally indifferent to helping me become a good teacher and seldom sat in the classroom to observe. She was very interested in my being a Vassar graduate, however, and constantly asked my advice about social niceties—whether it would be all right to serve Cold Duck wine when she had guests for dinner and was it okay to have stew.

The English curriculum covered grammar and two Shakespeare plays, *Julius Caesar* and *Macbeth*. I didn't feel competent to teach either drama or grammar, having had a choppy education myself with a

lot of gaps. All I could do was stay one step ahead of the students, hoping they wouldn't notice how unsure I was. As to Shakespeare, I was rescued by my daughter Lucia's wonderful English teacher, Miss Hughes, who was an expert. Luckily Lucia was studying the same plays in her ninth grade class in private school, so every day when I got home I would ask her, "What did Miss Hughes say today?" Then I copied everything she did. One day, my master teacher said, "My, you know a lot about Shakespeare." "Thank you," I replied modestly.

At the end of the semester, a recently arrived Filipino man who spoke limited English with a heavy accent was given the open position in the English department. Although I wasn't sure I could handle a full-time position at that time, I would have taken one if a job had been offered me, and the decision just wasn't fair. Despite the importance of diversity in the schools, I had worked hard for the job and knew that, once again, the students would be the losers. "You'll never get a permanent job in this district," the assistant district administrator told me. "You're the wrong race, the wrong age, the wrong gender and you teach the wrong subject."

I considered quitting but felt that would be wasting what I had learned so far, and, besides, I wasn't brought up to be a quitter. My only choice was to become a day-to-day substitute, the most despised and lowliest job a teacher could have. In the SFUSD, the assignments were handed out politically, the best jobs being saved for the buddies of the head office administrators and school principals. Every day you wanted to work, you had to dial the District between 6:00 and 7:00 A.M. Since the line was almost always busy, this took the entire hour, and when I finally got through, I got the jobs no one else would take. I would set off in my blue Volkswagen bug with my map and drive to a part of town I had never visited before. I was assigned to teach every subject—music, home economics, history, math, art, English. If I got a music class, however, the instruments were locked away as were the cooking facilities in home economics, and so forth. So the actual teaching was a joke, and often I had to turn the class period into a study hall, even though I knew the students had nothing to study.

Once at Galileo, I was assigned to a senior English class for three weeks while the teacher went to China. As was required of all the teachers, they were to provide lesson plans for the substitute teachers. Throughout my substitute teaching, I found that the lesson plans the regular teachers left were a joke—years old and obsolete. I knew I couldn't hold the class if I tried to use them, particularly as this was a remedial class. It was held in the "temporary" classroom shack farthest away from the main building. Moreover, in a misguided experiment in "meaningful" education, the English class was two and one-half hours long three days a week. The students were sixteen and seventeen, the poorest achievers, almost all non-white, and most of them very large and truculent. Facing the class, I was in despair. What in God's name was I going to do with these kids for nine sessions?

A friend who taught in the pregnant girls program of the school district gave me a book on values clarification, and I spent two days posing some moral questions to the students. I wrote each situation on the blackboard, illustrating it as best I could. *Mary and John are married and live in a little house here.* (I drew a square house.) *Bob lives nearby here* (another house, a street, a tree.) *Mary loves Bob and they have sex. Now Mary is pregnant, but John doesn't know he isn't the father. What should Mary do?* The class really loved these problems and discussed them heatedly, arguing whether Mary was bad to sleep with Bob and what she should do. They disagreed violently, but I was pleased to find how important the students considered the moral issues.

Whew! Two days down, seven to go.

Happily, Friday was a holiday, so borrowing another idea from a friend, I went to some used bookstores and bought three boxes worth of old magazines, as varied as I could find but not pornographic. I bought glue, blunt scissors and newsprint paper, staplers and colored pens. Larry helped me carry them to the classroom and set them up. On Monday, I announced the plan. They were to cut out pictures from the magazines and make scrapbooks of their lives. Each picture had to have captions, and they could write whatever

they wanted underneath, but they would have to present their stories orally to the class at the end of the project.

The boys all cut out photos of basketball stars as models for their own lives.

"How you spell Kareem?"

"Spell what?" I said.

"You know, Kareem—he the ball player."

"He mean Kareem Abdul-Jabar," another student added. Hmm, I'd better read the sports page more carefully, I told myself.

Embarrassed as I was to admit to myself I was teaching an English class this way, I saw that the project had some positive aspects. Everyone concentrated on his or her work intently, and there were no fights. The students liked having a chance to present their own stories without having to write very much, which they couldn't do. And even though they tried to shock me with dirty words in the text, they cleaned them up when faced with making their presentations to their peers.

Eventually, I figured out how the substitute assignment game was played so, bypassing the district office, I went directly to Lowell and Washington, the best high schools in the District, introduced myself to the heads of the English Departments and expressed my interest in teaching there. Soon I became a long-term substitute and my teaching experience improved. I got to know and respect many of the teachers and grew to love my students, many of whom were actually getting a good education. Most important, I proved to myself that I could hold my own and be accepted as a peer by my compatriots. This meant a lot to me.

Getting my first paycheck was the highlight of my early work experience. Although I deplore our culture's practice of valuing people based on the amount of money they make, the experience of actually being paid for value, even if it was only $44 per day, was thrilling. And, as a woman of my generation who never expected to have a career, especially so. I felt worthy and in command of my life.

I substitute-taught for seven years until 1977, when the school district abandoned the long-term substitute category and put us

back into the day-to-day pool. By this time I had seen enough of the District to know that if a teacher had a permanent job with his or her own classroom, excellent teaching could occur. Many schools with high standards were doing a fine job, but I could not get myself positioned for permanence. Although I would get my own class for a semester, I always got the worst classrooms and the most killing schedules. I decided that if I got a masters degree, I could teach at the junior college level where students would be more motivated.

Leaving the San Francisco Unified School District, I knew that even though later work experiences undoubtedly would present challenges, my teaching experience would be the most valuable time I ever had, giving me the confidence that, if I could do this, I could do anything. I got to know every part of San Francisco and became fearless in going into neighborhoods, some of which I might have found scary—Hunter's Point, Ingleside, Bayview, the Mission, Treasure Island, Chinatown, the Sunset and Richmond Districts, the Fillmore. I learned more every day than I would have thought possible and realized the important thing about my own education was not what I did or didn't know but that I had learned how to learn. I could feel my mind expanding as I figured out how to teach Children's Lit, Film Appreciation, Mass Media, English composition, Shakespeare. And I realized that even if I wasn't the best or most prepared teacher in the system, I really cared about the students and tried hard. That counted for a lot.

## II

In 1978 I enrolled in a masters degree program in Museum Studies at Lone Mountain College, designed to train people to work in the various departments of museums—education, exhibitions, curatorship, conservation, administration. At the time, most museum professionals had excellent academic training but no hands-on management or practical experience, and this was the first such program in the United States.

Classes were held at night or at other convenient times for working people and parents, for which I was glad. I had found that

working full time had caused some strain on the girls. Even though my vacation schedules coincided with theirs, I wasn't always available to attend an important school event in which they were to participate, and I could sense their disappointment when I would have to say, "I'm so sorry but I just can't take that day off to come." Often I would tell them, "I'm really sorry I can't be with you more, but just bear with me to the end of the semester," or "to the end of the month," or "to summer vacation." I knew that children need you when they need you, not later when you might find it more convenient, and you can only say you're sorry so many times.

Although Larry was supportive of my finding a career, he also missed my attention. Often I would have to forego nice business trips because of my schedule, and I had the feeling I was letting him down. But he never complained and had his sports activities to keep him busy beyond work. Besides he was proud of me and liked the extra money. Now I felt I needed to be home more, making delicious meals, not having such a busy agenda of my own.

It took several years to complete the master's degree, and by that time I had lost my motivation to get back into the rat race of teaching with its relentless demands, constant frustrations and low pay. I hoped the museum world would prove more compatible. I decided on museum work because I had majored in art history in college and been a docent at the Fine Arts Museums. But it wasn't so easy to get a job in that profession either, and I began to understand that to find meaningful work at a museum you either had to be willing to start at the bottom with little or no pay, or have a PhD in art history with a knowledge of German, neither of which was feasible for me at almost fifty.

In the course of my studies, however, I had researched and written an article on the history of the donors to the Legion of Honor Museum, which had been published in the Sunday magazine section of the *Chronicle*. My career was about to take another lurch.

## III

A board member of Edgewood Childrens Center, whom I had known when I volunteered there years earlier, called me in the spring of 1981. She had read my article and offered me a job at the Center doing archival research for the historic agency, which had been founded in 1851 for orphans of parents who died during the Gold Rush. In time it became a temporary home for troubled children instead of an orphanage. When he heard about the offer, Larry was bemused. "When you're sixty-three, you're still going to wonder what you will do when you grow up. Don't you think it's time you settle down?"

Amazed that anyone would offer me a job, I accepted. Edgewood was preparing for a capital campaign to renovate its six old buildings on Vicente Street and 46th Avenue in the Sunset, and my research job was the first step in establishing a development office and running a capital campaign. Never mind that I was completely inexperienced. I was lucky in that Edgewood had a dedicated constituency which had been donating regularly without being asked. Many were second generation donors to Edgewood, so when they were approached to help support the seismic renovations of its buildings, they gave willingly. We managed to reach our $3 million goal within the prescribed three years.

Although I didn't know it at the time, I was on my way to spending almost twenty years in fund development. My niche would become setting up development programs for well-established non-profits that had never done formal fundraising. I was suited for the work because I'd been a volunteer myself, knew a lot of people in the Bay Area and discovered I had a knack for genealogy, which is helpful in sorting out donor lists. But I knew nothing about management or about working as a professional in an organization with a hierarchy.

After the campaign concluded, I needed a break, so I left Edgewood, remodeled my kitchen and worked on short-term fundraising consulting jobs, which gave me a chance to catch up with family and friends.

## IV

Larry's eyesight had gradually been failing and, in the mid 1980s, he took early retirement, which added some urgency to my job search. In 1986 I noticed a small job announcement in the want-ads for a director of development for The Trust for Public Land (TPL), a national land conservation organization based in San Francisco. TPL was founded in 1970 to preserve open space around cities for recreational use. Basically a public-interest real estate company, it would buy property at a discount from owners and then sell it to public agencies for permanent protection for less than the fair market value but more than it paid for it. TPL's founders believed that the spread between the purchase and sales price would provide sufficient operating support to avoid the pesky fundraising that most nonprofits had to do. Since TPL's projects were often controversial, the organization maintained a low profile, but once in a while, the newspaper would announce that a scenic piece of land under contention had been protected by The Trust for Public Land. I was intrigued by this mysterious organization which seemed to do such good work but which no one knew much about.

Before I applied, I talked it over with my family. "It sounds great to me, but I don't know if I could handle it," I said. "After all, it is a national organization, and I really don't have enough experience. Also I don't understand the land conservation business."

"I think you should go for it, Mom," said daughter Sarah, just graduated from college and living in New York. "Just visualize how you think a development director might act."

So I applied, and Larry drove me to my first interview. TPL's office was on Second Street between Market and Mission Streets, over a Greek restaurant. The glass door had bright orange trim, and through it I could see a steep flight of stairs covered in dingy brown carpeting. A pungent smell of frying grease from the restaurant filled the air and, as I found out later, pervaded the upstairs. "I don't know about this," I said, as I got out of the car, "but here goes." Once upstairs in the crowded, busy headquarters, however, I found a group of smart, young, dedicated people who cared more about

their work than a fancy work environment. After several interviews, I was offered the job. I said to Sarah, "Okay, I've got the job, now what do I do?"

I discovered that I was the fourth development director in five years because the TPL didn't really want to fundraise. When the founders realized that their dream of being self-supporting didn't work in its cyclical business, they had to accept fundraising as a way to fill the valleys between the peaks of their deals. But they didn't like it and thought they could just hire someone to "go get the money," rather than doing it themselves.

My task was a challenge and it was made more difficult by a unique experience the Trust had had the year before. TPL had played a major role in protecting the Grace Marchant Garden on Telegraph Hill from an adjoining construction project that would have cast the garden into complete shade. A newspaper columnist heard about the threat and wrote an article in the Examiner, explaining the situation and mentioning that TPL wanted to "sell" square inches of the garden as a means of protecting it. Over 4,000 donations poured in, which netted several hundred thousand dollars. People wrote from all over the world. "I was in San Francisco during the War," one man wrote, "and wooed my wife in the Grace Marchant Garden. We want to help." From Alastair Cooke came a check, with "The garden is my favorite place in the United States." Fundraising must be easy, thought the management, and it was hard to convince them of the uniqueness of that situation.

I stayed at TPL four years, gradually making progress in helping staff to fundraise effectively. Raising general operating funds was the most difficult, but fundraising for specific land projects was simple. Among the many valuable sites the Trust protected were: Hernando de Soto's original campsite in Tallahassee, Florida, which had been discovered when construction workers were excavating for a new highrise; Weir Farm, in Connecticut, home of J. Alden Weir, the American Impressionist who gathered other artists there to live and paint; and the coastline of the Columbia River adjacent to Portland. In an attempt to bring environmental values to the inner city, TPL

also created community gardens in the depths of Manhattan, Oakland and other cities.

I particularly enjoyed the campaign to protect Lamoille Canyon in the Ruby Mountains in Nevada from second home development. A landowner near Elko owned a large ranch in one place and several small plots in Lamoille Canyon, the most scenic spot in the Ruby Mountains. Not able to turn a profit on the mountainous land in the canyon, the owner sold the plots to a developer for second homes. Since there had been a gold mining boom in the mid-80's, and Lamoille was the only scenic area nearby, the homesites were in demand.

The Trust swung into action. If it could arrange a deal in which the owner's land in the canyon would be traded for other acreage which could be added to his existing ranch, everyone (except the developer) would be happy. In order to make the deal work, however, TPL needed to raise $200,000. Aaron, the skilled project manager, described the project to me and asked me if I knew anyone in Elko. "Yes, as a matter of fact, I do," I replied. Perchance, my neighbor in San Francisco, who rented the flat next to mine, lived in Elko most of the time where she managed her family's gambling business, hotel and shopping center. I called her immediately.

"Mimi," I said. "Have you ever heard of Lamoille Canyon?"

"Have I!" she said. "I just built a house in the town of Lamoille right at the base of the canyon." I described the development threat and asked if she could introduce TPL to people in Elko who might give money to the project. Mimi offered to hold a meeting at her home and invited the key local players.

Three of us from the Trust flew to Reno, took a small plane to Elko, then drove south to Lamoille. Gradually the dry brown flatland turned into a green ecosystem. As we neared the tiny hamlet of Lamoille, the mountains rose ahead steeply and we could see snow on their 10,000 foot peaks. Before going to Mimi's, we drove up the canyon to the end of the road, parked and walked up the trail. I was astonished at its beauty with its clear flowing stream and aspen trees, already showing fall color. We could see a few old log cabins tucked away above the trail, which were still owned by the local residents,

but rather than detracting from the scene, they fit into the landscape and helped give definition to its scale.

Mimi's ranch was on the flatland abutting the mountain range. She had a large log house with a two-story living room, its glass walls facing the view. It was a perfect setting to launch a campaign. About thirty guests arrived and listened as we described the situation and introduced the need for funding. Most people were enthusiastic and agreed to form a committee for the campaign. I was encouraged, knowing that to be successful in a project like this, you need the support of the community. We seemed to have it here.

Mimi told me that two families from Chicago, who had just sold the family's large pharmaceutical company, had recently bought ranches in Lamoille where they lived part of the year. I called Benson and Jane Howard in Chicago, described my mission and made an appointment for the next week. Aaron and I flew to O'Hare, rented a car and drove to the family office in Northbrook. After suitable preliminaries, I asked Benson and Jane for $100,000 as a challenge, explaining that there wasn't a lot of money in Elko and $200,000 was a lot to raise in that community.

Jane responded immediately. "Oh, I think we absolutely have to do it."

Benson thought a moment, and then said, "We'll only give you $50,000 now, but you can come back later if you are short."

Not bad, I thought, as I flew home the next day with the check in my pocket. Staff and committee developed appropriate donor categories and made a mock-up of a plaque to be placed permanently at the most scenic overlook in the Canyon. With the $50,000 boost, everyone gave what he or she could, and we reached our goal.

In late August, almost one year to the day of Mimi's first meeting, she hosted a dinner to celebrate the end of the campaign. The president and several board members of TPL attended as did all the donors, including representatives of the mining companies. The evening was beautiful with a full moon and bright stars. The low wooden deck adjoined a large lawn that stretched south to the wall of mountains with the entrance to Lamoille Canyon slightly to the

east. A row of cottonwoods lined the edge of the lawn to the right, where Maggie Creek bubbled out of the canyon. People sat on benches at long wooden tables and conversed animatedly. Everyone felt deeply satisfied, and I got the sense that, perhaps for the first time, the little community had come together in a special way to save a cherished place. The Trust's president spoke eloquently as did some of the committee members. It was a memorable evening; I thought, this is really worthwhile work.

My years at the Trust for Public Land were intensely rewarding but demanding, and, as I was the oldest person in the organization, I found it increasingly hard to keep up with the thirty- and forty-something staff. I didn't want to travel so much with Larry retired and at home. I needed to find something with less pressure closer to home.

## V

I was fifty-nine years old and still hoping for another job. Wouldn't it be wonderful to work for an organization that helped donors give away their own money as they pleased rather than one that asked them to give it to you for your cause. I phoned Bob Fisher, the Director of the San Francisco Community Foundation, whom I had met in the course of my previous work. I told him I had left the Trust and asked if he had ever considered having someone on staff to help him with development. "As a matter of fact, I have been looking for someone quietly for a long time, but haven't found the right person. Why don't you send me your résumé?" This fishing expedition led to my last wonderful job as the Donor Services Director for the Foundation, which I held for eight years. I loved the job. Bob was a brilliant, tireless man, and working for him was more demanding than I could have imagined, but the thrill of helping people with charitable intentions figure out how to spend their money in a way that would gratify them made it all worthwhile.

The San Francisco Foundation was established right after World War II to manage charitable dollars left through people's wills. The income from these dollars was given to nonprofits according to the

donors' wishes. As a courtesy to trustees and their friends, the Foundation also accepted a few funds from living donors who advised where they wanted money to go. The donors would get tax benefits, and the Foundation staff would take care of the administrative details. It was a wonderful arrangement for donors who were wealthy but not sufficiently so to establish their own private foundations These donor-advised funds began to grow across the country exponentially during the 1980s but for various reasons, not at The San Francisco Foundation. Hiring me to develop new donors was the first step in inviting new donor-advised funds.

As the Director of Donor Services I stepped up the outreach, and, as more people learned of the charitable giving opportunities available to them, more and more joined up. My role was varied. I wrote informational materials, developed lists of potential donors, organized lunches for donors and prospects, recruited speakers who were expert nationally in one of our giving areas. Outside the Foundation I mingled as much as I could in the social and charitable life of the Bay Area and made sure that I spoke to potential donors when I ran into them. When donors called wanting more information about an organization, it was my job to supply it, and I met with prospects and donors and helped them to set up their funds. As attorneys, accountants and bankers were best sources of new trusts, I arranged informational meetings for the Director to meet with them. All this was much more than one person could handle—and this was to be the low stress job of my old age!

After the first year I was able to add staff to help handle the growing volume of work. When I started in 1991 as a department of one, the Foundation's total assets were about $250 million, most of which was in permanent testamentary dollars. Of the total, there were about eighty-eight advised funds. When I retired at the end of 1997, the assets of the Foundation had doubled to $500 million, with 250 funds ranging from $10,000 to $40 million. Out of these funds, my department facilitated gifts to nonprofits recommended by donor-advisors of more than $30 million annually. The time was ripe for this growth, and I was more the facilitator than the gleaner.

Over the last quarter century, donor types have changed. In the early days of philanthropy, most major donors were wealthy men or women, who had inherited their means from their husbands or fathers but never worked themselves. They knew the areas they wanted to support but often were vague on the specifics. "Do good works," "support the arts," " give to cancer research,"or "help needy children get healthcare" read the cover sheets of their files.

Today's donors are often younger, entrepreneurial types who, making a great deal of money early in their careers, have definite ideas on what they want to accomplish with their charitable dollars. Most lean towards less established organizations where they can "really accomplish something." Used to success and afraid of failure, they want to be personally involved in ensuring their dollars are handled wisely.

One of my favorite donors was Leon who had the slightly rumpled look of a math professor, which he used to be. A wizard at numbers, Leon had been persuaded by a friend to leave teaching and join him in the futures trading business, which made him millions. He and his wife Joan still lived simply, sent their four children to public school and wore inexpensive clothes. He came to the Foundation and asked our help in finding budding entrepreneurs he could support and advise. One of our donor organizations was a training center for people who thought they had a great idea but didn't know how to sell it. For a modest fee, they took a course in which they learned to do market research on the need and potential competition, write a business plan, learn personnel rules and manage a business. After the course, some of the students would go ahead with their enterprise, renting office space from the center, but many others found their idea was not viable after all. Leon became very involved in this wonderful service, giving money and doing some of the training himself. "For these people, $10,000 is a fortune, but for me it's nothing," he said. "Making it possible for new businesses to get started is the most fun I've ever had."

Often I would go with the Program Officers when they were visiting nonprofits which the Foundation supported. These visits

helped me understand the hundreds of nonprofit resources in the Bay Area which were doing good work and with whom I might be able to connect a donor. One organization, Stan's Boxing School in Oakland, exemplifies the talent and vision of so many nonprofit leaders. A high school teacher in one of Oakland's toughest schools, Stan wanted to do something about the terrible fighting that disrupted the schools by providing a positive after-school environment for the students. He got the city of Oakland to donate a storage facility and, using equipment donated by local corporations, set up a boxing ring. The ring was regulation size and made of high quality materials. Then he started an after-school boxing program, but it had a kicker. Any student wanting boxing lessons also had to do his homework on the premises. For this purpose, Stan scrounged some desks and chairs and set up the study area near the ring.

Soon students were flocking to Stan's. Through learning to box and the rules of the game, they began to gain self-confidence, resulting in fewer impromptu fights in school. It was as if, knowing how to defend themselves, they didn't have to prove they could all the time. Surprisingly, as the program became more popular, the students looked forward to their study time more than the boxing. Stan found another teacher who tutored, then got a second storage warehouse and set up a stage. "These kids don't know how to present themselves and they don't speak Standard English," Stan explained. "How are they ever going to get a job if they don't know how to act and speak?" His idea was that through memorizing and reciting speeches by famous people, like Roosevelt, Churchill, Kennedy, King, they would learn these skills. It really worked, and later the students performed plays as well as reciting speeches. Practical, brilliant, effective. Stan had found a need and filled it. The more adventurous Foundation donors loved it and provided dollars for it to continue.

As the person in charge of taking care of the donors, I often had to act as a sort of interpreter, explaining to them how things worked in nonprofits and to the nonprofits how the donors might react. "You have to understand that the value systems of nonprofits are

different than yours were in your business. If an investment you make doesn't work, you cut your losses, but it's not so easy to apply the 'bottom line' approach with human beings." I loved the role and think I had a gift for it. Connecting people with others who shared the same interests was always one of my favorite things to do, and in this job, I could give full rein to this interest.

In fall 1996, Larry had a heart by-pass operation during which he had a severe stroke. I became burdened with his care as well as learning to manage our finances, turning our two flats into condominiums, and working. It was too much, and I had a spell of illness in 1997 from which I couldn't seem to recover. At sixty-seven, my body was telling me it was time to retire.

Looking back on my career, I know my timing was incredibly fortunate. I had found worthwhile work, discovered talents I didn't realize I had, and worked on an equal basis with diverse and wonderful people, whom I would never have met otherwise. I had never imagined leading a life like this.

Shortly after I retired, I met a wonderful congenial man, and, when Larry died, we were able to marry. I was being graced with a new life and I was ready for it.

NANCY GENN

# Bronze, Paper and Paint

FROM EARLY CHILDHOOD I wanted to be an artist. I was fortunate to have been born into a family who valued art and working with one's hands and I owe them an enormous debt for nurturing my development as an artist. My mother was an active member of the San Francisco Art Association and the San Francisco Women Artists. Her résumé as an exhibiting artist is impressive. She knew that to be born into an artist's household gave me both a technical and spiritual advantage. I heard conversations steeped in aesthetics and art history and found it natural to go to museums and art openings. Dinner conversations about painting were commonplace. Through my mother, I met artists of her generation, Adaline Kent, Ruth Cravath and Claire Faulkenstein. I learned that family life and professional life could be intertwined, a knowledge that put me leaps ahead of my time.

In summers my mother taught me how to use tools: a saw, a hammer, how to blunt the head of a nail so as not to split the narrow wood of a stretcher bar. It surprises me now to know that my grandmother liked to use a hammer to build shelves. I knew her only by photographs, a lady in fine clothes, not a carpenter.

When I was in grade school, I attended Saturday morning class-
es at the California School of Fine Arts, now the San Francisco Art
Institute, where Hassel Smith was our painting teacher. He was a
stimulating teacher, taking us on field trips to see the artist at work.
Once, he took several of us to meet Anton Refregier when he was
painting the murals for the post office at the Rincon Annex on Mis-
sion Street.

My father was the manager of the Baldwin Piano Company in
the seven western states. Through his activities we met a stream of
world-renowned musicians. He created a cultural environment for
us by encouraging our participation in the arts and attendance at ex-
hibitions. He encouraged my mother's artistic endeavors, too, an im-
pressive attitude in the nineteen thirties and forties, considering how
few women artists were taken seriously then.

As an art major at the University of California, Berkeley, I devel-
oped friendships with teachers and students in the department that
continued after I married and moved to north Berkeley close to
many professors, which allowed for stimulating friends and valuable
contacts.

As a wife, mother of three, and an artist, I balanced three hats on
my head, and, having lots of energy, I never doubted I could wear all
three. At times my art operated in slow motion because I had to
weave my work time around the children when they were young.
My husband Tom always encouraged my work. His understanding
of aesthetics is an essential aspect of our relationship.

After our first child was born, I continued to paint by hiring a
baby sitter several mornings a week. The money came from my sav-
ings so that I did not disturb the delicate balance of our young fami-
ly budget. I used a bedroom for a studio and exhibited in juried
museum shows. Even after our second and third children were born,
I managed to keep the thread of work going. When they got measles
or mumps, I knew I would probably not paint for six weeks as each
child caught the disease in turn.

I was grateful that my time was my own. I never had to break off
and say I would pick up my career later. I felt strongly that keeping

the continuity of my work, the momentum of thinking about and doing artwork, was essential. I arranged my studio time around our family schedule. Only when the children were occupied or in school could I concentrate; I did not want the children to be jealous of the time I spent with art. I stopped when they came in from school and gave them Cambric tea and cookies. In the summers when I closed my studio, only a small amount of creative time was possible, but as the children got older, I had a couple of hours to work in the early morning, as teenagers sleep late.

Beginning in 1961, I worked in sculpture for nine years using the lost wax process. Our back yard and the area under the arbor became my studio. My first casting, commissioned by architect William Wurster, was a five-hundred-pound-pour of bronze for the lectern for the First Unitarian Church in Berkeley. I started with a plaster core upon which I painted a layer of wax. On this foundation, I built additional shapes in wax. In developing this technique, I was influenced by three professors at the University of California, Berkeley: Peter Voulkos, Harold Paris and Donald Hasken, who were also experimenting at this time with direct casting. The advantage of this method was that it bypassed the costly piece-molds of the traditional method, thus making bronze castings affordable.

Claire Faulkenstein, working in welded iron and glass, introduced me to the idea of the open form in sculpture, using direct casting. I employed the technique to develop linear sculptures using long cuttings of grapevine from the arbor to create the shape, but rather than working with welded iron, I cast my forms in bronze. I tied a vine firmly together with twine and covered it with wax to create the sculpture. I surrounded it with plaster to make a mold. After the wax and vine were burned away, the mold was ready to be filled with the molten bronze.

To make the procedure easier, I kept a block of microcrystalline wax in the broiler section of the kitchen stove so that the pilot light could soften the wax to the perfect temperature for modeling. It was always ready when I needed it. Almost always, that is. Once, our baby sitter turned on the oven to heat dinner for the children and

started a fire. Our daughter, Cynthia, opened the broiler door, saw the fire, threw in a whole box of baking soda and slammed the door shut. One of the younger children said in surprise, "But you're using up the whole box." Fortunately, Cynthia knew how to take away the oxygen and put out the fire. After that I decided a baby sitter was no longer needed. Our children had learned to be careful of tools and equipment and how to handle themselves. Years later when we had another fire in the broiler, I threw in a bucket of sand which was effective immediately but a mess to clean up.

Casting linear forms into bronze was difficult because the narrow channels could easily become blocked with ash stopping the flow of the metal. Experimenting as I went, I used compressed air to clear the channels before pouring the metal in. I had to remake the center section of my first linear bronze sculpture, learning by trial and error. Only later, when a visitor at a museum challenged me, did I learn that engineering books say it is impossible to do what I was doing.

It was an exciting time. In 1963, I was recognized nationally in the exhibition "Creative Casting" at the Crafts Museum in New York. There I was exhibiting a nine-and-a-half-foot wall sculpture entitled "Tide." Eighty percent of the show came from Berkeley artists, the leaders in the movement. I had lots of help. A neighbor gave me the special high-intensity bricks I needed to build a burnout kiln for the sculpture molds. Peter Voulkos advised me on the placement of the burners. The cashier at the welding supply company smiled and waved away any need for identification; it *was* unusual for a young woman to spend her Christmas money on heavy equipment. Tom, a mechanical engineer, whose engineering knowledge and experience were invaluable, built an overhead I-beam trolley and slings to move the delicate sculpture molds that were to go to the foundry. Events like this were usually on a Saturday; the children enjoyed the excitement when the household was alive with activity.

Some of the major commissions I completed were the bronze sculpture for the Peninsula Hospital, the menorah for Temple Beth Am, and the fountain sculpture, a two-thousand-pound pour, for

Cowell College at the University of California, Santa Cruz. When our daughter Cynthia proudly took a photograph of the fountain sculpture to her eighth grade class, several girls challenged her saying, "Mothers don't do things like that." Fortunately a classmate saved our shy daughter by saying, "Oh, yes, they do. I saw it in her back yard."

Hand finishing the bronze was heavy work. The equipment I used included high-speed drills, grinders and wire brushes and, to protect my ankles in the foundry, I wore cowboy boots. Once, my smock caught in a heavy wire brush that began to wind around my clothes but fortunately the electrical equipment had an emergency cut-off device. Finally, at the end of one exhausting day, I remember thinking, I cannot keep going like this; something will have to change, and it did.

In 1970, I rented a small studio away from home in the flats of Berkeley for thirty-five dollars a month and started painting again. There were times that I felt left out and alone but I was able to do little about that. I missed having lunch with colleagues on campus who entertained museum directors, curators and artists, which often led to invitations to show their work.

Incorporating art into an architectural plan has always been interesting to me, so I was delighted that following the exhibition of my painting on ceramic glazed tiles at the Richmond Art Museum, the owners of Sterling Vineyards commissioned a series of five wall murals for their new winery in Calistoga, California. The commission also included seventeen paintings on tile set flush with the surface of the concrete floor in the cooperage area and two tiled pools outdoors. Water came from the center of the pools and splashed over my bronze linear sculptures. I packed the tiles, numbering in the thousands, in specially constructed wooden trays to protect their delicate surfaces and trucked them from my studio to San Jose for firing. The commission took nine months to complete. Everyone in the family got involved. Our son Peter, age fourteen, often helped me load the trailer. One summer our daughter Sarah painted tiles of her own, beautiful line drawings of trees.

In the early nineteen seventies, I made calligraphic paintings on canvas of translucent color, an exciting new direction for me. Following a show at the Oakland Museum of four of these seven-foot paintings, I went twice a year to New York, with my paintings rolled in a construction tube, to find a gallery, which, I learned, was a slow process.

In 1975, I received a dramatic response when I started exhibiting handmade paper. I had found a new way of creating an artwork. The summer before, Garner and Ann Tellis at the Experimental Print Workshop introduced me to the medium. So that I could be with my children, I carried buckets of pulp to my family's summer home in Los Gatos. I made the paper on screens outdoors where the excess water could roll off onto the ground and I experimented with watercolors and threads, layering and embossing them into the freshly formed papers.

Pulp, an organic material, can be kept for months if cold. The Asian paper-makers store pulp in a snow-bank. I followed the same principal for storing pulp, using half-gallon ice cream cartons placed in the freezer. Our daughter Cynthia told me years later how frustrating it was. "When I tried to sneak vanilla ice cream out to the garden," she said, "I had to figure out which one of the cartons actually contained ice cream."

With the children back in school in the fall, I continued in my outdoor studio at home and collaborated with Don Farnsworth at his papermaking studio in West Oakland. I discovered that the image that slowly emerges becomes a beautiful complete abstract. I developed a method of "tear ups" that reveal the layers below. Later the speaker at a paper conference at the San Francisco Museum of Modern Art called it the "Genn Method."

The color was in the pulp; the image, created on a screen laid out on a table, followed a full-scale drawing. To facilitate the process, I purchased a Hollander Beater for making pulp, a cast-iron table model which could only be moved using a forklift truck. It was installed in the patio area off the kitchen. Producing a bold image and an appealing texture this way was new and exciting to me. On a

trip to New York, I introduced my new works to Jo Mill, print curator at the Brooklyn Art Museum. She was thrilled and called her assistant into her office to have a look. It was often the print curators who were the responsive ones, the encouraging ones.

I gained international recognition in the 1970's for my experiments with hand-made paper. Using the "Genn Method," I created three-dimensional abstract works that not only revitalized an ancient Japanese art form, but also the medium of paper itself. Paper is an old material, but I used it in an innovative way. The resulting works of art unite not only East and West but also my own experiences as both painter and sculptor.

Over the next few years, the Susan Caldwell Gallery in New York had four one-man shows of my handmade paper work, and I participated in museum exhibitions of artists working in handmade paper in the years that followed. Some shows traveled overseas: "New American Paperworks," curated by Jane Farmer for the Smithsonian, traveled to twelve museums in the U.S. and eight in Asia, including Kyoto, Seoul, Hong Kong, Manila and Singapore. Later the exhibition toured Europe. The audiences were amazed; we brought a freshness to work with paper they had never seen before.

Exhibiting in other cities gave me the opportunity to attend openings and compare their gallery scenes with San Francisco's. To keep my gallery contacts, I now went to New York as often as three times a year, staying for a week at a time, to show my new work to my gallery owner and museum curators. I packed the work in a wide wooden crate that traveled with the baggage and could fit inside a taxi. It was the perfect way to avoid leaving it hidden in the studio where no one sees it. I can't describe what a sense of accomplishment I have when the gallery sells an artwork.

I was thrilled to receive the prestigious United States-Japan Creative Arts Fellowship for 1978–79, a grant awarded to mid-career artists. The purpose of the fellowship is to further the development of an artist through the opportunity for residence in Japan for a minimum of six months. My experience there was fabulous. I made drawing notations inspired by the architecture, recording the

outline, interior spaces and the spirit of place. Even today, the visual impact of the experience on my work remains, bringing to it a subtlety of color and strength of line.

In 1991, Harvey Littleton of the Littleton Print Studio in the Blue Ridge Mountains of North Carolina invited me to create a series of prints using the technique of printing from glass plates. I use a thick sheet of plate glass instead of the usual metal plate, first creating the image with a heavy grease crayon as a resist, then etching the image onto the glass with acid and sandblasting. The special quality of this process, called "vitreography," is the luminosity of the color. The unique qualities of light and transparency resulting from the process appeal to me. I have returned twice to complete editions of prints using this new technique and have found it a springboard for innovation.

Now, the children are grown and away and I am painting in my big studio with north light. I am using casein, a milk-base paint, gouache, and pencil and often, to enrich the surface, I add a layer of monotype or a section of etched Japanese paper. I continue to exhibit in museums and galleries. In November of 2001, I returned to the American Academy in Rome as a Visiting Artist. I find it stimulating to be with other creative people: artists, architects, poets and musicians. We share our passions. In a studio overlooking Rome, I painted six large paintings that will be part of my next major exhibition at the Fresno Art Museum where I will be Artist of the Year in 2003.

Creating art gives me a deep emotional satisfaction. The joy and pleasure of it is in the doing. Art is not entertainment; it is never easy. Sometimes an artist needs weeks or months for a painting or sculpture to reach completion. Marcia Tucker, founder of the New Museum in New York wrote, "Art somehow changes the way you see. The visual arts use a vocabulary most people haven't learned yet. You can only learn by seeing. You can't learn by interpretation."

Though being an artist is difficult, being a woman artist with a family is especially challenging. I continue to struggle to keep studio time free for work as I did when my children were small. As my

mother's passion for art influenced me, so mine has influenced my children, and, in turn, their children. In May of 2002, the DL Gallery in Seoul, South Korea, presented an exhibition, "100 Years of Art," a four-generation show of the women in our family: my mother, myself, my daughter Cynthia and her two daughters. Each of us is a serious artist with a style all her own. It is almost impossible to mix up our painting and yet we have similar concerns. An appreciation for the importance of line, the layering of translucent images, and the rich colors of California are common threads. Yellow ocher and silvery blue are often present in our works. The San Francisco Bay with its ever-changing silver light on the water and its morning fog is embedded in our memories. We have all been strongly influenced by the rich texture of historic buildings. When we talk together about art, each can feel the others' love for and deep dedication to the visual field that we share.

A prominent French art critic once asked my artist mother what she did to produce such a talent. "I just produced the materials," she replied, "and had the crayons available. She did the rest." In the last few years three professionals in the field of art have told me that my work gets better and better. It is said that visual artists achieve their best work at the end of their lives, their mature style. I feel I have found my voice.

# The Way We Are

JOANN REINHARDT

# Make Pickles, Read Proust

MY LIST FOR weekend chores is always long, and I have been known to write things down that I have already done just for the joy of crossing them out. A list makes me feel organized and in control, even when I'm not, and I admit to an excessive sense of satisfaction when I can cross off most of the items. I say "excessive" because, in the whole scheme of things, is it really important to do the chores on the list when I have not done the long-term projects I ought to do? When will I get to that pile of unread 1997 *New Yorkers* and those *New York Times* book review sections that have probably had a longer shelf life at the Reinhardt house than the books they reviewed?

On a recent September weekend I was faced with a daunting list, starting with:

Make pickles
Read Proust
Update address book

And the list went on from there.

When one has a large vegetable garden—and the produce comes relentlessly rolling in—there is no doubt what the number one chore will be. Forget that the reading group is doing Proust on Tuesday, the cucumbers will not be denied. The gardener-husband arrives triumphantly in the kitchen, beaming with success as he deposits on the counter an enormous bag of future pickles.

For me, few domestic duties are as satisfying as preserving foods. I feel connected to a long history of women who "put down" provisions for the winter. Gazing at shelves of jams and jellies and pickles waiting to be eaten in the dark days of winter gives me an almost cosmic feeling of destiny fulfilled. My only reluctance is to disturb the bounty on the shelf and in the freezer and actually use the food instead of saving it for the famous rainy day.

Pickle-making requires huge kettles for sterilizing jars, small saucepans for heating the lids and a big pot for the mixture of cucumbers, onions and peppers. After each jar is filled, I set it on a dish towel on the kitchen counter and wait eagerly for the dull pop that means the jar lid has sealed and the preserving process has worked. The feeling of contentment is very much like tucking your sleepy children into bed, knowing they are warm and safe until morning.

The pickle-making project leaves very little time for number two on my list—reading Proust. Readers spend months, even years, on *Swann's Way* alone, and I have just a few hours. I want to get as far as the celebrated tasting of the madeleines, since they have become a symbol of recovered memory. What beautiful, gentle recollections Proust pulls from his character, connecting him to his past. But I am disappointed when I get to the madeleines and read that the little cakes are dunked into tea before being eaten. What a terrible thing to do to a perfectly delicious, buttery little cookie, crisp and brown around the edges! I thought that only elderly people with false teeth dunked things. It is clearly time to go on to number three on my list.

Number three has been on my list for months: re-doing my address book. Although I work on it for fifteen or twenty minutes

every now and then, it is obviously something I don't want to do. Whereas the first and second items on my list create connections between the earth and me and childhood memories, chore number three is about breaking connections. Somehow, I feel that, if the name remains in the book, the person is still alive. I would rather see the names of people who have died than scratch them out. The scratched out name looks harsh, like a mistake.

The only solution is to entirely re-do each page. That turns out to be a slow process and a bittersweet one. As I am accomplishing something that must be done, I am saying goodbye again to old friends and relatives. "Oh, Paul, just months ago you were in such good health!" And, "Errol, I thought you had licked that cancer." And, "Caroline, we were always going to take T'ai Chi together some day."

It is a time of quiet mourning.

The only bright spot in the whole process comes when you note down a new address because some friends have just sold their San Francisco house for several million dollars and are launched on a new life of less householding and more traveling.

So I keep that positive thought in mind after all the pickles are pickled and all the tomatoes canned, the plum jam has jelled, the peaches are frozen and I have no more excuses to postpone "update address book" when it climbs to the top of the weekend to-do list.

BETTY WHITRIDGE

# Custard for Granny

TWO OF OUR adorable grandchildren, Abby and Sam, six and four years old, are assembled in our kitchen. My mother, their beloved great granny, is sick. The two miniature chefs are going to prepare her favorite food, baked custard, which she assures them has magical healing powers.

Both cooks look enchanting, wrapped and wrapped and tied into full sized professional Williams Sonoma aprons, large wooden spoons held high—a photo-op for sure. They open the tattered old red and white check *Better Homes and Gardens Cook Book* to page 36, a very smeary, blotchy page 36. We've done this many times before. There is the list of the necessary ingredients. From long experience, Abby and Sam know where everything is. An exciting treasure hunt through grandma's cupboards follows. Yield: two large mixing bowls, two flat Pyrex pans with an accompanying dish of soft butter, a huge jar of sugar, two beaters, two measuring cups, two sets of tin measuring spoons. These two gastronomic artists insist upon each having their own tools, though they agree to take turns with the one can of nutmeg. All their treasures are carefully placed on the floor. (For three-and-four-foot tall cooks, floor-as-work-area is a stroke of

genius). The mysterious, good-smelling brown bottle of vanilla is routed from its shelf. The milk jug is hazardously hauled from the fridge. The carton of eggs, miraculously, gets all the way to the floor with no breakage. The ingredients and tools are all assembled.

A kitchen stool is dragged to the oven, another to the sink. Now all is in readiness for the great event. Sam and Abby take turns climbing the stool to the oven. Each places a big flat pan on the middle rack. Back to the sink, climb that stool in turns, carry the kettles, splashily, across the room to the oven, climb that stool in turns again. Empty, splashily, the kettles into the pans.

Climb down again. Abby, the only team member old enough to read numbers, must climb back up on the stool, study the numbers, turn the temperature gauge to 300, turn on the oven, climb back down. Sam gets to climb up and close the oven door; fair, after all, is fair.

Back down on the floor, milk is measured out carefully into the cups; almost all goes into the cups, not too much on the floor. Climb back up the stool to the stove. Milk poured into the pans on the stove. Burners carefully turned to LOW. Now comes the most exciting part of all: breaking the eggs into the big mixing bowls on the floor. Hardly any shell fragments go in. Beaters come into vigorous, somewhat competitive, play. "I'm stirring faster than you are." In goes the shimmery, slidey sugar whilst the beating continues. Errant sugar that just *will* fall, sticks in the floored milk; no problem there. "Look in our bowls, Grandma. The eggs are getting light and fluffy." Julia Child would be proud.

After the anxious wait for the milk to warm, the sous chef (moi) is allowed to hand down the hot-ish liquid from the heights of the stove, and the maestros pour it slowly, slowly, into their sugar mixture all by themselves. Hardly any falls to the floor. Vanilla is spooned from the brown bottle into the measuring spoons then drizzled into the big bowls; only a mere drop or two on the floor. The mixture is beginning to smell good, as if it should be tasted. "Hadn't we better taste it, Grandma, to see if it's okay?" Their little silver baby cups with their own initials are dipped in—Ahhhhh—

ambrosia—nectar of the Gods. Just a few more quaffs. Will there be any left for Great Granny?

With small sheets of waxed paper and soft squoozy butter, the Pyrex pans are rubbed and rubbed—the best rubbed pans in town. A and S are really *good* at this part.

What remains of the broth is laboriously poured, cup by cup, into the Pyrex pans. Just a little spillage. An artistic dusting of nutmeg follows "Mine looks really pretty." A perilous ascent of the stool bearing Pyrex pans to the oven. A difficult setting of the pans into the larger pans of hot water. Just a bit splashes in. Solemn, four-handed closing of the oven door.

During the interminable, agonizing wait for the custard to bake, the chefs smear wet sponges over the sticky floor "to clean it." They put pans, spoons, beaters, in the sink, replace all the ingredients, then curl up for a favorite story to be read.

This easy, quick recipe for baked custard, guaranteed curative for whatever ails you, is really very simple, neat and speedy and requires only basic motor skills. Try it the day before the house cleaner comes. Bon appètit!

LUCIA EAMES

# Context
# Life Flows On

BOTH MEN AND WOMEN make great contributions to and set examples for creating a nurturing context for life; however, the pervasive cultures may conspire more against men in this regard and conversely demand more of women. Although men and women may have the same initial potential to develop compassionate, sharing, honorable, wise and creative relationships, the daily burdens of maintenance more often seem to fall to women. Differences in expectation and performance tend to surface over time as, for example, in some couples' personal relationships.

Thinking generally of less than perfect nights, I find it ironic in old age, for both the fragile male and his long suffering mate, that, bluntly speaking: just at the time the withering womb of the woman tidily sets aside the fears and responsibilities of reproduction and frees her once-again-(well-almost) virginal vagina for unfettered joys of sex, the less predictable functioning of the male's penis heightens his despair and erodes his joy in sex with fears of incipient decline and failure.

As she matures, a woman tends to evolve a cherishing context for the sensual, sexual acts and pleasures of partner and self. She

weaves an airy content for this context with silken threads lightly spun of creative, thoughtful acts of love and friendship. It is a context rich in caring, sharing, laughing, working and carrying out plans together, thinking and speaking of memories and futures. She welcomes her mate in all matters, but alone or together, she remembers and with good spirit sees to whatever his, her, or her family's needs and passing whims require. Each phase of the process feels appropriate and contributes to the context as a whole. The embrace of context becomes a joy in itself and enables a relationship to weather rough spots with calm spirits, enjoy good times with enthusiasm, and continue to grow and flourish gracefully and naturally.

Each day is rewoven from every other day. And each day the shared context is rewoven upon the warp of past context with threads drawn from the present. With time, the strands can be woven into an ever lighter, stronger context. Intention and perseverance are implicit; humor and perception, prerequisite; and rewards, commensurate. Carefully unfolded, such a context provides a liberating safety net for the kind of exciting, straightforward exploration that can lift a relationship to higher levels of interaction that sparks innate spontaneous energy. Erasing the pressures of pre-set goals and fears of falling short, this allows the pair to explore together intimate contact on their own terms, a sensational, natural pleasure to share and enjoy at whatever level the moment carries them. Like any other web or hammock in the cosmos, this loving micro-context must be firmly anchored and kept in good repair to maintain dynamic tension. Any force acting on any one strand in this web obeys Einstein's Law and transfers an immediate effect to every other strand. The context must stay rooted in an interconnecting and mutual effort or risk becoming an empty illusion, a one sided delusion, a theatrical scrim onto which just one person's dream projects for a moment, then vanishes when the set is struck.

Some older men seem slow to see that the old saw "use it or lose it" applies to context as well as to instrument, and even seem reluctant to think beyond the rush of a testosterone high. Lost, with no context and unable to center himself, such a man may fixate on the

forceful flush of his youth, deny the need for context and opt for a simple adolescent dream of sex for sex's sake. Some seek to conquer again those slippery, exhilarating peaks and use the thrill of the chase or short lived flings to jump-start an inert libido, but this pursuit of the fleeting thrill of new conquests and infatuations dissipates any residual context of love between a pair and ends up, sadly, miring the pursuer in a sinking swamp into which his mate, just as sadly, is drawn.

Later, when a man's afterburners have lost their heady thrust, he may flounder anew. Adrift with no reserves, he might reluctantly attempt re-entry into the relationship he had left hanging on hold. Or, if totally burned out, without context and no ability to share one, he may lash out against his hapless mate and blame her for not putting a bounce in his prodigal step that would spring him back into the glory orbits, real or imagined, of his youth.

If either one in a pair puts off strengthening the relationship or clings to the venal spirit of *veni, vidi, vici*, both may become incapable of enduring delayed gratification, much less of engendering the unsung delights of a richly interwoven, caring context for their shared life. As incompatible as a frog and a mermaid, they are stuck in the same pond, and eventually, divorced or not, both may be doomed: most often, the woman, to slow drowning; and the man, to futile fishing expeditions—casting a frayed line into pools where pretty little fishes bite briefly, then steal the bait, or into other pools where older, seasoned fish may bring a swift but piranhic victory.

As an aging man begins to doubt himself, a woman may help him see what a solipsistic young buck does not: that within a resilient, supportive context, sex fulfills itself not as an isolated contest or passing incident, but as a marvelous, exciting part of an evolving experience.

It takes two to tango: A sufficiently dynamic pair joyfully rallies the energy, integrity and vision to weave for their shared life a context of ever growing openness, flexibility, strength and clarity with which to launch and enrich their private intellectual, spiritual, physical and sexual interactions as well as to support friendships,

community service and the fun and excitement of embracing the
world together as life flows on.

> Charity begins at home, again and again,
>   even on less than perfect nights.
>       And so to bed.
>                   Sweet dreams.

JEAN GANSA

# Feeling Young, Looking Old

I BEGAN TO experience these contradictory feelings about fifteen years ago when I was fifty-six.

First there was the set up. I was picking up my daughter Roberta at her office at the San Francisco Symphony for a lunch date. Robbie works with volunteers in the Development office. As we walked down the hall, we met one of the volunteers, a woman about my age. After Robbie introduced us, this woman said, "Oh you look like sisters." A warm glow filled me but as I glanced at Robbie, I saw tight lips and a toss of her head. I read, "Not pleased."

However I was feeling quite satisfied with my appearance. It was not that Robbie looked any older than her age of thirty-five but that I looked younger than my age. I kept all this to myself as we lunched together. After lunch, she invited me to the movies the next weekend. We often have lunch together but seldom do things together on weekends—perhaps she was taking care of me as my husband Alex was away. I thanked her and accepted.

We met at the Kabuki, a movie house that shows multiple movies from which we could choose only one. This was a change from my childhood when we saw a short subject and a double bill.

When I was Robbie's age, double features went out of business to be replaced by one big production, no longer a movie but now called a film.

As we stood in line, I basked in the feeling of being like sisters. When our turn came, a teenage Asian girl with a microphone in a large glass-enclosed booth asked me,

"Are you over fifty-five?"

I felt the question echo throughout the lobby. If words were weapons, I had just felt a hit to the chest. Before I could recover from such a blow to my self-image, I blurted, "No!"

After a moment of wondering whether I was going to let my vanity prevail over frugality, I continued, "Oh, I mean, yes I am."

Reality had to be recognized. I was over fifty-five, I did not look like my daughter's sister, and just because another woman my age knew exactly what would please me, I couldn't deny it. It was more important to be my daughter's mother than pretend that I was her sister. This experience sobered me up, and I was more respectful of my daughter's feelings and authority.

In the fifteen years since then, I have not given up enjoying things that I always enjoyed; I just do them by myself in order not to embarrass my husband or children. I still jog on the beach but probably slower, I still jump on pods of seaweed to hear them pop or on abandoned sand castles even if these activities seem inappropriate for a woman of seventy. Recently a young boy's boogie board shot out from under him, was washed up by the waves right under my foot as I jogged by, and sent me flying to the sand. As the boy stared at me in horror and his father rushed to help me, I recovered quite nicely on my own.

"Are you all right?"

I could tell by their worried eyes that they saw an old woman. I did walk rather than jog on down the beach but felt quite pleased that I was not hurt—just embarrassed and even a little amused. I was grateful to my father's good genes and for having Gentle Power Aerobics class to keep me fit.

I still consider riding the Muni bus downtown an adventure, but

I do like to sit down. Even though it is a shock to my vanity to be immediately offered a seat in the "Reserved for handicapped and seniors" section, I always gratefully accept.

Ten years ago when I was at a conference on aging, I found myself at sixty to be one of the elders and chosen to sit with some others around my age as a Council of Elders to give others advice about how we would like to be treated. I hated it and wanted to yell, "I'm not that old. I can do what all the rest of you can."

Now passing a mirror or a window on the street and glancing at my reflection I get a shocking reminder of my age. When I am with my old high school classmates who have had face lifts, I may feel quite physically fit and my husband Alex says my figure is better than many women half my age, but the wrinkles make me look older than these friends. In principle I am against facelifts, thinking we should look our age, but I admit I wouldn't mind it one bit if my face looked as unwrinkled as theirs.

My most recent experience with the ambivalence of being "in the country of old age" came one weekend in the Sierra at Fallen Leaf Lake, my favorite place since childhood. I was going for a walk by the lake, up a steep hill and across a path to smaller Lily Lake, now low enough that I did not have to walk on a log over a stream to get to it. As I sat on a rock waiting for my husband Alex, I was proudly remembering that I did walk across that log earlier this year while admitting I used a stick to help me. A young woman walked across the log and stood near me waiting for a friend who was leery of trying the log. One of the advantages of age is feeling free to talk to strangers. Being at Fallen Leaf makes me feel even freer. I called out, "You can go across the rocks now that the stream is low." She was a bleached blonde in a black t-shirt with a sparkling red star on her ample bosom.

"Your star glitters in the sun," I said.

"Yes, they'll always be able to find me if I get lost," she said. My idea of a proper Fallen Leaf type is a woman in sneakers or hiking boots and blue jeans. She did not fill the bill and I could sense the judgment of an old lady in me.

I turned to her friend beside me as she said, "I love going in the water here."

I became the elder with a long history and told her about the non-native beavers imported by the forest service many years ago. The beavers destroyed the land by building dams everywhere, causing great flooding and the loss of top soil. I could tell by the glazed look in her eyes that I offered more information than she wanted to hear.

Then I said, "Once when I went wading here as a child I came out with leeks all over me."

She looked at me with a slight smile and said nothing. Her friend who had just made it across the rocks said, "What are leeks? I've heard of leeches but not leeks."

"Oh, I meant leeches. Leeks are good to eat but hard to imagine in the water of Lily Lake." I laughed.

I made a good recovery but I felt pretty foolish, especially as I remembered the look on the girl's face. I watched them as they turned and walked back across the rocks. I sat thinking that they didn't look like they had ever hiked the six miles up the Tamarack trail to Desolation Valley Wilderness and Lake Aloha as I had done every year until then.

Alex climbed across the rocks and joined me for a walk farther around Lily Lake.

"Those girls were having trouble getting up the hill to their car," he said. "I had to help them and they look half our age." He put his arm around me and said, "We certainly get along better on the mountain trails than they do."

I looked at him in gratitude.

SUSAN RENFREW

# Take Five

LAST SUNDAY I was up at 7:00 on my way to Vacaville by 7:45 to sit for my five grandchildren while my son Todd and his wife Marty drove to San Francisco for a birthday party. There was a heavy cloud cover and it was chilly. I had the heater on in the car, but just as I reached the Vacaville city limits, the cloud bank stopped abruptly and I could see sunlight on the green round hills that are so much a part of California in the spring.

Two weeks ago, I watched the children while Todd and Marty went to a company dinner in Sonoma. That was easy. I fixed supper for Callie who is six, Cody four, and Susanna two and a half, and fed applesauce and cereal to the ten month old twins, Jessie and Sarah. The babies ate every bite and grinned at me. Then we watched a video about a teenaged baby sitter who takes her charges from the suburbs into the wilds of Chicago, gets caught by a car thief, sings in a rock club and finally returns home seconds before the unsuspecting parents know where the children have been—not the best movie for little children though Marty had checked to be sure it said PG. No one was killed, swore or made love. Putting the five to bed went smoothly, and I was asleep when Todd and Marty came home.

One of the reasons these five children aren't difficult, I told myself, was that they usually do what their parents say. Todd is a strict father and the rest of his siblings worried that he would be too demanding as a parent. It bothered me too. I wondered what would happen if he had a son who only liked to sit in his room and read. What if he weren't an athlete? As an adolescent Todd's patience was non-existent. Luckily, Marty has a magic touch, and fatherhood changed him. He still bursts into a room, lifts up the "guilty" child and carries him or her over his head to the bedroom, but I was comforted to see how when he comes home from work, he lies on the floor and they pile on him squealing and giggling. On a previous visit, Cody announced "Dad's in a bad mood" in front of his father. The two older girls nodded and laughed.

But Sunday was a different sitting experience. Todd had called the day before to see if I would come before breakfast since he and Marty wanted to stop on the way to San Francisco to do errands for his brothers. In return, he would watch the children during breakfast while Marty and I went to our favorite coffee shop for seafood omelets. How could I say no?

I was looking forward to seeing everyone but a little nervous about taking care of five for most of the day and evening. When I arrived, I walked through the garden and slid open the glass door. "Hi, I'm here." The older three ran to hug me. "Mima Sue, Mima Sue." The twins were in their swings on the other side of the room. One cocked her head and smiled, but the other looked shocked and started to scream. I wasn't sure which one because they both have blond hair, bright blue eyes and dimples. I have to find a blue vein on the right eyelid to tell that this one is Sarah. Todd explained that Jessie was suddenly afraid of strangers. In just two weeks she's forgotten me.

Eventually, Jessie quieted down and began to play with a toy bear, but when I greeted Marty, she glanced over at me, looked horror-struck again and sobbed. I thought, "Thank goodness Marty and I are leaving to have breakfast together. Maybe by the time I return I won't frighten her quite so much."

No such luck. When she saw me again after breakfast, she cried again. I've known this to happen. Babies at some point before twelve months can be startled by a new face. But this was pretty serious. It meant I couldn't feed her with Sarah. Instead, I would have to hold her in my lap with her back toward me and gauge where her mouth might be with a food-filled spoon. Even then she kept on crying.

The twins had completely shifted personalities. Two weeks before, Jessie wasn't afraid of anything and had bruises on her head to prove it. It was Jessie who climbed up the front stairs and tumbled down. It was Jessie who investigated the underside of every table and chair. And it was Sarah who was quiet and sometimes sad, whose cry was a piercing screech. Jessie rarely cried. Between six and seven months they both laughed and bounced in their platform chairs for an hour at a time and were happy all evening. Unfortunately, my maiden voyage with five for ten hours was not the best time for Jessie.

Before Todd and Marty left, she explained how to mix the Similac and showed me frozen dinners and Kraft macaroni and cheese which were the older children's favorite supper. Then they were off. She called about an hour later to see how things were going, but said she wasn't the least bit worried. I was pleased.

After a while, I found I could ignore the sound of Jessie's tears. Mothers learn how to sink into a semi-trance state when watching children. I am sure of this. When I had my four, I was in this state most of the time. I could never focus on a conversation completely because part of me was on the "qui vive" in case a child needed me.

We five had a lovely afternoon and so did Jessie as long as she didn't see me. Callie, Cody and I cut off the dead primroses and Callie watered the newly blooming iris. Their new house had a bank of stately, violet flowers. We used to call them flags. Soon Callie was sprinkling the rose bushes, "my job," she explained. She is a thoughtful, quiet girl with Alice in Wonderland hair and long tan legs, who thinks before she speaks. Then, two-and-a-half-year-old Susanna decided it was time to divest herself of her clothes and run around. Soon Cody joined her, two wiggly little white bodies running

through the water from the hose. Callie is much too ladylike to do such a thing. Finally, Susanna came to me shivering, "Mima Sue, I'm cold." So off we went up the stairs to the tub for a warm bath. I once wrote Marty about not leaving the children alone in the tub, my first and only suggestion to her about parenting, at least I hope it was. As Susanna got into the tub, the twins who were in their porta chairs downstairs started screaming. I looked out the window just in time to see Cody with a hoe raised over Callie's head. I made sure the water was only two inches deep and raced down two steps at a time to bring peace. I really wasn't worried that he would hit her, but decided I needed to make my intervention a significant event so Cody would think twice about asserting his rights with a hoe. "Put that down." Now it was Cody's turn to look shocked. He'd never seen Mima Sue so angry. "Go in the family room and sit in a chair," I demanded.

I knew I needed to make a point with him. "Cody, a hoe is sharp and much too dangerous to use to threaten your sister." His Dutch blue eyes were wide. I knew in my heart what a sweet boy he was and that it wasn't easy to always be kind and sweet to his sisters. And at the same time go off, a miniature of his father, in cowboy boots and hat to round up the cattle.

He is a satisfying little boy. When you tell him something, he listens and makes interesting observations. Though he sometimes pushes and hits those "pesky" girls, he is their protector. Suddenly, I remembered Susanna and panicked. I tore up the stairs. There she was sitting in the lukewarm water happily playing with a rubber whale. It is hard to believe she is only two and a half. She says whatever she wants to say, is very tall for her age, a wisp of a little girl with the widest smile imaginable. I picked her up in a fluffy pink towel and carried her into the three's bedroom where we opened up her bureau drawer to select the appropriate clothes. She adores dressing up, loves "hose" and dresses with sparkles. She even has a pair of pink mules with fake feathers. At the same time, she is very motherly. She is always patting or hugging the twins and climbs into their cribs to comfort them. It is Susanna who knows where the

mother cat keeps her new litter and isn't the least afraid of catching the wild older cats. Her favorite place to lie is across the broad back of Otis, the part Lab, part Weimeraner, her arms around his neck.

When I brought the twins in from downstairs Sarah took a nap, but Jessie was still too upset to sleep. I heard her whimpers over the intercom in the kitchen and carried her down with her back against me so she couldn't see my face. Callie, now in the kitchen, whispered that Jessie might like to sit in her jumping swing which hangs from the door jamb. It was a relief to finally see her bouncing there while I fixed supper, her thin legs pumping her up and down like a little frog. So far no one had asked to see television. I was proud I hadn't needed to tap into that resource.

When it was time to announce dinner, I was sorry I offered more than one choice, but Cody was so distressed by the thought of a Peebles TV dinner that I made macaroni and cheese too. The two older girls thought the idea of fried chicken, mashed potatoes, corn and a brownie all on a sectioned plate sounded so good. In the end, they only ate the chicken, poked the brownie and avoided the rest. And Cody lamented that he had had no chicken. All this was only too familiar. My children used to watch "Star Trek" during dinner and it was Taylor, now forty-one, who always wanted to sit near a pretty green plant. Only later did I find sliced hot dogs in the dirt and realized that she was burying the food she didn't want to eat. I had thought she wanted to be close to nature.

I fed Sarah and tried to give Jessie dinner and a bottle, but she couldn't stop crying long enough to eat. Fortunately, I could settle them both in their porta seats while I brought the others up to brush their teeth. Then I had them bring me books to read while we sat on Susanna's bed. Callie's choice was *Bambi*. "I like damaged books," she whispered. I noticed *Bambi* had no cover. Susanna picked *Babar and the Ghost* and several others. Cody's choice was *The Raven with the Rainbow Colored Tail*. With Susanna on my lap and Cody and Callie on either side I read *Bambi* first, remembering how much I cried when his mother died. *The Raven* was next. As I read I felt a thunk beside me and realized Cody's head had dropped the

way mine does sometimes at the symphony. He quickly rallied, but the next head to fall was Susanna's. I carried the two to bed and coaxed Callie up the double decker ladder to read another book by herself. Now for the twins...

By this time both girls were crying, but I devised a way to quiet them. Picking up Jessie, I carried her into the dark guest room and started to rock her holding the bottle in her mouth with her head turned away from me, her tense little frame still breathing in fits and starts. Then I began singing the songs on a record Taylor's god-mother gave me when she was born. It was the best baby present I have ever seen. I started "Dance to your Daddy, my little laddie, dance to your Daddy my bonny child." The thought that this was not quite appropriate crossed my mind, but this was followed by the next song on the record. "Hush little baby, don't say a word." "Much better," the inner voice said. Jessie soon forgot who was holding her. I could feel her tired little body slump and hear the sucking of her little pink mouth cease. I tried one last verse. "And if that horse and cart fall down, you'll still be the prettiest little baby in town, little baby in town, little baby in town." Oh, no. I was re-peating the part where the needle always got stuck, that mindless mother's trance again. I carried Jessie to her bedroom and leaning over the side of the crib, put her sweet little worn-out body down. I then collected Sarah. She, too, was comforted by a bottle and the rocking chair in the dark quiet room. Soon she nodded off to the song of an Irish mother during the potato famine that followed on the recording, one of the saddest songs. "Ee o eo, what can I do with ye. Black's the life that I'll lead with ye. Money ee o eo I've lit-tle to give ye. Black's the life that I'll lead with ye." The melody is lovely, but that is not why it keeps returning in my cycle of songs. It is because for a short time I step into another mother's shoes, a mother whose life is so dark she dreads her baby's future. I feel her lack of hope while I sit rocking this fortunate baby and then return to this moment of peace, my heart filled with promise for these five children.

I put Sarah down in her crib, checked the others and crawled

into bed pleased that I hadn't lost the ability to take care of children, especially ones I love so much. And then I thought of Marty. Here I am exhausted from only ten hours of caring for these five and she does this every day with a husband who comes home tired from work, wanting dinner and conversation. Marty's magic touch is the only explanation.

JOANN REINHARDT

# Thanksgiving

TWENTY-ONE OF US, aged seventeen to seventy-five, gathered around a single long table last Thanksgiving for the ritual autumnal feast, that most American holiday embraced with great enthusiasm by foreigners and recent immigrants, as well as those Americans whose ancestors started it all.

Almost everyone at the long table is related to our family by birth or marriage except for the host and hostess, Ken and Janis, who have been adopted into the Reinhardt clan on other holidays and are reciprocating by having the communal celebration at their house.

The only others from outside the extended family are Arthur and Mollie. Arthur, the oldest in the group, is the retired head of the theater department at the University of California in San Diego. Mollie, his good-looking wife, is five years younger and likes people to know it. She arrives in tight black pants and an angora sweater with fur around the neckline. Her short white hair is spiked, and several rhinestones are pasted strategically on her face. She makes everyone else look dowdy. The rest of the group is casually dressed, although my husband, Dick, out of long habit wears a tie.

What a different group it is from many years past, when our three boys, Kurt, Paul and Andy, were young. Dick and I would struggle to get all of us dressed for the occasion—me in a wool dress and high heels, Dick and the boys in gray flannels, blazers and neckties. Then, running late and barely speaking to one another, we would make the drive from San Francisco to Sacramento, the home of Dick's Aunt Agnes and Uncle Ed. The other guests would be Dick's grandmother, his mother and father, Ed's unmarried brother, Art, and Agnes and Ed's son, Ned, who is thirteen years younger than Dick.

The menu was virtually written in stone. Only the stuffing of the turkey was subject to innovation. Most years "the girls," Dick's mother, Eloise, and her sister, Agnes, would try something new, making a stuffing that involved chestnuts, or oysters, or chunks of cornbread, or a package of dry ingredients sold by Pepperidge Farms. One year they spent a long time with forks in hand, laboriously pulling the insides from a loaf of stale bread to pack into the turkey. By any recipe, the stuffing never tasted as good as the "dressing" they remembered from their own childhood.

Other parts of the dinner were traditional and were served whether anyone liked them or not. I'm thinking of creamed onions and Brussels sprouts. Onions often thin out the cream sauce, and they get all mixed up on the plate with the cranberry sauce. And the Brussels sprouts—well, all that business of saying to children "just give them a try, they're like baby lettuces" doesn't fool anyone.

The men were quietly invited to have a drink in the kitchen, but it was only the men who got the invitation. Dick's mother and aunt had a quick cigarette. They went outside the back door to smoke because they didn't want to disappoint their mother, who didn't know they had such a bad habit. They gargled with cologne and water before going back to the living room.

The pumpkin pie was the center of attention at Aunt Agnes's house. It was always homemade. I learned early on from her that it had to be baked and eaten on the same day, otherwise the crust would get soggy. The making of pie crust was a major subject of

conversation in this family, although they usually felt that it was not polite to talk about one's food. "Don't make a fuss" was their Iowa attitude.

"Agnes, this is the best pie crust I have ever tasted!" Eloise always said. (And it *was* delicious, made with lard, I think.) The odd thing was "the girls," after raving about the crust, proceeded to eat just the filling. They were always watching their weight. "That pie crust is wicked," Eloise would say, with a sigh.

There also were ritual stories. The first was about Mr. Kuser, an old friend of Agnes and Eloise's parents. Mr. Kuser had been the director of a boys' reformatory in Eldora, Iowa, and he now was the head of the San Francisco Protestant Orphanage, later called Edgewood. As the story went, Mr. and Mrs. Kuser had so many guests at their Thanksgiving dinners (including Dick's family) that the guests were sending back their plates for seconds before Mr. Kuser could stop carving and eat his own dinner. That was the extent of the story, but it was repeated every year. Eloise would turn to our boys and say, "I don't know if I ever told you the story of Mr. Kuser—"

The other annual story was about a certain Mr. Bigelow, who fortunately had remained in Iowa. Known for his fierce temper, Mr. Bigelow was carving the turkey when it slipped off the platter onto the floor. He was so furious that he kicked the turkey out the front door.

"Boys, I don't know if you've ever heard the tale of Mr. Bigelow—"

After dinner Ed's brother, Art, stood nervously and subjected us to his vocal renditions of "Trees" and "Pale Hands I Loved Beside the Shalimar," with Eloise at the piano.

Now, at Thanksgiving, we all talk enthusiastically about food— the recipes, the preparation, which person likes what, which person may have an allergy or be a vegetarian, which person needs her mother to cook her some tortellini because she doesn't like anything on the menu—the usual 90's conversations.

To me, the star of the table must be a turkey. A large chicken for a small family won't do. Better a small turkey and lots of leftovers.

In Dick's family, everyone pronounced each year's bird was the most delicious they had ever eaten. We follow the same custom.

The turkey is an exotic creature in most cultures. In Turkey, not surprisingly, it is not called a turkey but a *hindi*, as in Hindustan. In Greece it is called a *gallopoulo*, or French bird, and in France it is a *dindon* or *dinde*, a bird from India. In this hemisphere, where it originated, Dick and I once watched a wild turkey being roasted in a pit lined with banana leaves, under the supervision of a shaman, in a rural part of Mexico. In yet another culture, I watched my Chinese cooking teacher marinate her Thanksgiving turkey in saltpeter and spices and then steam it in a wok. It turned bright pink.

My most memorable Thanksgiving dinners are those that I have cooked in foreign countries—Greece, Turkey, Switzerland and England. It is never easy to find turkey except in special poultry shops where the bird is hanging by its feet in the window and costs about half as much as a Hermes scarf. Never is one more conscious that our traditional meal is made of "new world" foods than when trying to find cranberry sauce or sweet potatoes in European countries. When we lived in Greece in the late 1950's our grocer asked me: "Why are all the Americans asking for *glyco patates* today?" The Greek sweet potatoes aren't like our yams, but are a strange sweet white potato from North Africa. They wouldn't do for candied sweet potatoes or as a substitute for pumpkin in pumpkin pie. For our yams and pumpkin and cranberry sauce we depended on American friends who had PX privileges. We were one of the few couples we knew who lived on the L.E., the local economy, where such exotic foods were unknown.

At our present day communal Thanksgiving everyone volunteers to make something to bring to the dinner. Janis and Ken roast the two turkeys. We don't have Brussels sprouts, but we often have Ambrosia or sweet potatoes with marshmallows or some other regional dish that "means Thanksgiving" to one of the guests.

Last year, as we arrived at Ken and Janis's house, everyone gathered in the kitchen where Dick's cousin Ned was making Sea Breezes, a cocktail combining vodka, cranberry juice and lime juice.

"This is delicious," we all said, "but I can't taste anything. I guess I'll have another—it can't be very strong."

All the guests scurried around tending to their dishes, heating stuffing, making gravy and grazing on hors d'oeuvres. Dinner was two hours late, but no one minded.

During dessert, the group settled down to the thanks-giving part of the meal. Everyone in turn told what he or she was especially grateful for that year. It rapidly became like a therapy session. Our daughter-in-law Meg sobbed that she was grateful that her younger brother was spending so much time with their dying father. Our son Kurt choked up trying to express his gratitude at being the father of the enchanting Jackson. Mollie, the good-looking seventy-year-old, was grateful that she was not cooking a Thanksgiving dinner at her house. Meg's thirteen-year-old niece, Grace, broke down thanking her parents for letting her eat cereal when she doesn't like what's being served for dinner. Grace's twin, Lucy, in a quavering voice said she was thankful that her parents give her lots of attention, "because I *need* a lot of attention." Meg's older brother, Clay, a banker, was grateful that his daughters had no prejudices. He said he hoped to learn that outlook from them.

Each year, we remember the old stories and tell them to new-comers. Just last year Kurt said, "Remember the one about Mr. Kuser who carved the turkey and people came back for seconds before he had any himself and he got so mad he kicked the turkey out the door?"

I looked around the table. Although a generation had passed and the Thanksgiving of today is much more enjoyable than it used to be, we still appear to be fairly homogeneous. In truth, we're not all alike. We are a mix undreamed of in the earlier generation—Catholic, Protestant, Jewish, divorced, single, married, gay, Republican, Democrat, smokers, non-smokers, non-drinkers and those who probably drink too much. Love and tolerance and friendship bind this disparate group together. Everyone feels uplifted and grateful going out into the cold November night.

MARY THACHER

# My Friend Ruth

I WAS NEVER meant to live alone. But I do live alone now. I always wake up very early in the morning. I feel trapped by my four walls. I can't bear to lie in bed thinking about how alone I am. It's the hardest time of the day for me. I feel too tense to work at my desk or even look at a magazine. At that hour, the newspaper has not yet been delivered. My solution is to get up and go for a walk even though it is still dark. I have a theory that it is a safe hour. It is too close to sunrise for the "bad guys" to still be up to their mischief.

There is one neighborhood coffee shop which stays open all night. It looks like one of those coffee shops that Hopper used to paint. Sometimes I sit at the counter but mostly I don't bother. I don't want to think I'm like the other oddballs sitting there. No, better to take the coffee with me in its plastic cup and lid that's hard to open and even harder to drink out of without spilling as I walk on.

Anyway, walking is good exercise, as everyone knows, but I'd rather walk with someone else and quite often I do. Years ago when I would feel stressed out, I'd call a friend and say, "How about taking a walk with me?" Most days I would find someone to join me. I

do have loyal friends and now they often call suggesting a walk, which pleases me.

It's getting light now so I'll go back to my apartment and have another coffee and a piece of toast. I wish I liked to watch television but I really don't. Many of my friends watch the morning news shows. I should try it sometime. Then I would have more small talk readily available. But I don't like watching those smooth cats trying to sparkle at seven A.M. or interviewing someone hoping that person will make a revealing admission.

I'll go to the market soon. I prefer to go before it's too crowded. Anyway, I don't like to run into acquaintances and have to stop and make conversation. Some of them look so chic as they hurriedly do their shopping before going to work or to an important meeting. I just wear my warm-up pants and L.L.Bean jacket. I'm a lot more comfortable that way.

I usually try to do some volunteer work. I've been going to the Mission, to St. Anne's, where they serve breakfast from 6:15 to 7:30. I'm a friendly person and they seem to like me and I like them. In fact, one time I invited my co-workers over for cocktails and supper. We had a fine time. But I find it hard to stay at one organization for very long. I guess I'm restless. Besides, it's not so easy to get to the Mission.

Everything used to be different when my husband, John, was alive and our three children were growing up. We lived in a big, comfortable house in Presidio Heights. I didn't lack for activities then. I was very involved in the parents groups. I went to soccer games, brought birthday cupcakes to class, drove children on field trips and visited school fairs. You know, the regular routines. But John died of a massive heart attack in his fifties and the three children either graduated from college or just moved out. There wasn't any reason to keep the big house. I wasn't surprised when it sold quickly. I loved that house with its wonderful deck and sunny garden. It was wrenching to leave it.

I had a dreadful time finding an apartment that I liked and could afford. John had been a good provider but now I have to be careful,

which isn't easy for me. I've been in this condominium for three years. Every once in awhile I decide I must move right away but my friends keep talking me out of it.

Today I have a definite plan. I am going to pack because in three days I am leaving to visit my twin sister and her family in Chevy Chase, Maryland, that lovely suburb outside of Washington, D.C. When we were growing up we shared the same room and mother always dressed us alike, which I hated. In fact, we weren't at all alike. Frances did everything right at the convent and I was always in trouble. After high school we went in different directions, Frances to a two-year women's college (called "finishing school" in those days) then on to a secretarial course. She married a rich man. I went to Junior College, married a self-made man and moved to San Francisco.

My niece, Sally, is getting married. A friend of mine said, "Ruth, don't just go and be a guest. Why not give a luncheon for Sally and her bridesmaids?" Everyone seemed pleased with the idea. I spent a great deal of time conferring with Frances and a lot of money on phone calls. I do like to have something to plan. It will be held in The Little Club. In Chevy Chase, life revolves around country clubs and my sister belongs to two of them. The Little Club is the exclusive one. The menu has been chosen. I've talked to the best florist (several times) and have been assured that the flowers will match the pink tablecloths. It is all going to cost more than I expected but it has to be just right for the high-powered set Frances and Hector travel in.

It is June and it can be very hot and muggy there. I bought new clothes for the special occasion. I like to shop and I am a good shopper, although I must admit I do return a lot. I found a green linen dress for the luncheon and a silk print for the wedding, neither of which will be very useful in the cool San Francisco summers. Naturally, I had to buy beige shoes and a matching purse to complete the outfits.

My flight to Washington, D.C. was fine. I like to talk to the people next to me. The man on my right slept the whole way but the

woman on my left was quite friendly. Hector met me at the airport and made me feel welcome. I am staying with them. But once I arrived at their home they all seemed so busy over such unimportant details. Frances is a nervous person and can never seem to sit still or find even a few minutes to take a walk with me. Oh well, I'll go for a walk myself, I decide.

Their home is not far from where we grew up but it's much more elegant. Everyone seems to be competing with their neighbors to have the most dramatic entryway. Frances has an exotic plant in an enormous Oriental planter. I honestly don't think it's attractive but I'm sure it is expensive.

After an early dinner we all go to bed. I begin to worry, wondering, "When I wake up early tomorrow how will I find my way into the kitchen to get a cup of instant coffee without disturbing everyone?"

The morning is hot and muggy. I know they heard me early this morning as I fumbled my way in the dark. No one referred to it, but breakfast was tense and Hector looked at me reproachfully. Today is the luncheon. I told Frances I wanted to go to the Club early to be sure everything was just right. "Not necessary," she snaps, but I insist.

Leaving plenty of time, we get dressed and leave for the luncheon. It is even hotter than I expected. My crisp green dress is already wrinkled. Sally, with her curly brown hair and dark eyes, looks very pretty in her light and airy dress. She introduces me to the twenty guests and I shake hands with them, trying not to look nervous but the palms of my hands are damp. The service is excruciatingly slow. It's not like California—no one seems to want the Napa Valley Chardonnay I especially ordered. I don't hear laughter at all, only a polite buzz of conversation. Finally, the dessert arrives. It's a meringue ring filled with peppermint ice cream topped with chocolate sauce. It looks festive but it is hardly touched by the guests. The young girls rise and in a flurry of extravagant thanks they rush out. The luncheon has not been a success. I never should have given it.

When we return home, I decide to go to my room and rest. I can hear Frances and Sally working on the seating for the rehearsal dinner tonight. As the names are mentioned, they laugh and make the most dreadful comments about the guests. I am genuinely horrified. The relatives seem to engender the most scathing comments. Then their voices lower and I am sure they are trying to figure out where to seat me. No doubt I will be next to some nondescript or off-beat guest.

Suddenly my head begins to throb and I feel overcome with confusion and self-doubt. Sometimes I do talk too much and too fast. I tell silly jokes, especially if I have an extra glass of wine. But I do have a good sense of humor and one does have to keep conversation going. I prefer to go to parties early and leave early, but I won't be able to do that tonight. Am I just an embarrassment to my family?

Later in the afternoon, Frances knocks on the door, "Are you getting ready, Ruth? We're leaving in forty-five minutes." I make a sudden decision. "Come in, Frances. I have a ghastly headache. I simply can't go." Frances looks astonished. "We've just finished the seating. You ought to come. You'll feel better once you're at the party." But I absolutely refuse. She shrugs her shoulders saying, "There's lots of food in the refrigerator." No one else comes to the room but my niece calls out, "So long, Aunt Ruth. We will miss you."

I lie in bed, tossing and turning with misery. I decide to get up and make coffee. The refrigerator is crammed with snacks and leftovers but nothing appeals to me. Suddenly I think of a way out. I'll leave tonight! I call United Airlines. They have a seat on the red eye. I order a taxi. I'm not usually a fast mover, but now I dash upstairs, pack my suitcase (not even bothering to fold my new dresses) and make the bed. But first I must write a note to my sister and leave it by the front door. What can I say?

Dear Frances, I now have a fever. It must be a touch of the
flu. I can't bear to pass it on to the rest of you so I decided to

leave tonight. I am crushed to miss Sally's wedding but I know you will send me pictures. Thank you for everything.

Much love,

Ruth

The taxi is waiting. I barely make the flight. Once we are in the air, I begin to feel human again. The clamor in my head gradually subsides. Although it is a night flight, the woman next to me wants to talk for awhile. She is nervous about flying. It's a relief to talk to a simple human being.

My children are horrified when I call them the next morning and tell them what I have done. They don't understand at all. But it is not the first time I have behaved unpredictably. I didn't tell them that I realized I was on the verge of falling apart completely. I don't regret missing the wedding. My only regret is not having tasted the five-layer chocolate wedding cake that I heard so much about.

I keep telling myself, "I am a survivor. I am a survivor." This is one more crisis I have indeed survived.

JEAN GANSA

# The Time Has Come

"AREN'T YOU grown up enough to have your own computer and e-mail?" said my feisty colleague, Jack.

"I've had a computer for years, I'm just not on the Internet. I don't want to pick up any viruses."

"Jean, Alex's mail box was full, so I couldn't send you the letter I wanted to and had to mail it!" Rosemary, who rarely is cross, was irritated with me.

"Is that so bad?" I thought but didn't say. I did say, "I'm sorry."

"Jean, there are ten e-mail messages for you. I'm tired of printing them out and they are filling up my mail box." My husband Alex was also irritated.

"I'm sorry," I said and thought, "Alex is reading them and has several times said that he really agrees with or doesn't like Strephon's or Janice's or Michael's ideas." I liked it that he was reading them and thought he did too.

"Jean, everybody but you has her own e-mail address. We could send out our minutes by e-mail and save the secretary time and postage for the club if you would just get one. Alex's is always full."

Finally I heard an argument that convinced me.

"I'm going to get one as soon as we get back from Germany."

"Jean, you have been saying you are getting a new computer for the last two years."

"I'm really going to do it now. I've marked it in my calendar to go down next Tuesday to CompUSA and buy an iMac. I can get $400 off by signing up for three years of Prodigy. Do you think I should do that?" I asked my computer expert friend, Carina.

"Are you sure you want to get an iMac? There are lots of good deals on PCs now—half the price of the iMac."

"I love my old Macintosh. I never had a single problem with it. It is now ten years old and still works. I'm an Apple fan."

Janice, another knowledgeable colleague, agreed with Carina. She said she would help me donate the old one to a non-profit and set up the new one. Whether an iMac or a PC, everyone—husband Alec, children, colleagues—had finally convinced me to upgrade.

Recognizing my anxiety, Alex agreed to go to CompUSA with me to help with the choice. He talked me into the most expensive iMac because it had a lot of features he was interested in like DVD, which makes it possible to watch movies on the computer. I couldn't imagine watching a movie on a computer and wondered how much he was going to want to use it.

My one disappointment was that it only came in gray, not one of those delicious ice cream colors. We finally found a salesman, who was tall with long brown hair, which would look beautiful on a woman, and a lackadaisical attitude that I found disconcerting. He seemed to be floating a few feet off the ground. He managed to get me what he said I needed and when I told him that I wanted to sign up for the "$400 off" Internet access, he said they no longer had Prodigy but something called MSN and that I would have to go over to another counter to sign up for that. I could see that he was bored with my request.

I have a stubborn attachment to saving money at not always appropriate times, which I say is due to my childhood in the Depression. So I'm not sure how having to get an iMac when it was twice as expensive as a PC fits in this picture. It definitely is not rational

or consistent—but then how many people deal with money rationally? At least I comforted myself with that thought as I marched off to get my $400 discount, having suggested to Alex that he get the car. I signed up with MSN, got my discount, acquired a CompUSA credit card so I could pay it off with no interest in six months. While I was doing this I was thinking, "This is not the smartest way to do this, Jean. You have the money to just buy it outright and save all the 'to-do.'" However, I just kept at it and forty-five minutes later all was completed.

It was the first time the two men at the counter had done this kind of transaction, which entailed many consultations with others before they finished. I then went back to where the salesman had piled up my stuff—computer, printer, cords, and a special attachment for disks so that I could transfer my information from the old computer to the new—but he was nowhere to be found. I sighted three similar looking young men standing in a circle and asked them if they had seen him. One of them seemed to know what this was about and said that he would be back soon. Ten minutes later, I set off to find him and finally did at a check-out counter. He strolled back, decided the stuff was too heavy for him to carry and went looking for someone with a cart. Meanwhile, I worried about Alex sitting outside waiting for me. Fifteen minutes later I arrived at the car followed by the man with the cart and the computer. Alex was cross but much more accommodating about the wait than I would have been.

We carried my new collection up to my room. My friend Janice came over, partially set me up, tossed into her car my old computer, printer, and all the instructions that came with it, and was off. It was like saying goodbye to an old friend. I now wish I had kept the instruction books as the new one came with none. Before I could connect to the Internet to receive e-mail, I had to install a phone jack in the room. Two weeks later, a clone of the computer salesman, this time from the phone company, came and installed a phone jack, all the while complaining about how far behind he was in his schedule and how impossible it was to bring a jack from downstairs up to

where my computer was. Luckily he found an old phone line from my room to Alex's phone and connected the jack to that. Alex had not wanted my computer on his line, so to allow Alex use of his phone while I was on line, I had to start the arrangements to put in DSL at double the monthly cost.

As the phone repair man hovered over me, I thought, "The reason you are far behind is that you are a flake." I didn't say it, though, and checked "satisfactory" on the customer response form. There was no place to check "flake."

When I called MSN to find out about how to connect to the internet, the woman told me that you can't use MSN with the iMac and canceled it for me. Now I felt obligated to return to CompUSA to have them cancel the $400 rebate. It took three trips to finally get it done and a lot of tight stomach pains due to suppressed rage. I was tempted just to do nothing about the rebate but was afraid I'd lose my good credit rating.

Carina, who is more familiar with the iMac than Janice, came over to help me finish setting up and find an internet access. We found one but couldn't download it onto an iMac. We waited for it to come in the mail, and eventually, to my surprise, it turned up. But did the phone company really think I could connect it? Once again, no instructions. Finally, after three more visits, Carina, who loves to puzzle out computer problems, solved the riddles and I had an e-mail address.

When I did something wrong, my old Macintosh squawked like a cat whose tail was stepped on and I respectfully stopped what I was doing. This guy says, "It's not my fault" in a whiney voice when something doesn't work, and I feel like responding with, "It is too!"

Other strange behaviors complicate my life with the iMac. One day I pressed "Yes" when it said, "Do you want your pages numbered?" I printed the document only to find the number *1* sprinkled throughout the text. I found a solution but had to realize that the person who programmed my computer and I think differently. What a stubborn, difficult fellow this new computer is and how challenging to learn the technology all over again.

So far Alex has found my computer too difficult to use, but he loves to forward e-mails that interest him but not necessarily me.

"Jean, you must add your name and forward that petition to President Bush for more humane treatment of prisoners in Cuba."

It's not that I am not concerned about world affairs; I simply have other interests that take my focus. But so far, no DVD movies have invaded. The computer and the connection to the outside world with all their frustrating idiosyncrasies are truly mine, at least for now.

BETTY WHITRIDGE

# Clementine—A Love Story

OUR LOVE AFFAIR began in Northumberland in 1985 when we were guests of our friends at "Chesters," one of the stately homes of England. An ancient Roman road ran by the ha-ha at the bottom of the garden where cattle, sheep and sometimes deer, grazed in artistic arrangement. The benches in the entrance hall of the mansion were filled with walking sticks, Wellington boots, slickers, umbrellas, tweeds, caps and dog leashes, many, many dog leashes because there were many dogs—big black Labs, Irish setters, a spaniel or two.

Ruling over the canine hierarchy was the most adorable creature I had ever beheld. A feisty, happy, aggressive Jack Russell Terrier called Geoff. Geoff always had the prime spot in front of the coziest fireplace. Geoff told the horses where to stand outside the stables. Geoff instructed the sheep to stay put behind the ha-ha. Geoff arrived for breakfast in the enormous dining room and announced when it was time for a walk. Geoff's personality, Geoff's swagger, Geoff's mien were irresistible.

"Oh Fred," I said when we returned to real life in America, "I can live no longer without a Jack Russell." These were the days before the breed became chic, alas, in the USA. They were scarce then

and hard to find. We read want ads, made phone calls, wrote letters, searched and searched.

At last! A veterinarian in a grubby town in the hills outside Seattle advertised a litter with very good breeding lines. Since the American Kennel Club didn't then recognize the breed, tracing lineage was tricky. Jack Russell owners didn't want them recognized. "Look how they've bred the brains out of Cocker Spaniels," they said. "These are small dogs with big dog personalities." All a breeder could do was try to trace his line back to the Reverend Jack Russell's dogs in England. The sporting Reverend bred the dogs to hunt. They are working dogs, tails kept long to be seized to pull them out of foxholes.

A frantic phone call to the good doctor got me a promise of a male puppy with a black patch over one eye—my dream. I arose at dawn, caught the early morning ferry from our house on Orcas Island, drove miles and miles to the doctor's hard-to-find house/kennel. Playing in a cage in the sun was a wiggly mass of happy white puppies. "Here's your pup," said he, pulling a small white fellow away from his brothers and sisters.

"Oh he's cute all right, but what about this lovely one with a brown face?" said I.

"No, no, that's Jessie and I'm saving her for my daughter. My daughter just loves Jessie. Besides, you didn't want a female." The puppy under discussion came over to my hand and kissed it, looking up at me with longing eyes. I had to pick her up. I had to have her. It was overwhelming love at first sight. There was a good bit of haggling (did this doctor even *have* a daughter?), but I didn't care; this was my destiny to be achieved at any price.

"Now, Jessie is a sensitive dog like her father," said the vet. "She responds to suggestion, must be treated gently, is remarkably intelligent." After I had agreed to be both sensitive and gently intelligent and forked over more and more dollars, I was finally given permission to buy Jessie. The vet prepared an enormous cardboard carton for her to ride in and we were off.

I had to stop and whisper to the puppy that she really wasn't

Jessie at all but Clementine. Then I had to stop again. Clementine
was whimpering. After a bit of reassurance we again sallied forth.
Again we stopped. Clementine was vomiting. A bit of cleanup, but
then we had to stop again—woeful sounds echoed from the great
coffin-like box. Clementine missed her rollicking, tumbling siblings.
Ridiculous for her to be boxed like groceries—I'd just hold her in
my lap. Clementine snuggled right up to my body warmth and
soothing hand. As we would discover, Jack Russells love to snuggle
and cuddle.

It is really possible to drive with only one hand.

Luckily I had on a washable cotton dress as, by actual count,
Clementine vomited thirty-four times in my lap on the journey to
the ferry landing. I'd forgotten to inquire whether her sensitivity
meant that she would be a carsick, non-car-riding dog. Even so, I
never got angry, only felt sorry for her, and she seemed glad I was
there. We bonded on that voyage home.

During our absence, Fred had fashioned her a nest in the laun-
dry room complete with hot water bottle, ticking alarm clock, wooly
pillows and blankets. She loved it. Once, and only once did she pid-
dle inside. We told her sternly but gently, "*No*," carried her outside
and, *mirabile dictu*, she never ever made an indoor mistake again un-
til the ravages of old age overcame her. The vet was right—she was
a genius.

The next day was sunny. Fred had built her a wire enclosure on
green grass under blooming apple trees. It had a small box house-
like shelter in it, and toys and a water bowl and it was right by our
front door. Clementine positively smiled. She loved it. Later we
took her to the tennis court while we were playing. Suddenly, with
horror, we noticed that she was gone! I knew that a bald eagle had
got her. We ran crying, calling her name, all over the property.
When we got back to the house, through our tears we saw Clemen-
tine, the genius, sitting happily in her wire pen.

Clem really should have been a star on a Brazilian soccer team—
we found that she could jump three feet in the air and hit a flying

ball with her nose. We have pictures of her halfway up an apple tree after a squirrel—Jack Russells were born and bred to hunt, remember. On one of her first walks to Crissy field, when she was really tiny, she got out of its hole a gopherish creature almost as large as she and proudly brought it to us. Jack Russells are bred to hunt. The Orcas Island Tennis Club remembers her with awe coming around the corner of the court fence proudly carrying a huge rabbit in her mouth. Three ("brains-bred-out") Cockers followed her looking awfully amazed and impressed.

Clem learned several English phrases: "Clem can swim" made her bound from sleep, or any occupation, run out the door and down to the beach. "Feed the puppy" caused her to bounce up and down and run to her food dish.

She didn't actually speak English, but she always told us when it was 9:30 A.M. and 3:30 P.M., time for her morning and afternoon walks in the city and no fudging about it. Another Jack Russell fact: they are very exercise intensive. When we were in San Francisco, we took her twice a day to Crissy Field, Golden Gate Park or the Presidio, but even on Orcas Island, where she ran free as a breeze all day every day, we had to stop what we were doing and give her a little gyro around the road at 9:30 and 3:30—we didn't need a watch.

Far from my fears after my initial drive with her, we discovered that Clem was the best car dog that anyone had ever seen. She was never again sick and would sit at the feet of the person not driving and never stir. When she needed to get out on our long trips, she would just nudge with her nose and wiggle slightly. After we checked into our room at a motel with its endless anonymous halls, she never ever went to the wrong door. Incredible—and she didn't even have a numbered key.

When one of us was sick, we called Clemmie, dressed in white, our nurse; she would stay right beside us. She visited my mother in the nursing home and cheered up all the patients but wouldn't let the nurses come near Mother.

Fourteen years of joy and pleasure came to us from this little

white dog. A friend built her a fine cedar box from his treasured best wood; Fred wept as he dug her grave. Clem lies with her tennis ball and favorite blanket in a beautiful spot that she loved in our woods at Arcady.

# Another Country

LUCIA EAMES

# Splintered Reflections

Long ago,

as a child, I privately noted quite matter-of-factly:
the lashless pink lids rimming Eliel's water-blue eyes;
the deeply set, almond shaped nostrils in Miss Hades' face;
the delicate, downy, bewhiskered cheeks and chins
a-quiver in concert with chatter at afternoon teas;
the wrinkled, drawstring mouths at nursing homes;
the bewildered sad look in Trot's widening eyes each time
her mind dropped a stitch and began to unravel anew;
the birdlike clutch of Mother's hand to elbow.

Today,

that child, now *inner* but still strong as ever, is laughing
with me when I note those characteristics again:
reflected back with splintered precision
whenever I look in the bathroom mirror.

SUSAN RENFREW

# "I Think We've Stood and Talked Like This Before, But I Can't Remember Where or When"

"I KNOW SO LITTLE about Arabia, only that movie," confessed Joan.

"You mean *Lawrence of Arabia?*" The other Joan asked.

"Yes. The one with that British actor with bright blue eyes. What was his name?"

"I can't remember. It's on the tip of my tongue. I saw him on Charlie Rose. His eyes are still blue. He was talking about his career and how making that movie took two years," she said.

"But what was his name?"

"It always helps me to go a, b, c, etc. or it pops into my head in the middle of the night," Annette said.

"I can't bear this. It drives me crazy. I remember his drinking buddies, oh, no, now I have forgotten their names too," said the other Joan.

"The one with blue eyes was much more charming as an older man than I remembered. I never did like his chest when he was young. It was too white and weak looking," Sue said.

The other Joan laughed. "Here's Barb. She might just remember. Can you think of the actor in *Lawrence of Arabia?*"

Barb sighed with pleasure. "Omar Sharif."

"No, the one with blue eyes," all four women said together in exasperated voices.

"You mean Peter O'Toole," Barb said smiling.

"Oh, thank you. It would have bothered us all day," one said.

The two Joans, Annette, Sue and Barb all belong to a book club that meets twice each February when Barb, who lives in Cambridge, visits the Bay Area. All but Sue were from Denver and went to Stanford together. Four now live in Northern California. For the past eight years the group has chosen one or two books to read and discuss, and this time the choice was *The Passionate Nomad* about the intrepid traveler and writer Freya Stark. Their meeting lasts from eleven to two. For years each brought whatever food she wished and the arrangement had worked until this year when two weeks before, there were only cookies, pop corn, muffins and three dishes of fruit until Sue rummaged in her refrigerator to fill in the blanks. Today three brought protein to make up for its lack at the last lunch.

As they were about to sit down, Joan stood at the table and said, "I think you have too many places set, Sue." Sue counted. There were five. "It's right, I think," Sue said.

"Well, who is this one for?"

"Joan."

Sue pointed to each chair, "Annette, Joan, Barb, Joan and me."

"But you have put two Joans," said Joan.

"But there *are* two Joans."

"Oh, not another one of those lapses," Joan sighed and looked around hoping to be forgiven.

Annette changed the subject. "What are you going to do on your seventieth birthday?"

None had planned what they would do.

"I'll be seventy next year in June," Sue said.

"Next year?" Annette questioned. "But June is in four months. Isn't it this year?"

Barb hurried to close the long pause. "I'm glad we picked the book we did. What an amazing woman. I have to admit though she

made me more and more irritated at the end. I hate the photo of her when she is an old woman in a fancy dress showing off but I like the one with the Queen Mother."

"Mary?" Joan said.

"No, Elizabeth," Annette said.

"But Elizabeth is the present queen."

"No, that's Mary."

"No, Mary was her mother." They stopped talking about English royalty.

"Did you see the cartoon by Roz Chast in *The New Yorker?* It had a seated woman and a wedge on the right coming into her brain with the names of rock stars written on it and another wedge coming out on the other side with the history of the Roman Empire written on that. I guess that is what's happening to us," Joan said. "We learn something new, not even something we care about, and out goes a whole body of information."

"Just to prove it, I did the stupidest thing," the second Joan said. All eyes turned to Joan. "I couldn't find *Passionate Nomad* in any Healdsburg bookstore so I ordered one on Amazon.com. I always feel guilty, don't you, when I do that because I try to frequent my local store. Then a couple of days later I found a copy at the library. The next day this package arrived from Amazon. I couldn't imagine what it could be and opened it. There was *Passionate Nomad*. What in the world was it doing here? Had one of you sent it to me and why hadn't you told me? I was quite irritated, but then I remembered. I had ordered it."

"Well, I have a story that will top that," said the other Joan. "I was at a Senior singles of Stanford grads sitting between two men. I turned to the one on my right, who was quite attractive, and he started talking about a remote island he had visited where the goats were so tame they came up to you to be petted. I exclaimed with delight. We continued our conversation for awhile, but I began to feel I had left out the man on my left so I turned to him and chatted. It wasn't that interesting so I again turned to the one on my right.

'Where are you from? Do you travel? You know, not long ago, I heard about this lovely island where the animals are so tame that the goats come to lick your fingers and let you pet them?' He looked alarmed and then I realized what I had done."

"You could have acted as if it were a joke," Sue said.

"I tried, but he continued to look shocked so I knew that wouldn't work. He must have thought I was senile." All five women laughed until the tears ran down their cheeks.

"The actor's name is Peter O'Toole," Annette cried.

"Barb already told us," they said.

And then they planned to meet again next year and smiled, "If we don't forget."

JOANN REINHARDT

# The Backwards Catalog

THE CATALOGS, the catalogs! They come in every day in big batches, especially in the fall, when the companies hope to tempt people for holiday giving. The mistake I made years ago was placing that first order.

Suddenly, I am getting catalogs I have never heard of. I get catalogs that promise wrinkle-free travel clothes (someone knows I travel), wheelchair accessible toilet seats and electric foot massagers (someone knows I am a senior), and catalogs for the serious chef (someone knows I like to cook).

Recently, I received a catalog called "The Vermont Country Store," with a picture on the cover of a cupcake with an American flag stuck in it. Before tossing it out I started leafing through it. I started at the back. I don't know why I always start at the back of catalogs and magazines, but I do. (I think I got in the habit when I found the back pages of *Time* and *Newsweek* more interesting than the front.)

The first item that caught my eye was "1950's Steel Lawn Furniture Is Still Stylish." Pictured is a dark green molded chair with a shell back and tubular legs. I remember chairs that looked like that,

peeling and rusted, sitting forlornly on brown crabgrass. In a world of Brown Jordan, who would ever buy a chair like that? Perhaps it's fashionably Retro. The text says: "Remember summer evenings sitting back in a chair like this one after all the day's chores were done?" Even the word "chores" is from the 1950's. I don't think people do "chores" anymore, except for the jobs children do, setting the table or feeding the cat.

The next section was devoted to food—Charms candy, Chiclets and Teaberry gum, Junket custard powder, and Ovaltine, a "memory-packed drink," imported from Europe for the "taste you remember." The text tells us that American Ovaltine has changed over the years, and I approve of that. I never liked it very much and only pleaded with Mother to buy it so I could have the thin round aluminum seal to send in for an Orphan Annie decoder pin.

Moving on to the kitchen section, I saw Vinyl Bowl Covers, "Better Than Wasteful Plastic Wrap." I well remember those miniature shower caps that covered leftovers and then had to be washed and drip-dried on the drainboard. Personally, I have always thought that Saran wrap was a marvelous invention.

Next, my eye fell on iced tea spoons that were also straws. I haven't seen those for years, although somewhere I have some of them. They belonged to my mother-in-law. I should find them and use them.

Right below the iced tea spoons were "Customer Requested Aluminum Ice Trays." I can't imagine anyone requesting those infuriating things. After about the third time you use them, the ice cubes stick and the levers freeze halfway, without releasing the cubes. I have always thought that plastic ice cube trays that released with a simple twist were quite an innovation—to say nothing of automatic ice cube makers.

On page seventy-eight I found a "Reliable Steam Iron With The Hefty Feel Of Your Mother's Iron." The text goes on to say that it has the familiar weight that's missing from today's lightweight models. My hand hurts at the thought of its hefty feel.

The catalog offers many necessities for what it calls "wash day."

One may order old fashioned washboards, clothespin bags, Argo starch ("the one Mother used") and even an oval wash tub, which it says is ideal for washing your "delicates" or chilling cans of your favorite beverage. I like the metal pants stretchers for $14.95. I used to have a pair and they were very handy.

Earlier pages show more household items. One page features slip covers, "Because Mothers Truly Know Best." In my opinion, no self-respecting mother would put these on her chair or sofa. One is gathered and badly fitting, and the other is dark green with fringe dragging on the floor. It is described as "The Way Mom Used To Protect Furniture From Everyday Wear." It is clear that "Mom" as the authority and taste-arbiter is central to this catalog.

Continuing on, past record players and old fashioned metal telephone number flippers, I come to oilcloth "Like The One On Mom's Kitchen Table—superior to flimsy plastic." Next are the scalp products, including boar bristle hair brushes and two pages of hair removal preparations. Then we get to fragrances—Yardley and White Shoulders (isn't this politically incorrect?) and Blue Grass, an old favorite of mine in high school. The next page brings us to men's toiletries, among them two grades of shaving brushes, standard and deluxe, and 4711 aftershave.

In the women's lingerie section are things I haven't seen in years, such as Kleinert's dress shields and the kind of foot socks that we used to call Peds. The bras and panties shown would never make it into a Macy's ad, much less Victoria's Secret.

In the section on women's clothing (past shoe trees and spectator pumps, past swim suits and bathing caps, housedresses and muumuus), I discover on page nine (item F), a "Hard-To-Find Snood." Well, I should think it would be hard-to-find! I am in my early seventies, and I have never worn a snood, and don't know anyone who has. One of my aunts, who died last year at ninety-two, had a snood when she was in her twenties. I remember the crochet work encircling her dark hair. I thought she was very beautiful in it, but I haven't seen one since.

I asked my fifteen-year-old grandson if he knew what a snood was. He thought a while, then asked "Is it something medieval?"

"Well, almost," I said.

Somehow, I haven't felt so young in ages as I did after reading the Vermont Country Store catalog. I haven't been in Vermont in over twenty years, not since the time we took our youngest son on a college tour, but the catalog makes me curious. Perhaps snoods are all the rage in Vermont this year. The catalog makes me feel that I am forward-looking, not backward, although I do admit to being tempted, on the very first page, by "Jewel-Tone Aluminum Tumblers Like Mom Used To Have." My children remember these unbreakable glasses at our mountain cabin. I am so glad I started at the back of the catalog and saved the best for last, or first. I think the old cabin deserves more colored aluminum glasses as a nostalgic Christmas present. Our children and grandchildren will wonder where in the world we found them.

SALLY McANDREW

# The Waiting Room

MY HUSBAND LARRY'S heart bypass surgery was scheduled for 9:00 A.M. on October 25, but Dr. Zabriskie, his surgeon, told me not to come over to the hospital till about 11:00 so I wouldn't have such a long wait. Larry had had an angiogram the previous day, and the cardiologist was so concerned about the outcome he insisted on surgery the next day even though it was Saturday.

Bypass operations being common now, I was fairly confident when I entered the waiting room on the operating floor of Buchanan Memorial Hospital. There were two identical waiting areas across the hall from each other, one for surgery, the other for intensive care. The surgical waiting room was crowded so I chose the other. The room was, perhaps, ten by fourteen feet and cramped. There were no outside windows, but large windows lined one side facing the hall, so passersby could look in as if it were an observation chamber. The chairs, all straight-backed and armless except for two love seats with high, straight backs and sides, were arranged facing each other around the walls like a doctor's waiting room. In opposite corners of the room were two square tables, both with nonfunctional lamps and a few tired old magazines like *Family Circle, Modern*

*Maturity, Golf Digest.* On one table was a telephone with an outside line but the cord, with its frayed end, dangled loosely as if it had been yanked from the wall. The only working telephone was a stand-up pay phone down the hall next to the elevators, providing no privacy and a great deal of noise. Fluorescent lighting cast a depressingly lurid glow, making everyone look wan and exhausted. Remnants of food littered the tables and floor, exuding sickly-sweet smells of deep-fat-fried wontons mingled with stale hamburgers and onions. There was no TV, of which I was glad.

Serving both waiting rooms was a tiny inside bathroom with dingy once-beige walls, peeling paint, a cracked sink and a chipped toilet seat. There was no fan, the towel and soap dispensers were empty, and the room smelled of accumulated excretions and despair.

Another woman and her teenage son were in the waiting room that morning. Mrs. Lin's elderly husband was having bypass surgery also. Somehow she had commandeered several pillows and a blanket and had made her small frame sufficiently comfortable to sleep on one of the love seats. Her son told me they had been there for four days. Four days! I thought. No way could I stand to be in this horrible place for that long.

About 1:00 P.M. I went to find something to eat. The cafeteria situation was grim. During the week, there are two rather pleasant eating places, one run by volunteers, with windows facing the street, the other in the adjacent medical building, which had a pleasant outside eating area. But on the weekends the only place to find food is in the basement of the hospital, where there is a cafeteria as well as a tiny room lined with vending machines. I entered the cafeteria and looked for something appetizing. The hot food station occupied one wall where stainless steel bins of meat, fish, pasta and vegetables were warmed by orange infrared lights. The food offerings were swimming in grayish liquid with globules of fat floating on top. Maybe I'll check out the salads, I thought. It looked as if everything had been there for days, the lettuce limp and brown, the mushrooms slimy and decayed, the carrots and broccoli equally inedible. In the fruit section the jumbo-sized oranges were hard as rocks with thick

skins and the huge Red Delicious apples were covered in a wax coat-
ing so artificial-looking that even Snow White would not have been
tempted. In the refrigerated cases, salt, sugar and Aspartame were
displayed in their various manifestations: Diet Coke, Classic Coke,
Diet Pepsi, Dr. Pepper, Snapple, Hostess Twinkies, candy bars, fro-
zen yogurt. There were several stale sandwiches of mystery meat
and spongy white bread. One could die of malnutrition on a steady
diet of this food, I thought, but remembering how Larry would have
made the best of things in such a situation, I forced myself to eat
some chili and went back upstairs.

At about 4:00, Dr. Zabriskie came in and said he had done a sep-
tuple bybass on Larry, and that although he had come through it
well, his lungs weren't working quite right yet. He had a breathing
tube down his throat so couldn't speak. The surgeon said I could see
him. When I entered intensive care, Larry was alert and greeted me
with his eyes. He made a motion as if to write and pointed to some
paper on the table, so I gave him a pad and pencil and he scribbled,
"Don't forget the glaucoma drops." I asked the nurse if it was nor-
mal for the lungs not to function after a bypass, but she was non-
committal. A little warning bell went off in my viscera then, but I
only realized it later. I went home and called our daughters and a
few friends and told them that Larry had come through the surgery
well except for a small complication with his lungs, which didn't
seem serious. Then I poured myself a glass of wine, took it upstairs
and soaked in a long, hot bath. I dressed, had a bite to eat and re-
turned to the hospital. By the time I went home to bed, there had
been no change in Larry's condition.

Sunday morning I got to Larry's cubicle early to find his lungs
still were not working. Clearly the staff was worried and told me
they were taking him to have an echocardiogram. Anxiously I re-
turned to the waiting room where a large family of Latinos had
joined the Lins, their small children lying on the floor, playing and
crayoning. They had brought a radio and tuned it to a Spanish-
speaking station playing loud salsa music.

After about an hour the surgeon came in and, in the absence of a

conference room, sat down next to me and related the bad news. "Yesterday during the surgery," he said, "I noticed there was tissue stuck to the catheter when I pulled it out of the heart. At the time, I didn't think it was important, so I went ahead and closed him up." He paused and took a breath. "When his lungs didn't regain their function, I realized the tissue must have been torn from the tricuspid valve, making a hole." He went on to explain the impact that this opening could have on the functioning of the heart. If there is a malfunctioning valve, the blood, which is pumped to the lungs, could flow in the wrong direction. "I have to open up his heart immediately and close the hole," he said. "It's a simple process," he added. Larry had given his permission and, having no other options, so did I. I sat there numbly, trying to absorb the news.

When a disaster like this strikes, you think you are coping and carrying on as usual, but you aren't. I couldn't grasp what had happened nor understand the technicalities of blood flow. All I knew was that Dr. Zabriskie was going to assault this seventy-two-year-old man with a serious heart condition, to whom I had been married for forty-three years, re-cut the same incision from the sternum to the navel he had made yesterday, once again wrench apart his rib cage and this time slice open his heart, which had been subjected to major trauma the previous day, to repair a hole that should not have been there in the first place. I knew that this must end in disaster.

I had to get away to try to make sense of what had happened, so I walked around the halls for awhile, then went down to the vending machine room in the basement to get some water. I fished out a dollar from my purse and inserted it into the slot, but it was the wrong slot and there was nothing in the little box. I stood there contemplating whether it was worth finding another dollar and suddenly it was all too much. A motherly-looking kitchen worker came into the room and stared at me for a minute, then said "You're having a bad time, aren't you?" As I broke down in tears, she led me to a bench in the darkened cafeteria and in a minute returned with a bottle of water—on the house. I took the water and went to the ladies room, closed the door of the booth, sat on the toilet and cried and cried.

After a while, I washed my face and went back upstairs to the waiting room.

In total, I spent ten days in the waiting room and in intensive care watching Larry for some sign that he was emerging from the massive stroke he suffered during the second surgery, willing him to open his eyes, move something, make a sound—any sound. When he did, about two months later, he was paralyzed on one side, could not speak intelligibly and was severely mentally impaired. He was transferred to another hospital for four months of rehabilitation until Medicare ran out and then taken to a nursing home where he lived three more years.

In thinking back on this time, I wonder why the hospital's facilities were so important as to command several pages in this memoir. Surely no degree of comfort and good food would have brought my husband back, so what difference would it have made to have nicer accommodations? In my mind, the waiting room and the medical catastrophe are so closely entwined I cannot separate them. As I tried to cling to some shred of normalcy, the unwelcome, toxic atmosphere of the hospital comprised an entirely alien reality to which I could not relate. To me, the waiting room symbolized the cruel indifference of the medical establishment to the non-medical needs of patients and their loved ones. In this new world I had entered, I knew instinctively that in order to survive, I had to shut down my feelings as much as possible. Perhaps that is why the kitchen worker's kindly gesture was so touching that black, lonely day before my children came and friends rallied round.

BABS WAUGH

# Sunday Lunch

"WE'LL HAVE THAT crab bouillabaisse we had at Christmas when the family was here," I told my husband, Dick. We were having a few people in for Sunday lunch and I wanted something easy and light, something I'd made before. I could roast a chicken, but that seemed too heavy, too traditional.

"Mm," Dick said absently. "That's fine." I knew he probably didn't remember the time I was talking about, but he usually went along with my suggestions and anyway, I pretty much did what I wanted in the kitchen. We had a lot going on that weekend, and I liked the idea of being able to make the soup base a day or two ahead, then finish it by adding the fish, shrimp and crab after everyone arrived.

"I suppose I should have a salad, too," I said.

"Yes," he said, deep in the sports page, "we certainly need more than soup."

Even though it was winter, I flipped through Diane Worthington's *Taste of Summer* looking for something different; I was tired of plain green salad and was feeling like the young daughters of English friends who had turned up at our house some years ago

after driving across the country. As we talked to them about their trip, one said casually, with that British way of emphasizing consonants, "All that lettuce!" I understood instantly how the eating part of their trip had been, day after day stopping at roadside restaurants that offered barely varying iterations of salad bar after salad bar. For this Sunday lunch, at least, we would have a green bean salad with mushrooms and walnuts and a walnut oil dressing. We'd have Mary Thacher's poached pears for dessert with that heavenly winey syrup and good bakery bread, too.

"Dick, you wouldn't mind going down to town for bread Sunday morning, would you?"

"Not at all," he said agreeably. I had decided on sourdough and a walnut bread I like even though it's bluish. I would give him the details just before he leaves; I've learned about the hazards of sending men for groceries without specifics in hand as they go out the door. We'll start with my guacamole, I decided; everybody always raves about it, and a Bloody Mary while the soup finishes.

"I'm early," my old friend Leslie announced firmly as she came in the door at ten to one. We go back a long way; her late husband, Bill Luttgens, and mine were partners.

"Here's a box of white chocolates somebody gave to me, I have to admit," she said, handing it to me. "I'm trying not to eat this sort of thing."

"Thanks," I said, remembering how tight my slacks felt as I'd zipped them up a moment before. "What a pretty package. I'll pass it around after dessert."

The doorbell rang, and it was Hewlett (Hewey) and Ely Lee. "Well, look who's here," they said with real pleasure as they caught sight of Leslie. Years ago, the Lee family had taken Leslie in after her father, an old family friend, died, her mother having died years before. They had remained "family" ever since.

Joe and Betty Hirsch, the last to come, arrived on the heels of Hewey and Ely. Joe, the youngest of us all—he calls himself a pre-geezer—was limping and wearing a pink slipper on his left foot. "I've got the gout," he said, "and I can't wear a shoe at all."

Joe is a lawyer, his feet usually well-shod in good-looking tas-
seled loafers. His wife Betty handed him a black leather slipper.
"These hurt, too, but they're OK for just sitting around," he said.
What a shame, I thought. He certainly doesn't resemble the over-
fed caricature of the eighteenth century Englishman, foot with huge
bandaged toe resting on a footstool. Joe is trim, youthful looking,
only just retired.

Introductions made, Dick took orders and I brought out the
guacamole. At the last minute, I'd remembered that Hewey's wife
Ely is allergic to avocados so I rummaged around in the refrigerator
and found some presentable cheese. When I passed the guacamole, I
found out that Joe doesn't eat avocado either, and Ely, seemingly de-
lighted to discover a fellow allergy sufferer, asked him if he was al-
lergic, too.

"No," he said, "I just don't like the taste." So much for my fa-
mous guacamole; no one seemed to be making much of a dent in the
cheese, either. Well, they shouldn't eat too much before lunch, any-
way, I thought, as I went into the kitchen to attend to the bouilla-
baisse.

It was ready at last, and I put the huge pot of soup on the buffet,
then called everyone to lunch. "Oh, that smells wonderful," Ely said
as we moved into the dining room, but Joe's wife Betty pulled me
aside to ask if the bouillabaisse had shellfish in it.

"It does," I said, "but I'll just give you the fish, not the crab and
shrimp."

"I just can't eat it at all," she said apologetically. "Once shellfish
are in the broth, I can't touch it. I get terrible hives. Don't worry, I'll
just have the other things." The "other things" were only beans and
bread, hardly enough for Sunday Lunch. I was thinking longingly of
my initial idea of roast chicken.

"I'll warm up some chicken soup," I said brightly. "I make it and
freeze it and it's delicious." She protested, of course, but I stuck a
container of it in the microwave anyway. Soon everyone except
Betty was well into the bouillabaisse. "I can't eat anything with pu-
rine in it because of the gout," Joe was saying gloomily, "and all the

things you can eat if you have gout are what you aren't supposed to eat if you have a heart problem—like milk and cheese and eggs." Joe, youthful as he seems, had a heart attack at fifty-five and is in Dick's cardiac rehab exercise program. "Purine's in everything else," Joe went on.

"What is purine, anyway?" I asked.

"It's a bunch of things," he said. "Uric acid is the bad one. It's in everything, meat, chicken, lentils, spinach, crab…" He paused. "Oh, oh," he said and looked at Betty. "I know," she said. "Just this once, I figured." I'd really hit the jackpot on my menu today.

"Well, you've got the disease of kings," said Hewey expansively. "Spinach has purine *and* calcium carbonate in it. I make kidney stones, so I can't eat anything with calcium carbonate in it." At least I hadn't made the spinach quiche I sometimes serve for lunch.

Ely chimed in with "Well, I can't eat walnuts."

Of course, I thought, then said, "You'd better watch the bean salad; it has walnuts in it." I decided not to mention the walnut bread. Leslie at the other end of the table suggested I put a chart on the front door next time I have a lunch or dinner party so people can check off what they can and can't eat. It's not like Leslie to be so dense, I thought; a chart on the door is too late. In the general hilarity that followed her idea, someone suggested sending out a questionnaire with the invitation. Much better, I shouted as I went out to the kitchen to retrieve the chicken soup from the microwave. When I came back, the conversation had moved on to a discussion of the different kinds of carbohydrates and Dick was quoting from the Harvard Health Letter.

"Is there anything you can't eat, Babs?" Ely asked me when I'd sat down again. I felt she was trying to draw me into the conversation.

"No, not really," I said, then thought hard, hoping I could come up with at least something. "Raw green peppers," I finally said. "I taste them for days."

"Oh, everyone does that," said Ely, dismissively, as her husband, Hewey, was saying, "I've got old guy's diabetes. I'm not supposed to

eat ice cream, you know, and most everything else that's good." We would soon be having the pears. Oh well, I thought, he can just not eat the syrup.

"Hewey takes a pill and eats anything," Ely was saying reassuringly now. Had she had a premonition of dessert? Hewey is a renowned surgeon on the Peninsula, was once the head of the Palo Alto Medical Foundation and prominent in state and national medical circles. He eats what Ely tells him to eat and Ely takes full credit for his losing forty pounds last year. "I love to eat," said Hewey, happily. "I like everything and I'm hungry all the time. Ely is never hungry." They are devoted to each other.

"Well, when I'm not home," I said, "Dick almost forgets to eat lunch." He and Ely are pencil-thin soul-mates.

It was now time for dessert and Betty having finished her chicken soup volunteered to pour the coffee while I arranged the store-bought cookies on a silver tray and dished up the pears in the kitchen. They really did look pretty, glistening and fragrant after I'd spooned the sugary syrup over them. Tiny strips of orange zest decorated them and floated in the syrup in the bottom of each bowl. As Dick and I prepared to bring them in, I heard a worried voice call out, "Is the coffee decaf?" It was. At least I'd got that right. At our age, what did they think I'd serve after twelve-noon, for heavens sake?

After dessert, I started the box of white chocolates around without much hope, and sure enough it came back barely touched. I took one as a reward or a consolation prize, I wasn't sure which, then sat back listening to the stories: Hewey was regaling the rest of us with tales of growing up in the Lee family, the brothers duty-bound to waterbag Leslie's dates if they seemed too well-dressed; others had stories to tell, and as the afternoon wore on, the conversation seemed a thing unto itself, careening around the table, bouncing back and forth and around, laughter erupting like a cheer at a basketball game when someone makes a basket. No one seemed to want to leave, but finally, as dusk came on, one, then another began to make sounds of departure. As the last of the guests went out the

door, Dick and I followed them down the steps toward their cars, waved them off, then walked slowly back up toward the house.

"That was a nice party," Dick said. "I think everyone had a good time."

"My menu was almost a disaster, though," I said, remembering how every course posed a threat to at least one of our guests.

"That didn't matter a bit," he said. "Everyone had a great time talking about their ailments. And you did produce some chicken soup for Betty." Arm in arm we continued on and I felt warm and loving towards Dick and towards all our wonderful, funny, clever friends just departed.

How smart I was not to have served the chicken.

JEAN GANSA

# Vacation Special

Dear Mr. and Mrs. Ganja, This year treat yourself to a most exclusive vacation invitation. Marriott, the world's leader in hospitality, cordially invites you to steal away to Southern California's Desert Playground and experience a lifestyle that dreams are made of. Reward yourself and enjoy a:

5 day / 4 night "Desert Escape for Two"

at Marriot's Desert Springs Villas

for a mere

$298.

*Call within the next 72 hours.*

THIS INVITATION arrived in the mail sometime in January. Usually I threw such things away especially if our name was misspelled, but not this time.

"Alex, how about taking a real vacation in Palm Desert. It would be very different from the usual things we do."

Alex, my husband, was reading the paper and watching the stock prices slide by on the television screen. He didn't look up at me but said, "Um."

I repeated my question.

"Um, sure, whatever you'd like, dear."

"Don't you think you should look at the invitation?"

"No, you just go ahead."

I knew he wasn't really paying attention but nothing would

happen if I didn't do it. Our vacations usually consisted of visiting his relatives in Russia, Germany, New York or Los Angeles. We hadn't been to a resort since we spent one night in Crete ten years ago on our way to an archaeological dig that his son Charles had been on. We'd been to Palm Springs once, fifteen years ago after following Alex's two-week Navy Reserve duty at Twenty-nine Palms.

"What about the weekend of April fifteenth?"

"I don't know, I think we must have something then. I'll look later."

"We have to call within twenty-four hours to get this offer." I fudged a little on the time.

"O.K., O.K., I'll look now," he said with a big sigh, put the paper down and went down the hall to our board where all the invitations are pinned.

"I guess it's all right. You sure you want to do this?"

I picked up the phone and called the 800 number listed on the invitation. A cheerful female voice answered, said the date we chose was fine and gave me a ten-digit confirmation number. A letter arrived confirming our dates on Thursday. Friday morning at breakfast the phone rang with a cheerful man's voice.

"This is Robert with the Marriott Desert Escape. We are so happy you are coming. However the date you have chosen is no longer available."

"But I have a confirmation number."

"I'm so sorry but that date is no longer available. May I help you choose another? The next available weekend is May sixth and seventh."

I checked with Alex. He said, "O.K." and I agreed rather irritably but I had already paid with my credit card and the reservations had to take place within six months. Already the expected temperature had moved from seventy degrees to ninety degrees. Another letter arrived with the second confirmation number and dates. Alex looked at it and said, "Remember Charles and Pumpkin's baby is due May first and we are going to New York when it comes."

I gulped and hoped it would all work out. February and March

went by. My son John and Cidnee announced their engagement and said they would be married in June. My daughter Roberta and I agreed that we must give Cidnee a shower. Robbie discovered that the only date that Cidnee had free was the first Sunday in May and sent out the invitations. I finally realized it was the same weekend we had reservations in Palm Desert.

"Well, I'll just have to miss the shower," I told Robbie.

She, smart girl, said nothing except, "Will you tell Cidnee?"

"Yes."

Next I got a phone call from my friend Eleanor who said that she and Sue could give me a ride to the shower. It finally sank in. I couldn't miss the shower.

The rules on the invitation to the "Desert Escape" from which at this point I wished to escape, were that you must change your reservations thirty days ahead or forfeit the deal. I tried anyway and called the 800 number, told my story and said we could come Monday instead. The cheerful female voice said,

"I don't know but I'll check and call you back."

The phone rang and it was she, "You're going to really like me."

"Oh, you were able to change it. Oh I do, I do really like you."

She laughed embarrassedly and said, "I shouldn't have said that."

"Of course you should. Thanks a lot."

Aside from being grateful, I enjoyed hearing a genuine human reaction on the other side. I got a new letter of confirmation. Now I had to change the airline tickets. Not cheap! We were now not going to stay over a Saturday night and the price went up several hundred dollars. Oh, well, a small price for no guilt and the vacation might still be a bargain.

At nine A.M. on May first we got a phone message from Charles:

"Pumpkin is in labor—will call when the baby arrives."

At 2:30 P.M. we got the call that a little girl was born. No name yet but it would be between Poppy and Aurora. The final decision was Poppy Louise or Poppylou. Alex and I shook our heads realizing that we were of such a different generation that we were astonished at such a name. We wisely shared no such awareness with Charles

and Pumpkin who were ecstatic about their accomplishment, and we were happy and delighted to have a granddaughter among all the boys in the family.

Fortunately for our Palm Desert plans, Alex had a cold and had to postpone a trip east to meet Poppylou until his cold was over— dried out by a visit to the desert, we hoped.

The shower was a success and the mother of the groom (me) did the right thing by attending. Monday morning arrived with no further obstacles to our trip. I was packed and ready by nine A.M. for a flight leaving at 10:55. Alex was ready by 9:30, having survived my impatience. I took my suitcase down to the car to find the front passenger window smashed and glass everywhere. Stuff from the trunk and glove compartment were scattered all over the car. We always have to park on the street because we have no garage. I could feel my insides tightening, but I was determined somehow to go on this trip.

I came back to the house, told Alex, grabbed a whisk broom and paper bag to start sweeping the glass out of the car.

"We'll just drive this car to the airport parking lot and fix it when we get back."

"Jean, we can't do that. There is glass everywhere. You better take the car over to the Toyota place and see if they will fix the window and keep the car until we get back. I'll follow in the other car and we'll take it to the airport."

I was grateful to Alex for such quick thinking. I swept up some of the glass and drove the five blocks to Toyota where they took pity on me and said they would fix the window and keep it until we got back. Another $250 was added to our vacation special.

We actually made it to the airport in time for our flight, conveniently delayed. Our flight to Ontario was uneventful and we set out to find the rental car.

"The sign over there says, 'Bus to car rental building,'" I said.

"When I ordered the car," Alex said, "they told me the car rental was in the airport building itself."

We dragged our bags from one end of the building to the other.

Then we took the bus to the car rental building. Alex had already arranged for the car and asked why the Toyota Corolla, for which he had a confirmation number, was not available.

"We don't have any Corollas."

So much for that "convenient central booking."

I asked the wife question, "Did you ask for directions?"

"No, Palm Springs should be easy to find. If you're worried, you ask."

I went up to the counter and asked the young woman, "How do you get to Palm Springs from here?"

"Where are you?"

"I'm standing right in front of you."

The events so far seemed to have made me literal. The man next to her tittered as she looked bewildered.

He said, "She means where is your car?"

"I don't know, we haven't gotten it yet."

"From the lot, you turn left and then right, left again, right again and you're on Highway 10. Look for the signs to 10 East," she rattled off so automatically and quickly that I thought I could never get it straight but I didn't want to ask again. We went out to the parking lot to find our car. It was bright red which didn't please Alex. He went back for a white one which turned out to be a two-door, so he went back again and finally got a four-door white one that looked like a cat in heat with its rear end sticking way up in the air.

We climbed in and were off. I got the first two turns correctly and then there were signs and we found our way to Highway 10 east. It was two o'clock and I said, "I need to eat lunch."

"I'm not going to eat a full lunch when it's dinnertime two hours from now. Can't you wait 'til dinner?"

"No."

"I can't understand why you always have to have lunch. I could go all day until dinner. Well, if you can find a Wendy's, we can stop and have a baked potato."

I looked and looked as we drove towards the desert with huge

trucks zooming by us, but I could find no Wendy's. It was then three o'clock and I was starved.

"Look, there's a Sizzler's. They are sure to have baked potatoes. I promise not to eat anything more."

"Are you sure?"

"Yes."

We went in with some nostalgia because we used to take Alex's mother and father, gone over ten years now, to a Sizzler's when we visited them in L.A. It was kind of embarrassing to ask the man who was waiting on us for just two baked potatoes, but we did. He was quite gracious.

Two potatoes later, we continued on to Palm Desert and found the entrance to the Marriott Villas. As we entered the gate we left the sand, rock, cactus-strewn desert to enter a world of green grass, golf courses, pools and building after building of appropriate pink sandstone colors. We followed the signs to reservations and saw only a sign that said "Previews." We drove around in a circle and returned to the same sign.

Alex said, "Try 'Previews,' maybe it's there. You go in and I'll wait in the car."

I went in and approached a desk with a seated woman and another standing. They both gave me big smiles.

"Where are reservations?"

"Over there at the counter."

I walked over and showed my reservation form to another young woman with a smile also plastered on her face,

I said, "I had a hard time finding you."

"Everyone else finds it without trouble," she said.

I felt cross and blurted out, "I guess it's because I am old." Then I felt really cross at myself for saying that. We both regained our composure and she, remembering what she had been taught to say, said, "I'll let others know you had trouble."

She handed me a card with two plastic key cards, drew directions to our room on a map—room 2736 in building 26 and wished me a lovely stay.

One of the other more mature women came over to me, still smiling and said, "We'll call you in the morning for an appointment to come get your gift certificates after the accounting office processes your reservation."

I escaped out the door, thinking, "This may be a bargain but I'm getting the feeling that this is more than I bargained for." I didn't dare tell Alex about my latest verbal exchange and we set off to find our room in this questionably exclusive resort. How could a resort be exclusive with us staying in room 2736? We drove around the same circle again and located building 26, found our room with only a small amount of difficulty. It was quite pleasant with a king-sized bed, microwave, sink, refrigerator and a small patio looking out over a stream of running water and one of the golf courses. We settled in and looked over the material they had given us. There were quite a few restaurants in the resort; we chose an Italian one with an early-bird special and called for a reservation.

"I'd like a reservation for two at Tuscany's tonight."

"I'm sorry, the reservation desk is closed for the night. Would you like me to connect you to the operator who can help you?"

"Yes, thank you."

"Operator."

"I'd like to make a reservation for dinner at Tuscany's tonight."

"I will connect you."

"I'm sorry, reservations are closed for the night."

I hung up and looked at our material again, found a separate number for Tuscany's, called and made the reservation. I hoped everything wouldn't be quite this complicated. Maybe I needed a good night's sleep. After some wandering around in this 400-acre exclusive resort we finally found Tuscany's, which was tucked down and behind a big hotel, also part of this resort. The maitre'd first gave us the regular menu which was very expensive but I persisted and the waiter reluctantly produced the early bird menu, saying,

"It's just at the end of the early bird time."

I looked at my watch and then at our waiter—he looked irritated with us, silently nodded acceptance and took a long time coming

back for our order. This menu was expensive enough. We were bathed in Italian opera arias as we ate our very good dinner. After exploring some more we took the car outside the resort area and found a Ralph's grocery store to buy breakfast and lunch. It was going to be work to keep this to a bargain! As we walked into Ralph's, Alex and I again had a sense of nostalgia because we always took his parents to Ralph's for shopping on our L.A. visits. Ever vigilant, I pointed out to Alex as we checked out that if we joined Ralph's club they would take some money off our bill.

We returned to our room and settled in for a good night's sleep. However we had not expected the on and off noise of the tiny refrigerator, rather loud in this small room, nor the air conditioning racket. Just as I had feared when they changed the date of the reservation, the temperature was in the nineties. The screen door wouldn't lock so Alex felt we needed to keep the door closed. Later on in the stay we gradually adjusted to the noises.

We got the morning call and walked over to pick up our gift certificates, three $25 ones to spend in the resort on restaurants, the spa, and so forth. The sales people kept saying, "No obligation."

I wondered why. They then proceeded with an enticing offer of $100 in certificates if we would give them ninety minutes of our time to learn about the Marriott resorts all over the world. The original sales promotion never suggested that they would try to sell us anything, though it did seem likely they would. I wondered what path we were being led down.

We spent the day in a relaxing manner, with time at the closest swimming pool, reading, napping and deciding where to eat dinner. After dinner we succumbed to the lure of the certificates and agreed to go at 9 A.M. the next morning for our presentation. At eleven I planned go to a water aerobics class at the spa. I tried to include Alex, but he was worried about sunburn—an appropriate worry I discovered later as I got a bad sunburn myself.

We appeared at 9:00 and were directed into an adjacent building to wait for our tour leader. A nice Brit by the name of Sandy showed us around the rooms with large photos of the resorts, then took us

for a ride in a golf cart around the resort. I looked at my watch. It was now 10:15.

"Don't forget I have an eleven o'clock appointment."

"Oh, I'm cutting things short," she replied.

It became quite clear that ninety minutes was far less than they hoped for. We learned all about Marriott vacation rentals—their form of time share—and how much money we would save over our usual travel arrangements. I looked at my watch again. It was 10:45.

"Our ninety minutes is coming to a close."

She quickly brought in another woman who was a real estate agent who launched into her spiel. At the ninety-minute cut off, I said, "I am terribly sorry and I appreciate your presentation but I have to go."

I was not sure that Alex would leave with me but he did, saying we would think about it. They gulped, looked cross, and gave us our hundred dollars of certificates and their cards.

Later Alex said, "I was worried you were going to go off and leave me there!"

I did feel uncomfortable but determined. At the time, the offer was tempting, but then it wore off. I was sure that was why they wanted to get us to sign up right at the close of their pitch. We felt a certain pleasure in beating them at their own game but it wasn't easy.

Finally we were free to enjoy ourselves. We went to the spa, found a 7 A.M. three-and-a-half-mile walk, yoga classes, swimming pools, and a nice cafe at the spa serving healthy food with a naturally friendly black woman manager. We swam, read, watched two good movies on the pay T.V. using our free certificates. Of course we used them all up and more so!

This "Exclusive Vacation" from "The world's leader in hospitality" was not quite as advertised. Room 2736 in Building 26 didn't quite measure up to exclusivity; the rude receptionist, the pushy sales people and the reluctant waiter would not have met Emily Post's criteria for hospitality. It's not likely we will be tempted by anything like this again. I felt I met the challenge, however, and had Alex's appreciation for all my effort.

As we left he squeezed my hand.

"That was really enjoyable. I know you had to drag me kicking and screaming. Thank you for being persistent. Our getting out by the skin of our teeth was our real 'Desert Escape for Two.'"

We stopped to let a mama Mallard cross the road with her twenty or more ducklings and then turned out the gate, returning to the natural desert world of sand, cactus and sage.

LUCIA EAMES

# Like an Insect Caught in Amber

A STRUCTURALLY ELEGANT insect preserved in amber, its delicate perfection intact, is a marvel, a wonderment; it is also a cosmic side-show featuring several chilling curiosities: a macabre celebration of the entrapped, inanimate state of a creature exquisitely detailed for grace and flight; a weird dislocation of time that collapses eons into a single frozen moment; and a bizarre example of the random, pinball-like impact of chance, haphazard timing, hapless choices, and/or inadvertent oversights on lives.

The sight of a hapless creature thus entombed evokes heartfelt, frequently asked questions: "Who gets caught?" "Who doesn't?" "Why this one?" "Why not another?" "*Why me?*" "*Now* what?"

Merciless chance does seem to determine for insects, planets and people, the space, time, geography, and state of being to which they are born and thus the happenstance to which they progress. The beautiful nightmare shadow of an insect caught in amber stirs rising empathy for this distant evolutionary relative and an impulse to examine the pattern of its plight for clues to understanding our own. The spirits of humans and those of insects are both like small

winged creatures, darting and flitting in ceaseless motion around a
tree of life. In this Eden, a honeyed streak of resin snakes down the
tree of life. Implacable, it draws these winged spirits into a compel-
ling, tangible void called melancholia or depression.

Many spirits fly safely past its gluey grasp, but others may brush
against a drop of resin and be held fast. Of those, a number may still
struggle free from its sticky hell, leaving behind, perhaps, an anten-
na, a foot or a leg… later to be found in amber. A higher price is
paid, and swiftly, for the complete release effected by a passing bird's
sturdy beak.

Entrapment disorients the spirit. If no escape is gained by out-
bursts of frantic tugging at the elastic tether, the bewildered being
can not compute a course to take. The ooze of resin deepens. Time
and energy dwindle. Isolation seems cold but natural; numbness,
more so. Loss increases. Wing power ceases, barely noticed. Paraly-
sis deepens within the amber tomb.

A brief but insidious euphoria may stem from being held fast in
place against the tree and gaining the secure vantage point of "a fly
on the wall": able to see everything without having to do anything.
The effort required to stir at all stifles any latent urge to do so. Ex-
haustion spawns denial. Fear unspools desperate rationalizations.
Claustrophobia is welcomed blindly, mistaken for the warming cozi-
ness of a wrap-around security blanket. Deepening darkness erases
the last shreds of protective instinct.

The spirit panics in frozen frenzy, but it is too cold, too dark,
too late. The weight of thickening resin presses hard against the gut,
the thorax, the larynx, crushing cries. They fade, then cease. The
quivering antennae are stilled forever.

The resin secures its hold and proceeds to the inexorable con-
clusion. It morphs, transmutes, and hardens into amber. Within the
insect, seen so clearly in the amber, a splinter of brain may spin on
for a time recording transmissions passing through the ever-open
tearless eyes. No signal passes back. The translucent sarcophagus is
sealed. Eons speed by at torturous length.

The amber is polished and passes from hand to hand.

Sealed in Depression's silent, frozen Hell, the unblinking eyes freeze on each hand as it closes around the amulet.

Conclusions are clear:
1. There, but for the fickle, graceless workings of chance, go I;
2. Steer clear of all resinous matter in this life, and the next;
3. If you *are* stuck, *KEEP KICKING*.

KATHRYN K. McNEIL

# Blue Oak Summer

I LIE BACK IN MY Pauley's Island rope hammock, testing it, settling myself into its rough fibers. My friend John has strung it between two blue oak trees. It's a beloved souvenir from another place, when my view from it was full of mountains, row behind row of mountains, too many to remember their names. This is my first summer of change after thirty-six others spent on an Appalachian mountain top.

This day my hammock hangs here in these hot California foothills where vineyards speckle the hillsides. John has offered me his summer home to heal the wound of parting from my own. He knows the moment is delicate and smiles down at me. "You need a pillow under your head," and he walks back to his house to find just the right size.

I am left alone, staring up into a thousand leaves and a slice of hot sun behind them, straining its way through them to find me.

It is the second week of June.

I was always there by now, wandering each day down ferny paths in the dark Appalachian forests. Great Smoky Mountains National

Park ran along the western border of my property, and it took only a quick step over its frail chestnut fence to be in wilderness, preserved forever.

The land sat at 5000 feet and the air was still cool when I arrived. As the daylight lengthened and the days grew warmer, I watched spring reveal itself with violets and "spring beauties" appearing in the sun-filled forests before the leaves of the hardwoods unfurled. Each day brought its discoveries and much time was spent in finding them. Up above the house, this very week, the wild lilies of the valley must be blooming. I counted fifty last year.

Over my head the leaves of the blue oaks move silently, parting, letting the sun in to make bright hot spots on my hands. Now it is gone again, into hiding, behind the leaves.

I can barely see the roof of John's house from my hammock. It nestles comfortably into the oak woodland, its wooden siding the same color as the pale green-grey lichen that hang in long strands from the oaks around it. My own house stands stark and gray, alone on its grassy mountain top with not a tree nearby to shelter it. His house is small, one large high-raftered room for living, mine, two-storied, large enough for many guests with a twenty-foot window that catches the mountains in its view.

I am in my remembering now: the jeep is loaded with groceries for the weekend visitors, dust flying behind my wheels, I climb one thousand feet, two thousand feet, feeling the air cool as I take turn after turn on the old dirt road, and there, as I break out of the forest into the sun, is the house at last, on its hill, waiting for me! "I'm back," I whisper to myself as I open its wide door, "I won't have to leave you for another day or another week, or until summer is over!" I have four hours to get ready for my guests. The drinks are put in the cooler, the meats and vegetables stored carefully in the refrigerator. There's not an inch to spare. I will need lots of ice this weekend for the radio says no rain and warm. There are flowers to fix, towels to put out, a cake to make and the table to set for eight. I put Rach-

maninoff's Second Symphony on the stereo to speed my labors. This is one of the few summer weekends when the the driveway will be filled with cars and every bed occupied.

Later, my friends, holding their drinks, will push back the glass doors and walk outside to the porch. The afternoon is cloudless. There is always silence as they look north, south, east. My Smoky Mountains are always their best these weekends, jumbled one on one in the blue haze of distance. I count on them to entertain my guests while I am inside doing kitchen tasks. Conversation comes in fits and starts, easily, the mountains filling in the gaps when the words stop. My guests drag the chairs closer together and put up their feet on the porch railing.

I have come out now with my drink and a tray of crackers and cheese.

"That's a new house over there, isn't it, on that grassy bald? New since last year?" they ask. The same friends come year after year.

"Yes, and each year there're more," I said. "Roads and people keep going higher and higher up."

"They see your house on top of the world and think, why not us?"

"See that one over there?" and I point to it. "It's higher than mine, must be over 5,200 feet. They leave their spotlight on all night. You'll see it when it gets dark. Nobody likes that around here. Bothers everybody when you're outside on a pretty night. You want to concentrate on the moon, not their security light."

"What's your security?"

They are teasing me. They think I'm fearless and foolish, a widow, living alone on a mountain top. "But who is out there to hurt me?" I ask them. "I lock my doors at night, my phone is nearby, my flashlight."

They laugh at my list of preparedness. "You're not scared?"

"Of what?" I ask them. "Of bears, or wild pigs?" They shake their heads. What really frightens me, though I keep it to myself, are storms. Those nights when the wind howls in the gutters outside my bedroom, and the thunder follows the lightning in terrifying

bursts of sound. Those are nights when I close the curtains to calm myself until the storm wanders off to other mountains, leaving me drained and weary.

The dawn after such storms is like creation day, the sky washed clean, the meadows shimmering with moisture, the barn swallows darting about my eaves through the tranquil air of early morning.

So many summers to remember, and then one day last summer it was time to turn it over to others.

John has put a pillow under my head. "Better?" he asks. He is solicitous of my mood. Dearest of friends, dearest of companions, he knows I am trying to make peace with my memories. We are friends from childhood, reunited again after a separation of fifty years.

The hammock sways as I shift my weight, adjusting to the pillow.

"The mountain lion is back," he says, leaning against a tree. John likes to lean against something. I tell him he wakes up tired.

"You've found more shavings?"

"Lots of them, in the usual places," he says.

He has a resident lion. In North Carolina they'd call him "panther." He stalks John's twenty acres while we're sleeping and preens his claws on one of the many redwoods around the place. Redwoods have a lovely shreddy bark that suits our lion.

I saw him once. I had awakened at dawn to write and sat at the desk in the window. I saw the long tail first, very long. I guessed three feet. I stood up, amazed, to see what animal could own a tail like that and looked straight into the yellow eyes of his little cat face. As I watched, he walked elegantly, languorously, between the chairs where our bathing suits lay draped from a late evening swim, across the grass, and suddenly bounded into the forest. It happened so quickly I wondered if I'd dreamed it.

It was ludicrous to see him amid the patio furniture. He has no place here. Or is it I who is out of place? Have we not usurped a place that has been his for thousands of years?

I think of him when I walk these trails, holed up in some cool

rocky cave, waiting for night to come so he can hunt at leisure. Will he hurt me or John? Excitement has been added to the landscape, not fear. We are in his country and take our chances.

I smile at John. We like the wildness the lion brings.

"I'll be down at the pump house for awhile," he says. "When you're ready we'll have a swim."

John's house is on the edge of a wild, uninhabited area of foot-hills laced with chaparral and rocky cliffs, ascending higher and higher until they reach Mount St. Helena, the only mountain around. The grassy hills, a dazzling green in spring, lie parched and brown now in June, and the ground is hard as cement. By October, with no rain in four months the earth pants for relief, and many of the blue oaks have dropped their leaves. The buckeyes are well ahead of them and stand bare in August as if it were winter already. Thus, they conserve.

Fall is fire season. As we sat with our drinks one lazy afternoon on the patio, he told me that forty years ago, he watched a fire sweep across the hills towards his house, burning everything in its path. The house was spared by wetting down the roof, and the large oaks next to it survived though badly scorched. The pump house had burned down so he watered the oaks daily with buckets from the swimming pool until they showed signs of recovery. The next spring, with the help of the Forest Service, he planted two thousand new seedlings.

I look at the hills now, marveling at the size of the trees and their diversity. They are a patchwork of greens: the live oaks a dull, dusty shade, the big leaf maples, a yellow green, the Madrones rich and deep, the Knobcone pines a lacy gray.

How different my Appalachian mountain top. Some summers rain came every day, great sweeping bands of it, and just as quickly disap-peared into rainbows and great fleecy clouds. The grasses thrived as did a vast spectrum of wildflowers mingling with them, from June through fall. After a walk in the meadows, I came back like a brides-maid, my arms full of Queen Anne's Lace, Bee Balms, and Black-eyed

Susans. Every vase was filled, and when I ran out, I used empty jars.

Those early mornings on awakening I walked out on the porch in my nightgown to see what the day might hold: clouds blowing in rain from the west, or cloudless with the rising sun turning the sky a blue gold? Things changed fast in my mountains!

I wrapped my arms around myself against the early chill as I looked for any movement in the fields. Foxes and wild turkeys didn't expect me up so early. I surveyed all I owned, and all I didn't, from my porch with its view of mountains, hundreds of miles of mountains. I owned a sunrise house, the woods behind hid the sunset from me. Its reflection on any floating clouds was good enough.

I had a garden there, a tiny patch off the porch by the pool. With a cool mountain sun all day long and rich black mountain soil, the cone flowers and Cosmos and sunflowers made my heart leap for looking. I called it "Bonnie's garden." She was my friend, my neighbor, my caretaker, who planted it each spring while I was still packing my suitcase in California. We were close as sisters, Bonnie and I, though we led different lives.

John has prepared a garden here, digging and softening the hard packed soil with his trusty mattock, and installing a drip system so my poor little plants have a chance to make it through the heat of a rainless summer. I'm learning fast what not to plant, a trial and error game, with many disappointments and a few triumphs.

It was a separation that had to come. Inevitable. My house was too isolated, the tasks too many, the job too big for a woman near eighty to handle. There were days without water when the pump was hit by lightning. Or a tree blown down by the wind might lie across the road, isolating me, until someone with a chainsaw arrived. There was loneliness, with daughters and sons turning up only intermittently, staying two or three nights at a time. I had my mountain friends, my reading, my daily rambles over the meadows and down the dark forest paths. But solitude is best when it has a terminal point. And widowhood carries its own aloneness.

John came for his two weeks every year and each day became significant with his presence. But two weeks is gone in a flash and I had my solitude again.

"How much is beauty worth?" I'd ask myself year after year as I walked down the road in the evenings, the mountains descending with me until I stood at the bottom, five hundred feet below the house, looking back at it as a setting sun silhouetted its rafters. Then a thought came to me. Why not give it all to the Park? They were our neighbors after all, along the western boundary. That way the land would never change. The alternative, selling it and watching the meadows be subdivided into home sites, was unthinkable to all of us. Would the Park accept it? The day it was offered, it was accepted with delight.

That last day in August, a year ago now, I stood for a farewell look, marveling how large the big room looked with its hook rugs and furniture gone. The floor boards shone despite the years of footsteps. The mountains framed in the many windows waited to greet the new owner, as they had greeted me each summer morning.

Bonnie was with me. "It will never be the same." Her eyes were filled with tears, too, and we clung together in a last embrace. "I'll keep the garden up for the Park like I was doing it for you, but it won't be the same." When I reached the bottom of the hill, I stopped and got out of the car for a last look. When I saw it again it would belong to someone else.

A hot breeze stirs the leaves again. They are a special blue-green, these oak leaves, for a wax coats the upper surfaces that face the sun helping them cope with the extreme dehydration of a foothill summer.

I close my eyes and listen to the junco making his strange smacking sounds on a limb above me. Farther away a woodpecker taps out his hole in an oak. Three o'clock and the sun has reached its zenith. The whole world sleeps in the hot silence but for the four of us.

I thought it too dry in June for wildflowers and I had given up

looking. Yet only yesterday with the thermometer in the nineties, I found surprises in the sunburnt grass. "Golden Nuggets," John calls them but I recognized them as Mariposa lilies, beautiful golden chalices on delicate stems, eight inches high perhaps, with inner markings of maroon. Next to them in the brown grasses were wisps of sky blue called Elegant Brodaeia. How could they pick this hot month as their time to bloom? I've learned that nature has strange, inner clocks of its own that we can only wonder at.

The junco smacks again.

Perhaps he is telling me that the feeder is near empty. One of my first tasks on arrival here is to fill the feeders. Within minutes, the juncos and towhees are back. I visualize a vast gossip network in the trees. How else do I account for the silent message spread abroad that the feeders are full again? Do they recognize our car? Our voices?

Suddenly there is much splashing in the birdbath, a shallow scoop of a clay saucer in a corner of my garden. I leave the hammock to take a peek at the bather. The birds have waited all week for their bath, and the dipping and fluffing of feathers while this task is accomplished is delightful to watch. The bird bath evaporates in a day unless I am here to fill it. These wild little creatures seem to adjust to our ways, taking what we give them and doing without it when we stop, without complaints. I walk down the path to the pump house to find John. His spring is wonderful, never ending, a sweet water phenomenon on which he depends. Fifty years ago, his parents hired a man with a divining rod to find them water and he led them to this spot where ferns and rushes grow in profusion and nowhere else.

My heart contracts. I remember my own "forever spring," and the hours spent watching it pour itself out of its hidden earth opening, giving me endless sweet mountain water. Wild brook lettuce grew nearby in the overflow, and bluets.

John is inside the house.

"Time for a swim before lunch," I call to him. He comes to the door, a piece of walnut in his hands.

For him, the pump house has a dual purpose. It is packed with remnants of fine wood, too small, too large, or generally too odd for any practical use. My laptop computer rests on such a remnant, a piece of Honduras mahogany he made for me last Christmas into a polished stand, just the right height above my keyboard. He hoards all manner of things. One day he mounted an exotic wire spiral atop a small post where I latch my garden fence, to protect it from the wild turkeys and rabbits. It has the look of a wispy Russian steeple. When I exclaimed, he answered, "See, Kathryn, you would have had me throw that away." He walks gently on the earth and believes everything can be used again.

"We'll need a swim after lunch, too," he said, smiling at me, "in this heat."

He sits on the edge of the pool, his legs in the water, his old felt hat shielding his face from the sun. "Swimming is best for what ails you," he says, watching me loll around in the shallow waters in my Panama hat. He is a surgeon, expert at mending bodies. "Minds are different," I tell him, "ever changing, vacillating, moods swinging up and down."

I study him. He is still handsome, his shoulders broad and strong, his body firm. It embarrasses him when he catches me staring at him. "Take your hat off and do some real swimming," he orders me. "That's what you need."

He is usually right and I obey because I want to. His few commands are gentle and easy to heed.

I swim the length, turn, swim back and turn again, five times, feeling the cold water sweeping past my arms and legs, my eyes closed against the strength of it until, breathless, I stop before him, coming up between his legs, shaking the water from my hair.

"Feel better?" he asks.

"Yes," I answer, and give him a wet kiss on the lips.

I spread my towel on the warm cement and lie down.

Suddenly it is August and the grapes that twine around the posts on John's patio hang, half hidden, ripening beneath their leaves. My

pain for my lost home ebbs and flows, triggered by simple things, a word, a sound, overwhelming me with memories and just as quickly waning as I become distracted with the present.

One day I found the answer to the question I had asked myself so many times, so many summers. "How much is beauty worth?"

We were reading in the warm shade of a late summer afternoon and the strains of a Spanish guitar sounded distantly from the living room stereo. I looked up from my page and saw a cluster of grapes, the color of red wine, dangling not far from where we were sitting. I arose, although I could almost have reached them from my chair, the patio is so intimate.

"Look John," and I held the perfect fruit in front of him. "This year we got them before the birds."

He smiled at me and reached out to pick one. Then I understood what really counted. It wasn't the things I had ached for, my land, my house, the meadows full of flowers, but the loving I had plenty of, right here in front of me.

# Contributors

AVA JEAN BARBER BRUMBAUM was born and raised in Berkeley, graduating from the University of California with a degree in bacteriology and zoology. She worked at the Crocker Radiation Lab until her marriage to Harold Pischel when they moved to San Francisco and raised four children. Considering herself lucky, she chose a volunteer career, much of it centered around the San Francisco Symphony—where she holds the track record for Board membership, fifty-four years and still counting. She has also contributed considerable time and energy to the Conservatory of Music and served as chaplain's aid on the AIDS ward at San Francisco General Hospital. Widowed and remarried (to her second Harold), she retired fourteen years ago to rural West Marin, where she keeps busy gardening, playing tennis, entertaining grandchildren, and thoroughly enjoying country life.

LUCIA DEWEY EAMES was born in Saint Louis, Missouri and grew up in the Midwest, spending summers in Southern California during the 40s. She graduated from Radcliffe and remained in the Boston area until she and her husband moved to San Francisco in 1960 to pursue careers in the arts, in her case, photography and designing metal works. Since the mid-90s, she has lived in Sonoma where she and her daughter conduct a sculpture and design business. She also manages the Eames office in Pasadena, whose mission is to preserve, communicate and extend the work of Charles and Ray Eames. Her five children and six grandchildren are her greatest joy; and the privilege of friendships, a treasured pleasure.

MARGARET EVANS GAULT was born in Los Angeles, grew up on the West Side and graduated from Marlborough School. Following graduation from Vassar College, she married attorney James Gault, and they came to San Francisco. After raising four children, she became a secondary school teacher. On retirement from teaching, she assumed a second professional career as a financial advisor and has managed clients' investments for more than twenty years.

Born in San Francisco, JEAN CHARLES GANSA is a fourth generation Stanford graduate. Her grandmother and great-grandmother attended Stanford together, allowing all four generations to fit into the 100-year life span of the University. She earned an MA in Clinical Psychology at the University of San Francisco and has a private practice in psychotherapy, also leading seminars on spiritual and psychological subjects through The Guild for Psychological Studies. Her current focus is on finding meaning in old age. She has five children, all in California, four grandchildren, three stepsons, and two step-grandchildren. She and second husband Alex enjoy foreign travel, including seeing Alex's relatives in Russia, Latvia, and Germany.

Artist NANCY THOMPSON GENN has exhibited her work worldwide, including in New York, Tokyo, London, Washington, D.C., Japan, Italy, and her native San Francisco. Her art is represented in the permanent collections of many museums, including the Museum of Modern Art, New York; MOMA, San Francisco; the Albright-Knox Museum, Buffalo; the National Museum of Fine Arts and the Library of Congress, Washington, D.C. She has worked in bronze, ceramics, and handmade paper, completing major sculpture commissions of cast bronze. She studied at the University of California, Berkeley, and the California School of Fine Arts, working mainly in the Bay Area, with periods of working and lecturing in Japan and Italy. She and husband Tom live in Berkeley where they raised their three children.

SARAH ROBINSON MCANDREW (Sally) was raised in Pittsburgh and graduated from Vassar College with a BA in Art History. She married and moved to San Francisco where she raised two daughters and volunteered for charitable causes. Later she received a secondary teaching credential and a master's degree in Museum Studies and taught for many years in San Francisco public high schools. In the early 80s she switched careers to philanthropy, working as Fund Development Director for nonprofit organizations. She was widowed in 1999, when she retired, then remarried and moved to Marin County, where she and her husband Peter McAndrew enjoy golf, gardening and each other.

A native of San Francisco, KATHRYN KENDRICK MCNEIL raised five children of her own and became the stepmother to five more upon her second marriage. She loves the out of doors and spends as much time as possible hiking both in the North Carolina mountains and the Bay Area. Her particular interest lies in the flora of wherever she happens to be, an enthusiasm that has led to her work as a docent at the Arboretum in Golden Gate Park. When not out of doors, she pursues her other interests, writing and keeping up with a growing number of grandchildren.

ROSEMARY DUNDAS PATTON came to writing her own stories after teaching writing in the English Department at San Francisco State University for fourteen years. Born in England, she moved to Scotland where, at eight, she vowed to become a writer. At twelve, with her three sisters, one brother, and her parents, she moved to North Carolina. She followed a BA in English from Duke University with an MA from San Francisco State several years later. By then she, her pediatrician husband Gray, and three daughters had settled in California. Today, the balance has shifted to include five grandsons. Her vow to write was postponed many decades, but a college textbook, *Writing Logically, Thinking Critically*, launched her, and a recently discovered old letter from her English professor father-in-law validated her wishes: "Thank you for your wonderful letter; you are my favorite author."

JOANN MAXWELL REINHARDT was born in Indiana and moved to Southern California when she was six. Soon after graduating from Stanford, she moved to San Francisco, where she has continued to live except for extended stays in Greece, Turkey, and Switzerland with her husband, author and journalist Richard Reinhardt. At various times she has been an elementary school teacher, a San Francisco guide, and the owner of a small cooking business. But her primary career has always been her home and family, grown from three sons to include three grandchildren. In addition to writing family memoirs, she enjoys cooking, traveling and long weekends in Sonoma County where she reads Proust rarely and makes pickles often.

SUSAN WHEELOCK RENFREW, born in Ohio, grew up in Michigan. She came to San Francisco in the '50s with her lawyer husband and has been well acquainted with boys as a second grade teacher of thirty-eight children, an art teacher at a facility for emotionally disturbed boys, a mother of three boys and grandmother of two. She also has a daughter, six granddaughters and one great-granddaughter. Currently single, she leads seminars on art, music and psychology in a Jungian Center north of San Francisco, enjoys travel and writing her memoirs.

JEAN-LOUISE NAFFZIGER THACHER (BEENIE) was born and raised in San Francisco. She received a BA in Psychology from Stanford, worked for the American Red Cross and for a publisher in New York. She continued her education by marrying a U.S. Foreign Service Officer, moving first to Pakistan, then to Philadelphia, India, Washington, D.C., Iraq, Iran, and Saudi Arabia with their three children. She enjoys keeping in touch with her widely scattered friends as well as working on her bibliography of Arabic literature. Recently widowed, she enjoys her family, including six grandchildren, and continues to be passionately interested in the politics of the Middle East.

MARY WILBUR THACHER spent her early years in San Francisco in a house overlooking the Bay where she watched the Golden Gate Bridge being built. She attended Grant Elementary School and after moving to Burlingame, a Sacred Heart convent. She attended Vassar College, then graduated from the University of California, Berkeley, after which she married Carter Thacher and raised three children, all living on the West Coast. They divide their time between San Francisco and Sonoma, where they display their considerable art collection. Several years ago they acquired an apartment in London and travel there often for art shows and the theater. A few years ago Mary spent some time contemplating what "I would do if I were penniless." She decided that she would open "Mary's Truck Stop," claiming she can cook good breakfasts, soups and pies. In other words, she'd make a good short order cook. "After all, that is what I have been doing all my married life."

OLIVE GAMBLE WAUGH (BABS) was born in Berkeley, grew up in Los Angeles, received a BA from Stanford and attended the University of Pennsylvania Medical School. She married a physician, whom she met in medical school, and has lived most of her adult life in San Francisco, raising two daughters there. She worked for a time as a research technician studying cardiac arrhythmias, then started a medical career program for high school students and, later, an adult literacy program, both of which are still flourishing. After she was widowed, she married again and lives with her husband in Los Altos Hills, south of San Francisco.

BETTY BIRD WHITRIDGE moved on from "only child" in Arlington, Washington, to the University of Washington and then marriage to "a tall, handsome Easterner, Fred" who had come west after college. They moved around for a number of years until they settled in San Francisco, where they raised four sons, traveled extensively, and took part in the cultural and civic life of the city. They spent summers on Orcas Island in the San Juan Islands of Washington, and after Fred's retirement, moved to their property there, returning to their San Francisco house for only four winter months each year. Twice they did extended stints in Brazil and Kenya, volunteering with the International Executive Service Corp (IESC). No matter where she is, Betty has a spectacular garden, needlepoints every surface, sings with choral societies, reads at dazzling speed, supports her community, and with Fred, enjoys expanding and restoring their property. Somehow, she finds time to write about her life and entertain nine grandchildren.